the **creative** photography **HANDBOOK**

A sourcebook of techniques and ideas

Lee Frost

David & Charles

For my partner, Julie,
and my children,
Noah and Kitty.

A DAVID & CHARLES BOOK

First published in the UK in 2003

Copyright © Lee Frost 2003

Distributed in North America
by F&W Publications, Inc.
4700 East Galbraith Road
Cincinnati, OH 45236
1-800-289-0963

A catalogue record for this book is available from the British Library.

ISBN 0 7153 1310 X hardback
ISBN 0 7153 1537 4 paperback (USA only)

Printed in Hong Kong by Dai Nippon Printing Co Ltd
for David & Charles
Brunel House Newton Abbot Devon

Commissioning Editor Sarah Hoggett
Senior Editor Freya Dangerfield
Designer Nigel Morgan
Production Controller Kelly Smith

Visit our website at www.davidandcharles.co.uk

David & Charles books are available from all good bookshops; alternatively
you can contact our Orderline on (0)1626 334555 or write to us at FREEPOST
EX2110, David & Charles Direct, Newton Abbot, TQ12 4ZZ (no stamp
required UK mainland).

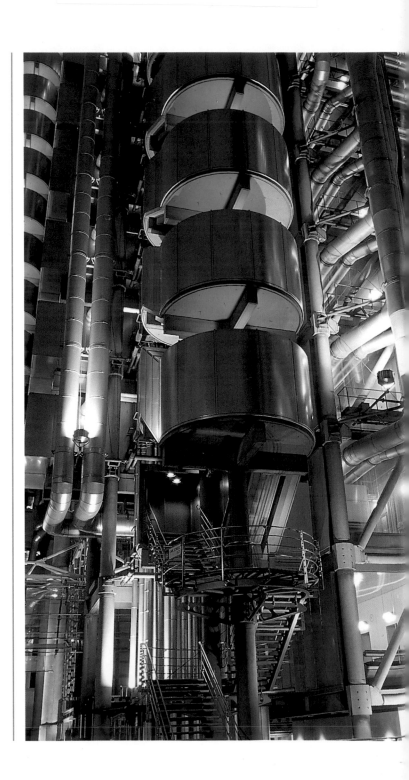

Contents

Introduction

When I first became interested in photography during my mid-teens, I devoured anything and everything I could find that might help me take better pictures.

I waited in eager anticipation each month for the latest issues of my favourite photography magazines to go on sale, in the hope that they would be full of inspiring articles, and read my growing collection of photo books again and again, just in case I'd missed something important the last time – something that would turn on that creative light bulb in my head and allow me to produce the kind of pictures I so longed to produce.

Occasionally I got what I was looking for and slowly my knowledge and skills began to develop. The pictures got better too. But those occasions were rare, and more often than not I was left wanting by books and magazines that failed to provide the inspiration and information I needed.

So I started writing books of my own, hoping that I could perhaps provide photography enthusiasts with the kind of material I found so hard to come by during my formative years behind a camera. *The Creative Photography Handbook* is the latest stage in that quest.

Following on from the international success of *The A–Z of Creative Photography*, published back in 1998, *The Creative Photography Handbook* takes a look at popular techniques and subjects and explains them in a no-nonsense way so you can put the advice and information into practice immediately and use it to create inspiring, innovative images.

Part One of the book deals with the fundamentals of photography – Light, Composition, Focusing, Colour and Darkroom – while Part Two looks at the main subject areas – People, Scenics, the Urban Landscape, Nature and Movement.

Each chapter is then divided into smaller sections that discuss creative or unusual topics so you can learn something new without having to read pages and pages of text.

In Chapter One: Light, for example, you will find advice on painting with light, lightbox lighting, creative flash techniques, lighting for mood, and night lights. In Chapter Two: Composition, you can read about creating balance, learning to see, leading the eye, using foreground interest, composing for impact, and breaking the rules.

Each chapter is illustrated with inspiring colour and black-and-white pictures – more than 200 in total. You will also find a What You Need section in most cases which details the best cameras, lenses, films, filters and accessories for the job, plus top tips and step-by-step guides.

Ultimately, the aim of *The Creative Photography Handbook* is to shed new light on popular subjects, and to teach you to see and think more creatively. So, whether you're new to photography or you already have years of experience, I feel confident that it will be an inspiring addition to your photographic book collection.

Lee Frost
July 2002

◀ Loch Eil, Scotland
Photography is all about light, and the best light of the day can often be found at dawn. On this occasion I rose at 5am and drove 30km (19 miles) to my predetermined location in order to capture the magical start to the day. My effort was rewarded with perfect conditions – flat calm on the loch, light mist, reflections and beautiful pastel colours. Well worth sacrificing a lie-in for – and I managed to get back to my hotel in time for breakfast!
PENTAX 67, 55MM LENS, TRIPOD, CABLE RELEASE, FUJI VELVIA, ½ SEC AT F/16

▶ Millennium Eye, London
Although this giant big wheel on the banks of the River Thames was only unveiled in 2000, it has already been the subject of millions of photographs from every conceivable angle and viewpoint. I went for a simple approach here, capturing the arc of the wheel against a polarized blue sky to create a simple, graphic composition.
NIKON F90X, 28MM LENS, POLARIZING FILTER, FUJI VELVIA, ⅟₆₀ SEC AT F/5.6

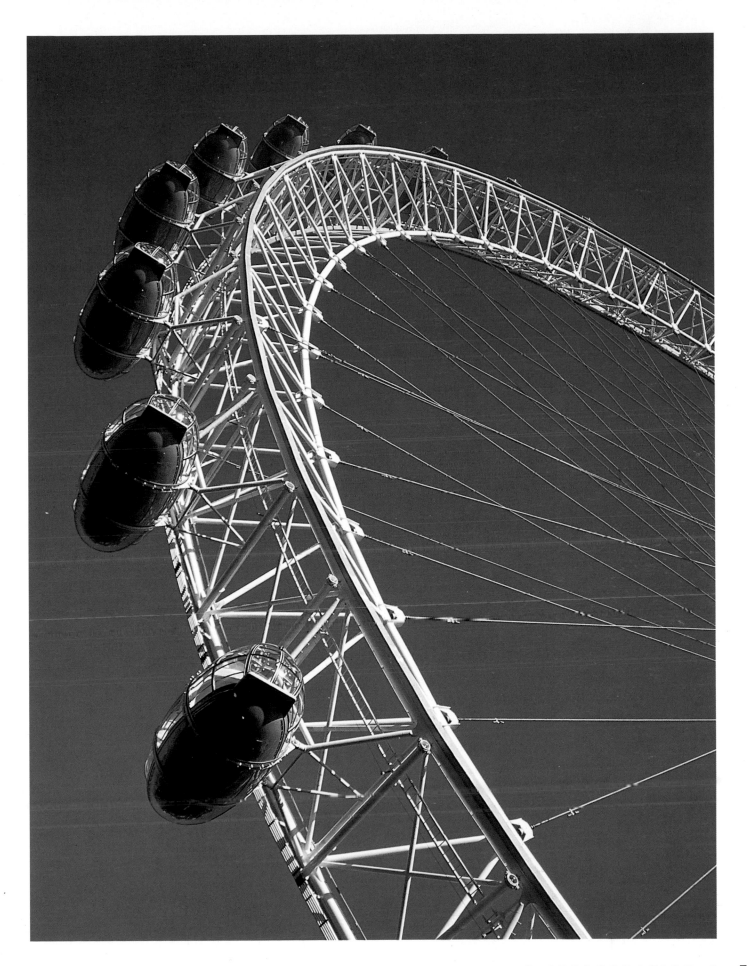

Part one
creative techniques

Chapter one
light

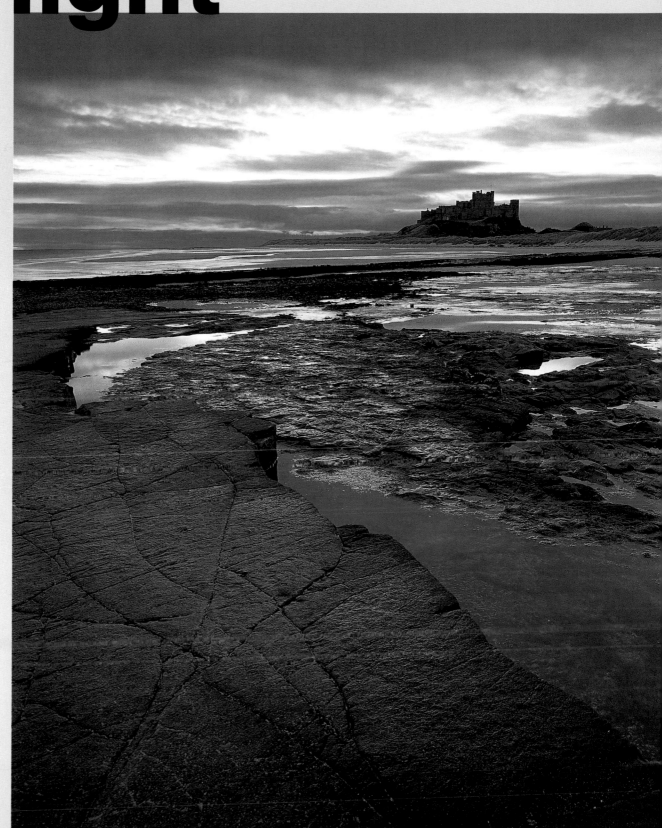

▶ **Bamburgh Castle, Northumberland, England**

PENTAX 67, 55MM LENS, 0.6 ND GRADUATE FILTER, TRIPOD, CABLE RELEASE, FUJI VELVIA, 2 SEC AT F/16

Painting with **light**

This technique involves building up the light on your subject gradually using a controllable source so you can create unusual lighting effects. Professional studio photographers tend to do this using expensive equipment, but you can produce great results using a range of more accessible items, of which a torch is the most versatile.

Using a torch to light your subject

There are various ways to create painting with light effects using a torch. Indoors, you can use one to selectively illuminate still lifes in a darkened room. Outdoors, a powerful torch or lamp can be used to illuminate the foreground of a scene or a whole structure, in the same way as flash.

What you do will depend on how powerful the torch is. Maglite torches, available from most camping, photographic and hardware stores, are ideal because you can adjust the head to make the beam of light narrower and more intense and subsequently use it to illuminate very small areas. For bigger subjects you will need more power, so consider investing in a large re-chargeable security torch – the more power the better for this.

Torch bulbs generally have a low colour temperature and will add a warm colour cast to anything they illuminate. You can balance this by taping a blue gel over the torch, but often the warm cast can also look really effective.

How to calculate correct exposure

Determining correct exposure is fairly easy, as the light from a torch is constant. Shine it on your subject and take a meter reading from the torch-lit area. Alternatively, hold an incident light meter in front of your subject and shine the torch on the metering dome (invercone). You can then vary the exposure to make other areas lighter or darker. For example, if you get an

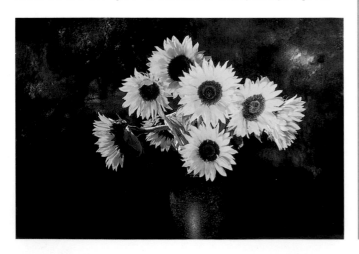

exposure reading of 6 sec at f/16, you know that if you shine the torch on an area for 4 sec any subjects in it will come out a little dark, while if you shine it on it for 8 sec the area will be slightly overexposed.

For still-life photography, set up your props, compose the picture, and then turn all the lights off so the room is in total darkness. That way, the only light recorded will be coming from the torch, so you can create exactly the effect that you choose. Lock your camera's shutter open on bulb (B) at f/11 or f/16, and leave it open for as long as it takes to build up the lighting on your still life – this may be 5 min or more.

Using torchlight outdoors

Outdoors, the same technique is employed, only on a bigger scale. With your camera's shutter locked open on B, you can leave the camera in position and move up closer to whatever you're lighting.

Again, correct exposure is determined by shining the torch on the area from the distance you expect to be working, then taking a meter reading from that area. On a large subject,

◄ Sunflowers
A traditional use of a torch is as the primary light source – in this case to illuminate the sunflowers and painted background. The still life was set up in a darkened room, then the light levels were built up gradually, with more light being directed towards the flowers so they stood out.
MINOLTA SLR, 50MM LENS, TRIPOD, CABLE RELEASE, FUJI VELVIA, 30 SEC AT F/11

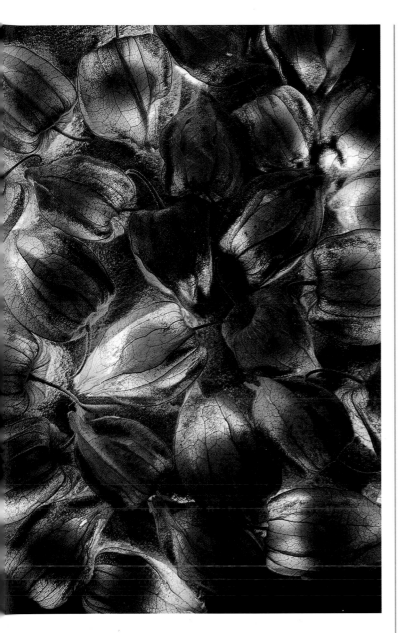

For this unusual image the lantern fruit were laid on a lightbox and sand was scattered between them to fill in any gaps and prevent white light showing through. This created the attractive backlighting on the pods. In a darkened room, the photographer, Tim Gartside, then used a torch to paint the fruit with light from above and create the warm glow.

MAMIYA 645, 80MM LENS, TRIPOD, CABLE RELEASE, FUJI VELVIA, 20 SEC AT F/16

Using car headlights as a light source

When taking pictures at dawn, dusk or night, your car's headlights can be used as a light source – either to illuminate the whole shot or simply to throw some light onto the foreground of a scene.

You could shine the headlights on the shore of a lake, for example, so boats, rocks or driftwood are picked out against the darker background. You can also create interesting effects by shining the lights onto trees or down a country lane so they cast an eerie glow, or use car headlights to illuminate the front of a building.

The bulbs used in car headlights have a colour temperature of around 3200k, rather like tungsten bulbs, so the light comes out very warm on daylight-balanced film. This means that anything lit by them will come out with a warm yellow/orange colour cast, while the rest of the scene records naturally. When the colour temperature of the ambient (day) light is high and the light has a cool cast, this contrast between warm and cold light can look really stunning.

such as a building, you may need an exposure of 10–15 mina at f/16 on ISO 100 film.

In order to keep the camera's shutter locked open on bulb for this length of time without overexposing the whole shot, you will need to wait until ambient light levels are very low and the scene is almost in darkness. A good time to shoot is in the evening, soon after any colour has faded in the sky and it appears black to the naked eye.

▶ **Headlights on boat**

This is the kind of effect you can achieve by using car headlights to illuminate the foreground. Here, they lit up the boats moored by the lake, adding a golden glow that enhanced the warm, dreamy feel of the image.

MAMIYA 645, 50MM LENS, SUNSET GRAD AND SOFT FOCUS FILTERS, TRIPOD, CABLE RELEASE, FUJI VELVIA, 1 SEC AT F/16

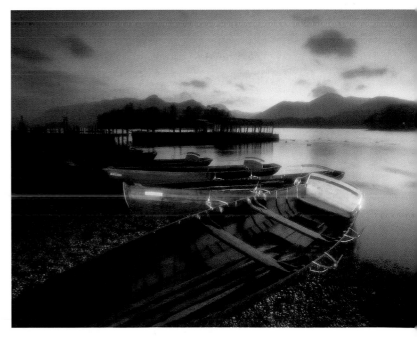

Lightbox **lighting**

Lightboxes used for viewing slides can be employed as a versatile source of illumination. The quality of light produced is rather like that from a softbox placed over a studio flash unit to soften and spread the light. The bigger the lightbox, the more diffuse the illumination in relation to the size of the subject.

Using a lightbox as a primary light source

Stand the lightbox on its end or side and point the illuminated screen towards your subject. Place it at 90° for bold side-lighting, perhaps positioning a sheet of white card on the opposite side of your subject so some of the light from the lightbox is bounced back into the shadows. Alternatively, position the lightbox at 45° to your subject for classic three-quarter lighting. You can only do this effectively with small subjects, so concentrate on things like flowers, or create still-life compositions from interesting objects.

A great benefit of using a lightbox in this way is that it's a continuous source so you can see exactly the effect it will have on your subject, whereas with studio flash you have to rely on the modelling lamp.

For the best results, keep other lighting in the room to a minimum, either by switching off the interior lights or drawing blinds or curtains to cut down the amount of daylight coming in.

A lightbox as both light source and background

You can also use a lightbox as both the primary light source in a picture and the background at the same time, so you get flattering illumination and a crisp white background as well. This technique is ideal for pictures of small subjects such as flowers. Stand the lightbox on its side or end, then position

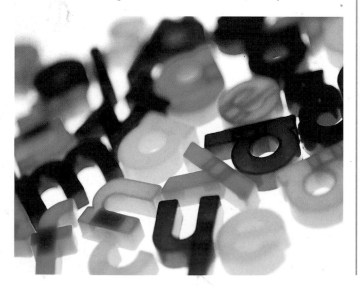

What you need

Lightbox The bigger the better. An A3-size lightbox (42x30cm/ 16⅝x11¾in) was used for the pictures here

Camera Must have good metering control and exposure override – a 35mm SLR is ideal

Lenses A lens that offers close-focusing will be required, such as a macro lens, close-focusing zoom or 50mm prime standard lens

Film The tubes used inside a lightbox are daylight-balanced (5500k), so you can use normal film without worrying about colour casts; use slow-speed film

Accessories A tripod and cable release, plus coloured lighting gels for colouring the background in your pictures

your subject in front of the screen, perhaps 15–20cm (6–8in) away. Next, put your camera in position on a tripod, then place a sheet of white card either side of the camera so it bounces light from the lightbox onto your subject. Alternatively, take a large sheet of white card, cut a hole in the centre for your lens to poke through, and place it directly opposite the lightbox.

Because light levels are higher in the background than on your subject, the background will automatically come out white. Also, because the opal perspex screen of the lightbox spreads the light nicely, there is no risk of flare.

◀ Letters on lightbox
The easiest way to use a lightbox as a light source is to place translucent objects on it so they are backlit by the illuminated panel. This works with leaves, slices of fruit, flower petals and, as you can see here, the plastic letters from a child's alphabet kit!

NIKON F90X, 105MM MACRO LENS, TRIPOD, CABLE RELEASE, LIGHTBOX, FUJICHROME VELVIA, ⅛ SEC AT F/4

▶ Flower close-up
This close-up was taken by placing the flower in front of an A3-size lightbox so the illuminated screen acted as a background. Doing so backlit the flower, but the area facing the camera was in shadow. I placed a sheet of white card either side of the camera so light was reflected into the shadow areas. I then set my lens to its widest aperture so there was minimal depth-of-field and focused on the part of the flower closest to the camera.

NIKON F90X, 105MM MACRO LENS, TRIPOD, CABLE RELEASE, CARD REFLECTORS AND LIGHTBOX, FUJICHROME SENSIA II 100, ¹⁄₂₅₀ SEC AT F/2.8

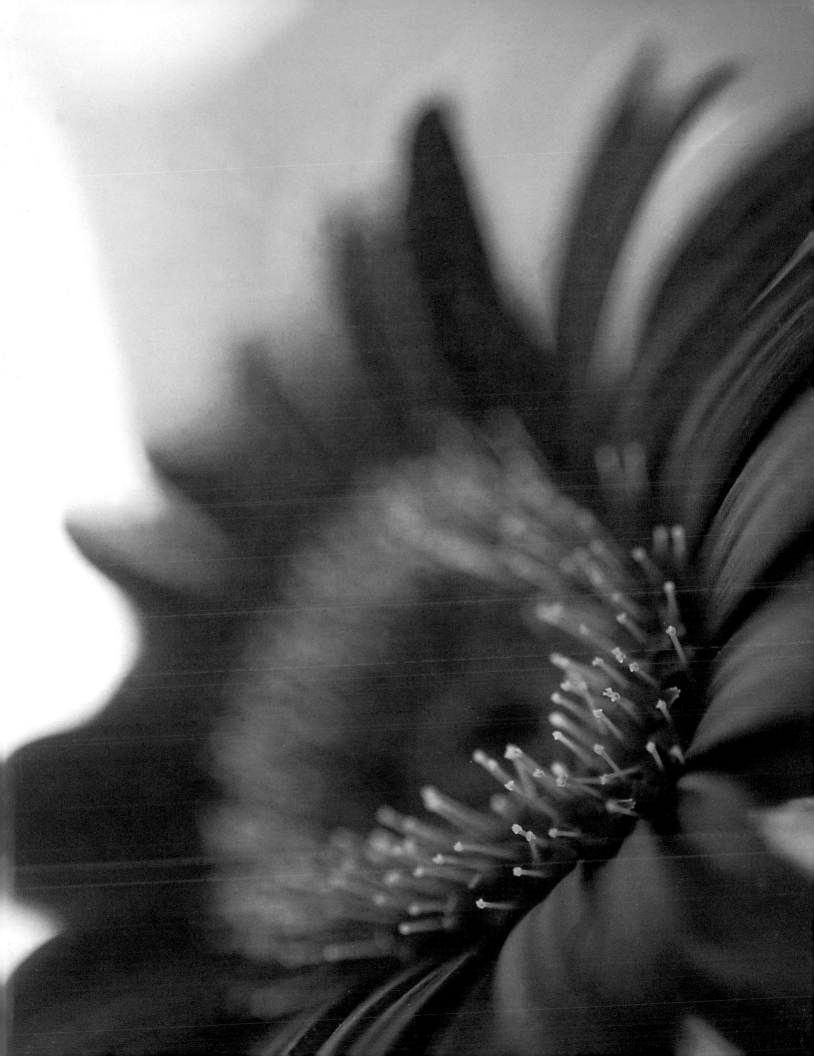

Projected light

If you're a slide-film user, in addition to having a lightbox you may also have a projector. This is another much underrated piece of equipment, as the harsh, directional form of light it creates is ideal for highlighting small objects or parts of bigger objects.

Many lighting options in one compact package

The compact size of a standard projector also means that you can vary its position in relation to your subject, using it from very close range for a bold effect, moving it further away to reduce the harshness of the light, or placing it on the same level to produce bold, raking light that glances across the

What you need

Slide projector Any type of projector can be used – 35mm projectors are the most popular type and work perfectly well. Being able to focus the lens manually is important, as this allows you to vary the lighting effect by narrowing or widening the beam of light

Camera Any type of camera that offers good exposure control and override will be suitable – a 35mm SLR is ideal

Lenses You will generally be photographing objects from close range, so a lens that offers close-focusing will be required, such as a macro lens or close-focusing zoom. Alternatively, use an extension tube or supplementary close-up lens with a 50mm standard lens

Film Use slow-speed film for optimum image quality (ISO 50–100)

Accessories Tripod and cable release, colour gels or filters and a selection of colour slides

surface of your subject, revealing texture and casting long, deep shadows. It's this type of lighting – more than any other – that makes a slide projector particularly effective for still-life photography and allows you to take eye-catching pictures of otherwise overlooked everyday objects.

The type of light source used in slide projectors – typically tungsten halogen – has a very low colour temperature (around 3400k), so the light produced is very warm. On normal daylight-balanced film this will produce a strong yellow/orange cast which can work well on some shots, but not all. If you want to cool down the light so colour balance is more natural, use a blue 80A colour conversion filter either on the camera lens, or placed over the projector lens.

Used in any or all of these ways, a slide projector is therefore ideal for lighting simple still-life shots or graphic close-ups, especially when you make good use of the long shadows it casts.

Projecting slides onto your subject to colour the light

A projector can also produce more unusual lighting effects. By placing colour slides in the projector's light path, for example, you can add patterns and colours to the light which will be projected onto your subject.

A slide of a scene at sunset will warm the light even more, for example, while a slide with a blue cast will cool it down, and detailed slides will throw patterns across your subject – the sharpness of which you can control by adjusting the focus of the lens until you get the desired effect.

As well as still-life shots, you can also use this technique for portraits or nude studies, shining the projector onto your subject with a slide in the light path so the image is projected onto their body or face.

By placing coloured lighting gels such as red, green and blue over the lens you can add cold colour casts to your pictures. These gels are available as sets from photo dealers. They are normally used over studio lights, but can be cut to size and placed over a projector lens.

Use tape or rubber bands to hold them in place, however remember that a slide projector bulb generates a lot of heat. This could not only damage both the gel over the lens and any slides inside the projector, but could be a fire hazard, so never leave a slide inside or a gel on the front of a projector for more than a minute or two – either remove them or switch the projector off.

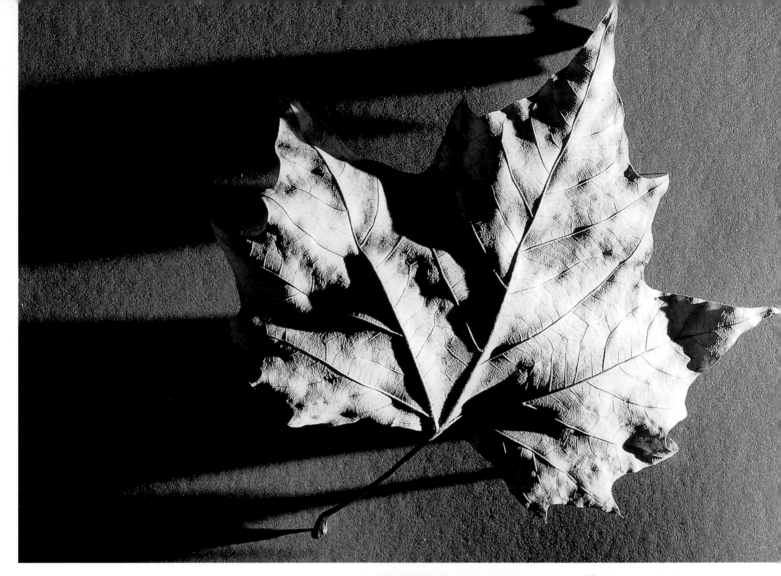

▲ Leaf

This is the kind of dramatic lighting effect you can achieve using a slide projector. The autumn leaf was placed on the floor on a sheet of green card, then a standard 35mm slide projector was positioned next to it, 68.5–76cm (27–30in) away, also on the floor so its beam of light glanced over the leaf, revealing the texture in its dry, rough surface and casting a long shadow. This play of light, shade and colour creates a striking effect. The projector light source was left unfiltered to add warmth to the colour of the leaf.

NIKON F5, 105MM MACRO LENS, TRIPOD, CABLE RELEASE, 35MM SLIDE PROJECTOR, FUJI VELVIA, ¼ SEC AT F/16

▶ Spectacles

This pair of pictures shows not only the effect you can achieve using a slide projector as a light source, but also how the colour of the light can be controlled with filters.

NIKON F90X, 105MM MACRO LENS, TRIPOD, CABLE RELEASE, 35MM SLIDE PROJECTOR, FUJI SENSIA II 100, ½ SEC AT F/16

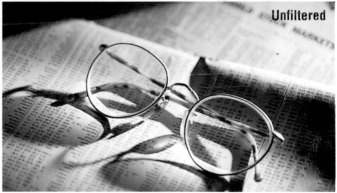

Unfiltered

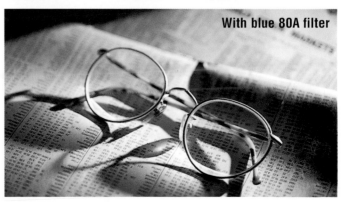

With blue 80A filter

◀ Projected light

You can colour the light and throw patterns and shadows across your subject by placing slides in the projector when using it as a lightsource. For this shot I used a slide taken at sunset to add the orange glow, and shone the projector through the strip of film so shadows were cast by the sprocket holes.

NIKON F90X, 105MM MACRO LENS, TRIPOD, CABLE RELEASE, 35MM SLIDE PROJECTOR, FUJI VELVIA, ¹⁄₁₅ SEC AT F5.6

Using a projector and lightbox together

Once you've mastered the art of using both a lightbox and a slide projector as creative light sources, why not combine the two? By doing so you can produce really stunning images that look far more sophisticated than they really are.

The key is to experiment and see what you can come up with. I tend to use the lightbox as an illuminated base for my props, which have been everything from credit cards and gear cogs to electrical components and piles of coins. I usually place a coloured lighting gel on the lightbox then stand the props on that, so the background is coloured. I then use the projector, often with a coloured gel over the lens, to light the props from the side or front so they take on the colour of the gel over the projector lens. The result is a striking image with bold colours.

To ensure I get a perfectly exposed shot I set my Nikon to aperture priority and Matrix metering, then take a shot at the exposure set by the camera, and then a sequence of others bracketing over the metered exposure in ⅓ stops until I'm at +2 stops. This may use a little more film than other metering methods, but it's foolproof.

▶ Projector and lightbox

This set of pictures gives you some idea of the striking colour effects you can achieve by using a slide projector and lightbox together. In each case the background colour was created by placing a coloured lighting gel on the lightbox, then the objects were arranged on top of it. A different coloured gel was placed on the projector and used to light the subject, with the exception of the mobile phone, which was photographed in a darkened room on a lightbox; the green glow was created by its own illuminated display.

NIKON F90X AND NIKON F5, 105MM MACRO LENS, TRIPOD, CABLE RELEASE, 35MM SLIDE PROJECTOR AND JESSOP A3 LIGHTBOX, FUJI VELVIA OR FUJI SENSIA II 100, VARIOUS EXPOSURES ON APERTURE PRIORITY MODE

Adding grain to your pictures with a slide projector

Take a selection of colour slides, project them onto a sheet of aluminium oxide paper in a darkened room, then re-photograph the projected image back onto colour slide film. You will need a macro lens or close-focusing zoom to fill the frame, as the sheets of paper are only around A4 size.

Aluminium oxide paper is used on car-body repairs and is easily obtained from car accessory shops. The benefit of using this material is that it's white, so when you project an image onto it that image doesn't take on a colour cast – it just picks up the rough texture of the paper, which records on the new image like coarse film grain.

This technique works well with all kinds of subject, from landscapes and architecture to flowers, still lifes, portraits and abstracts. And the great thing is you can choose exactly which pictures you want to add the grain to.

One final point – you will need to use a blue 80A filter over your lens to balance the projector bulb for daylight-balanced slide film, otherwise your pictures will come out with a yellow/orange colour cast. Alternatively, use with tungsten-balanced film.

▶ Adding grain

This is the type of effect you can achieve by projecting an existing colour slide onto a sheet of aluminium oxide paper, then re-photographing it to add a grainy effect.

NIKON F90X, 105MM MACRO LENS, TRIPOD, CABLE RELEASE, 35MM SLIDE PROJECTOR, ALUMINIUM OXIDE PAPER, FUJI VELVIA, ¼ SEC AT F/16

Creative flash **effects**

The majority of enthusiast photographers own an electronic flashgun of some kind, but few actually use it for anything more ambitious than indoor snapshots at parties and other special occasions. What they fail to realize is that no matter how basic a flashgun is, it can be used to create some amazing effects – all it takes is a little imagination and lots of patience.

What you need

Flashgun A flashgun with a manual mode is the best option for open flash and multiple flash, while dedicated or automatic guns make light work of slow-sync flash and filtered flash

Camera 35mm SLRs are the quickest and easiest to use for slow-sync flash, but any type or format of camera can be used for creative flash effects

Lenses Wide-angle and standard lenses are the most useful because you will need to work fairly close to your subject

Filters Use coloured filters such as yellow, orange, red and blue for colouring the light when using open flash and filtered flash

Film Use slow or medium-speed film (ISO 50–200) – faster film effectively makes your flashgun more powerful, allowing you to use a smaller lens aperture, or to work at greater flash-to-subject distances

Accessories A tripod and cable release are essential for all the techniques covered except slow-sync flash

Using flash with a slow shutter speed

Commonly known as slow-sync flash, this technique is used for pictures of moving subjects. By combining an action-stopping burst of electronic flash with a slow shutter speed, you can capture both a frozen and blurred image of the same subject in a single picture and create a dramatic sense of movement – even if your subject is moving relatively slowly.

Slow-sync works on any subject that you can get close enough to so it's within range of your flashgun – motocross, rally driving, cycling, cross-country running and canoeing are all popular examples. It's also ideal for everyday action, be it kids riding their bicycles in the park, your family's pet dog catching a stick in mid-air, or people dancing at a party.

The way you achieve slow-sync flash effects depends on the type of flashgun you have. Many modern dedicated flashguns and 35mm SLRs have a slow-sync flash setting, so all the hard work is done for you.

If this isn't possible, set your camera to shutter priority mode so you can select the shutter speed required and prevent the camera automatically selecting the correct flash sync speed, which is too fast to produce a good effect (you

▶ Running boy

This picture is a great example of slow-sync flash. The photographer combined a burst of flash which froze his subject with a shutter speed of ⅛ sec to blur the background when he panned the camera. A range of different shutter speeds were used to see which one would produce the most interesting effect.

CANON EOS 5 HANDHELD, 50MM LENS, DEDICATED FLASHGUN, FUJI VELVIA, ⅛ SEC AT F/11

▼ Ruined mine, Cornwall, England

Derek Horlock created this amazing photograph by painting the old mine building with flash. Several flashguns were used together so he could light the exterior and interior of the building at the same time, thus eliminating the need for a long exposure. The picture was also taken during the daytime, but Derek underexposed it so the background scene came out dark, creating a night-time effect. This was enhanced by using a blue filter on the lens, to cool down the scene, and orange filters on the flash to counter this and make sure the flashlit areas came out looking normal.

MAMIYA RB67, 50MM LENS, TRIPOD, CABLE RELEASE, SEVERAL FLASHGUNS, KODAK EKTACHROME, 1 SEC AT F/11

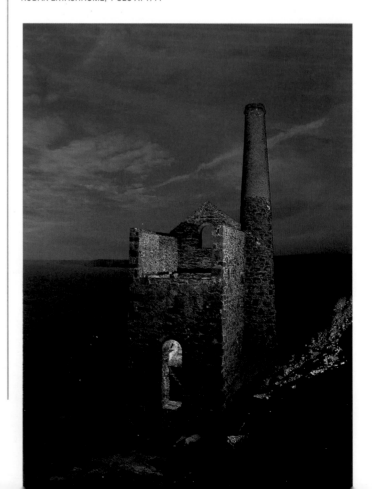

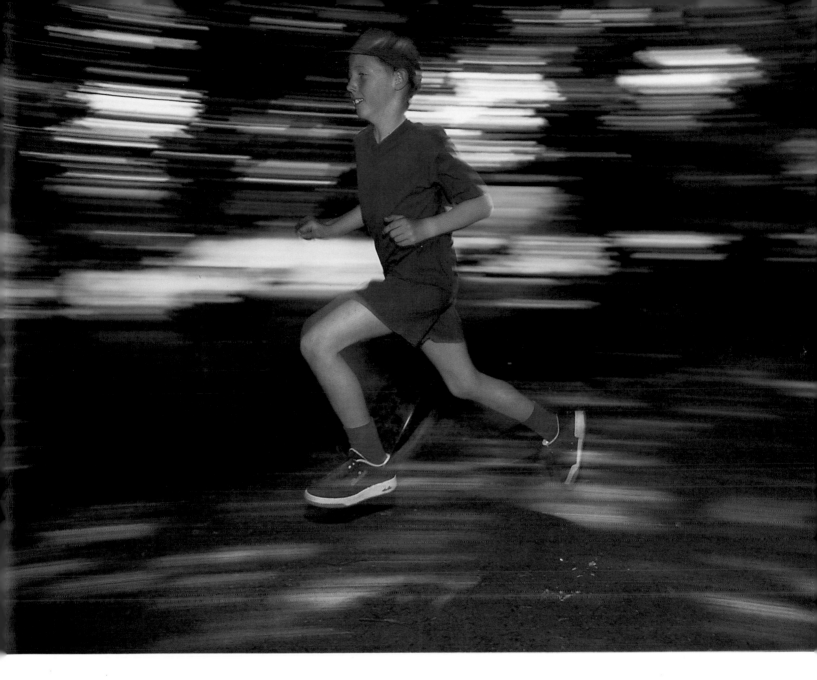

really should be shooting at 1/15 sec or slower). Your camera will then automatically set the correct lens aperture, and as it's the aperture that controls the flash exposure, not the shutter speed, your flashgun will output the correct amount of light for the aperture set.

If you have an automatic flashgun, set your camera to aperture priority mode so you can set the aperture of your choice; the camera then sets the shutter speed required to correctly expose the ambient light.

To achieve a good balance between the ambient light and flash, a ratio of 1:2 is normally used. With an automatic gun you can obtain this by setting the auto aperture scale on your flashgun to one stop wider than the aperture set on the lens. So, if you've set f/11 on the lens, set f/8 on the flashgun using the auto aperture dial or switch, and it will pump out less light.

With dedicated guns it's even easier – just set the power output on the gun to a half or 1:2.

Having set up your camera and flashgun, you will get the best effect by panning the camera to track your subject and tripping the shutter while the camera is still moving. This will record blur in the background and produce a more dramatic effect. Don't worry about the panning action being perfect, though, because you also want some blur in your subject as well – the burst of flash will provide the dominant, sharp image.

Combining a long exposure with multiple flash bursts
Known as 'open' flash because you fire the flashgun while the camera's shutter is locked open, this technique can be used in numerous different ways.

You could use a single burst of flash to illuminate a feature in the foreground of a low-light scene, for example, or fire the flash many times during an exposure of several minutes to illuminate the interior or exterior of a building, different parts of a scene, a monument or tree, and so on.

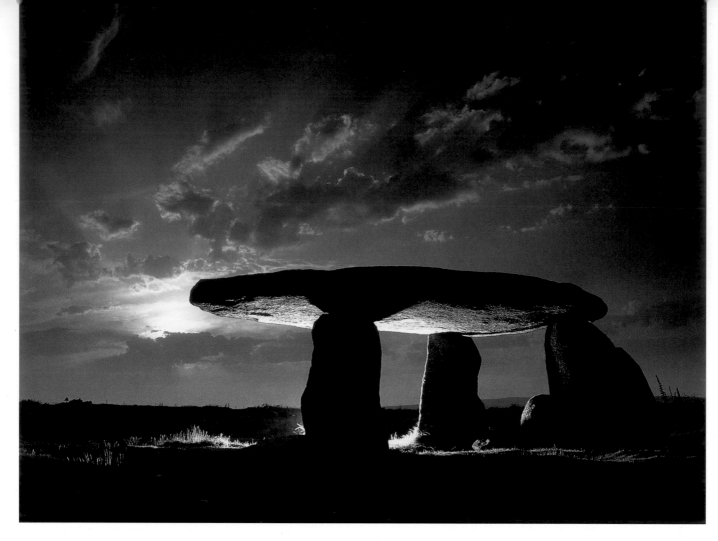

Filters can also be used to colour the light for more interesting results. How about placing an orange filter over the flash then using the coloured light to illuminate a statue against the blue evening sky, or using different coloured filters on different areas?

Whatever the subject or scale of the picture is, the best way to use open flash is by taking the flashgun off the camera and firing it manually with the test button, so you can control when it is fired and what it's fired at while the camera's shutter is locked open on bulb.

This means that the sophisticated features of modern dedicated flashguns become obsolete, so don't worry if you only have a basic manual flashgun – it will be fine.

If you have an automatic or dedicated gun, set it to manual mode and full power so it delivers a consistent amount of light each time you fire the test button. Also, the more powerful the flashgun is the better, as it will allow you to work at greater flash-to-subject distances, fire fewer bursts to achieve correct exposure, and use a smaller lens aperture for greater depth of field.

Calculating exposure

To determine correct exposure, divide the flashgun's guide number (GN) into the lens aperture you're using to find out how far away the flash needs to be from the area you're going to light with it.

For example, if you have a flashgun with a GN of 32 and are using an aperture of f/16, the correct flash-to-subject distance is 32/16 = 2m (6ft). This is correct for ISO 100 film. If you are using ISO 50 film, open up the lens aperture a stop to f/11, or reduce the flash-to-subject distance to 1.5m (4ft 6in); for ISO 200 film, stop the lens down one f/stop, to f/22 in this example, or increase the flash-to-subject distance to 3m (9ft).

If the area you want to light with the flash is relatively small and accessible, then you should be able to provide sufficient illumination in a flash single burst. With your camera on a tripod and the picture composed, you can then trip the camera's shutter, lock it open on bulb (B) with a cable release, walk up to the area you need to light so you're the right distance away to achieve correct exposure, and fire the flashgun.

If you can't get close enough to light your subject with a single burst, you will have to fire the flash more than once to build up the light on it.

For example, if the correct flash-to-subject distance is 2m (6ft) and you can only get within 3m (9ft), you will need to fire the flash twice; if you are 4m (12ft) away, four times, and if you are 5m (15ft) away, six times, and so on.

In situations where the area you want to light is too great for a single flash burst due to the flashgun's limited coverage, such as the front of a building or a dark interior, you have no choice but to use multiple flash bursts. You will also need to walk around your subject and fire the flash at different areas so that you can gradually light the whole subject or parts of it that need lighting.

◄ **Dolmen**

Here's another superb example of painting with flash, this time used by Derek Horlock to illuminate the underside of an ancient burial chamber so it stands out against the glowing sky. Derek set up the shot in advance, then waited until sunset before taking it. Underexposing the daylight makes the image more dramatic, while use of flash makes the burial chamber look like a huge stone dinosaur striding across the landscape.

MAMIYA RB67, 50MM LENS, TRIPOD, CABLE RELEASE, SEVERAL FLASHGUNS, KODAK EKTACHROME, ½ SEC AT F/22

► **Albert Memorial, London**

For this picture, Simon Stafford placed a warm filter over his flashgun and used it to light the ornate gates in the foreground of his composition. The warmer colouring contrasts well with the cooler background.

NIKON F5, 20MM LENS, TRIPOD, CABLE RELEASE, NIKON FLASHGUN, WARM FILTER, ¼ SEC AT F/16

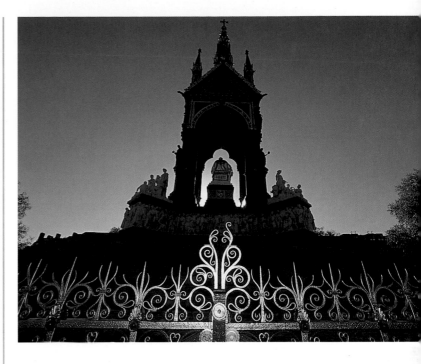

Step 1 Mount your camera on a tripod and compose the picture, ideally using a wide-angle lens so you don't have to walk too far to reach the areas that will be lit by flash.

Step 2 Set your lens aperture to f/11 or f/16, the shutter to bulb (B) and your flashgun to manual. Make sure you have a spare set of batteries for the flash in your pocket, and ideally use two flashguns so you can be firing one while the other is re-charging in order to save time.

Step 3 Plan how you are going to light your subject: where to start, how many flash bursts you will need for certain areas that are further away – such as a church tower – if you are going to use filters on the flash at any point to colour the light, and so on.

Step 4 Once levels have dropped sufficiently so you can lock the shutter open for several minutes, trip the camera's shutter and lock it open on bulb with the cable release. Now head towards your subject and start firing the flash to illuminate it. This is where two guns will come in handy – especially if you need to use lots of flash bursts. Keep moving around – but don't stand between the camera and flashgun, otherwise your ghostly outline will record on the picture.

Step 5 Once you feel that you have fired enough flash bursts to light your subject, go back to the camera and close the shutter to end the exposure.

This technique can be very hit-and-miss, so it's worth repeating the procedure several times, giving more flash bursts each time – the chances are you'll need more than you think due to reciprocity failure caused by the long exposure time used, which makes the film lose speed.

Using your flash with filters

Placing coloured filters and gels over your flashgun is a great way to create more unusual lighting effects and add a creative twist to pictures of everyday subjects.

Using filters on a flashgun instead of over your lens is interesting because it means that only the areas lit by the flash will take on the colour of the filter, so you can colour the foreground or one element in a scene while leaving the rest unchanged – such as an orange filter used to light a tree in a picture taken at dusk, so it stands out against the cooler colours in the background.

You can also use one filter on your flashgun and another on the camera lens. If those filters are complementary colours, one will cancel the other out so the flashlit area looks normal while the rest of the scene takes on a colour cast.

The best filters for this are the blue 80 series and orange 85 series, normally used to balance colour casts. If you place a blue 80B on your lens, the whole scene will look blue. However, if you then place an orange 85B on your flashgun, it will cancel out the blue cast so any areas lit by the flash will look natural against a blue background. By using the orange filter on the lens and the blue filter on the flash, the opposite happens and you get an orange background.

A variation of this is to use tungsten-balanced film in daylight with an orange 85B filter placed on the flashgun – a technique often used by fashion photographers. The result will be that all areas lit by daylight will come out blue, because tungsten-balanced film is intended for use in warmer tungsten lighting, while the flashlit areas look natural because the flash has been warmed up by the orange filter.

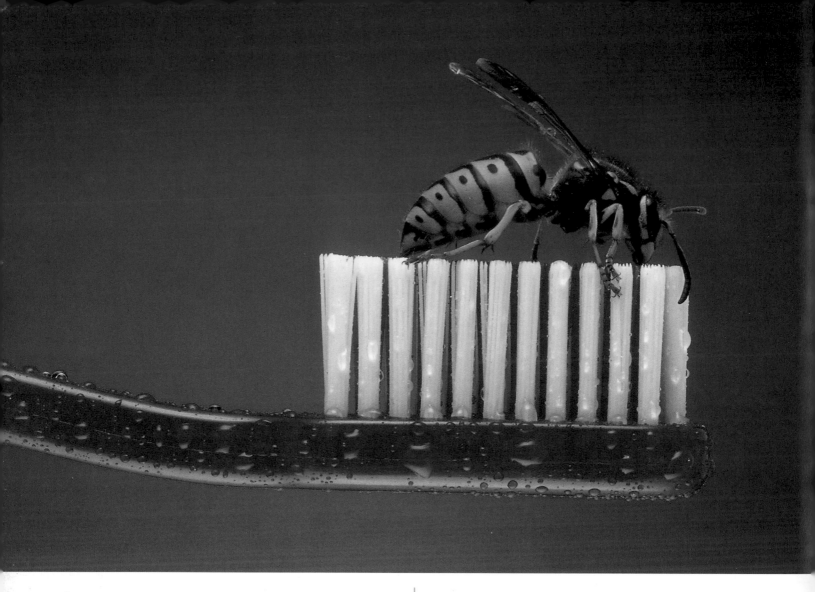

▲ Wasp on toothbrush

Using flash for close-ups opens up a whole new world of possibilities by overcoming common problems associated with the subject. You can see from the amount of detail captured in this amazing shot just how effective flash is, and because your subject is very small, you don't need a big, powerful flashgun to achieve such results – just lots of patience.

MINOLTA X700, 90MM 1:1 (LIFE-SIZE) MACRO LENS, TWO FLASHGUNS DIFFUSED USING HOME-MADE SCREENS, TRIPOD, CABLE RELEASE, FUJICHROME RFP50, 1/30 SEC AT F/16

TOP TIPS

- Experimentation is the key to good flash technique – try things, and if they don't quite work, try again until you master them
- Modern, dedicated flashguns take a lot of guesswork out of techniques such as slow-sync flash, but you don't need one. A basic auto/manual flash is just as capable – I use an old Vivitar 283, purchased second-hand many years ago
- With the exception of slow-sync flash, the techniques discussed in this section are best practised outdoors at night or indoors in a darkened room

Shooting close-ups with flash

Photographers shooting close-up pictures face two problems. First, depth of field is minimal so you need to set your lens to a small aperture to optimize what little there is. Unfortunately, by doing this you will often find that you need to shoot at slow shutter speeds, so any movement in either the camera or, more commonly, your subject, will result in an unsharp picture.

The easiest way to overcome these problems is by lighting your subject with a burst of electronic flash. Not only does this allow you to work at small apertures in order to maximize depth of field, but the brief burst of light will freeze any subject movement too.

If you own a dedicated TTL flashgun, using it for close-up photography is easy because the hardest job – getting the exposure right – is done for you automatically. That said, you may find you need to adjust the flash exposure for certain subjects, setting the flash exposure compensation to +1 or +1.5 for white subjects, for example. The best way to find out is by conducting tests, bracketing exposures up to two stops over what the camera and flashgun says is 'correct', and keeping notes so you can see when you need to compensate, and by how much.

If you can't afford expensive, dedicated flashguns, don't worry – you don't need a lot of power when shooting close-ups, so a pair of small, manual guns will be fine. The only difference is that you need to calculate the aperture required to give correct exposure. This is done using the formula below:

$$\text{Aperture} = \frac{\text{guide number (m/ISO 100)}}{\text{Flash-to-subject distance (m) x (magnification + 1)}}$$

For example, if your flashgun has a guide number of 20, the flash-to-subject distance is 60cm (23½in), and the magnification is 0.5x (a reproduction ratio of 1:2, or half life-size), the aperture required = 20/0.6 x (0.5+1) = 20/0.9 = 22.22, or when rounded up, f/22.

This aperture is correct for ISO 100 film, so a different film speed must be adjusted accordingly: for ISO 50 film set to f/16, for ISO 25 film set f/11, and for ISO 200 film set f/32. By using this formula for a range of common flash-to-subject distances, you can produce an exposure table and tape it to your flashgun.

In terms of flash position, ideally the gun should be taken off your camera's hot shoe and held closer to the lens so your subject will be evenly lit. Special brackets are available for this, and usually allow two guns to be used, one on either side of the lens. The best angle for general use is 35–40°.

Freezing action with flash

One of the most amazing things about an electronic flashgun is its ability to freeze even the fastest action. This is because the flash duration of even a basic gun can be as brief as $\frac{1}{30,000}$ sec, and that's fast enough to stop pretty much anything in its tracks.

Today's dedicated flashguns make this easier than ever before because they link up directly with the camera's metering system to ensure perfect exposures every time. So, all you have to do pretty much is switch the camera and flashgun on and fire away.

Your flashgun's ability to freeze movement is invaluable in situations where you're shooting action in low light, because it enables you to take pin-sharp pictures that would otherwise be impossible if you worked in available light, no matter how fast the film. So why not make the most of this, instead of leaving your flashgun gathering dust somewhere?

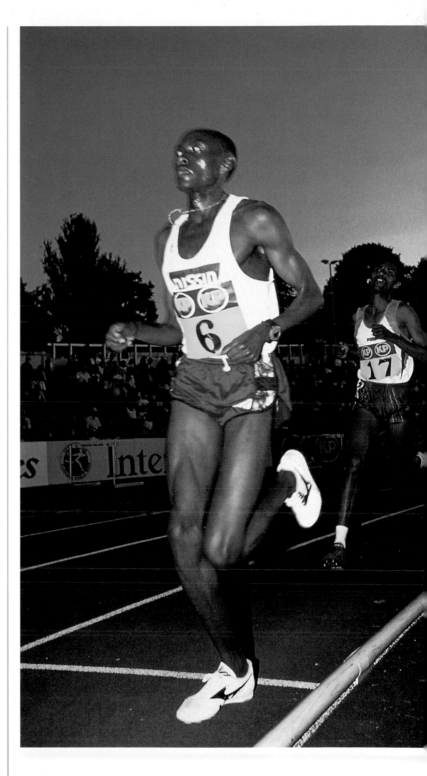

▲ **Racers**
The brief burst of light from your electronic flashgun is invaluable for freezing movement, and in low-light situations allows you to take pictures that couldn't be achieved in any other way. Modern dedicated flashguns also make this easier than ever before – you can literally just point and shoot, and perfect exposures are almost guaranteed.

NIKON F5 HANDHELD, 50MM LENS, NIKON SB26 FLASHGUN, FUJICHROME PROVIA 100, ⅟₃₀ SEC AT F/8

Night lights

Many photographers are put off venturing outdoors with a camera at night because it seems like a world full of mystery and mistakes. However, modern cameras are surprisingly capable in low-light situations that require the use of long exposures, and once you grasp the basic principles involved it's surprisingly easy to produce successful pictures.

The best time to take night pictures

The term 'night photography' can be a little confusing, because the best period in which to shoot isn't at night at all, but during the cross-over period between day and night when the sun has set but there is still colour in the sky, and daylight levels have fallen sufficiently for artificial illumination to be clearly visible, but not so much that shadow areas show no detail.

This period lasts for only 20 min or so during the winter months, but come midsummer you will have 45 min or more of prime shooting time. More importantly, if you shoot during this period your pictures will not only look much better, but you will also find it easier to get the exposure spot on.

If you start shooting too early, the artificial lighting won't be obvious enough and you'll get a daytime effect recording on film. Leave it too late and the ambient light levels will have faded so

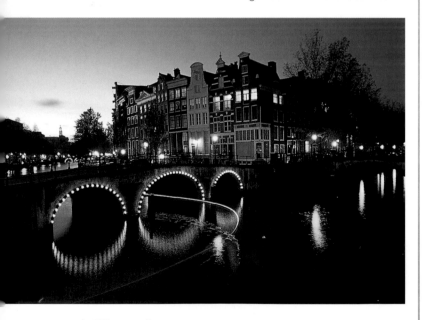

▲ City canal

Amsterdam is a more interesting place to photograph at night than it is during the day, thanks to the myriad of different colours that illuminate the city once the sun has gone down. Here, I chose a viewpoint where I could include an illuminated bridge and its reflection in the foreground. The light trails were created when a boat passed through the scene during exposure.

NIKON F90X, 18–35MM ZOOMLENS AT 24MM, TRIPOD, CABLE RELEASE, FUJI VELVIA, 20 SEC AT F/16

What you need

Camera Any type of camera with a long exposure capability. Most modern 35mm SLRs have an automated shutter-speed range down to 30 sec or more, so work in an automatic mode such as aperture priority and it will sort out the exposure time for you. A bulb (B) setting is also essential, allowing you to hold the shutter open for as long as you like – for minutes, even hours

Lenses A range of lenses from a 24/28mm wide-angle to 200mm telephoto. Wide-angles are ideal for traffic trail shots from bridges or for pictures of floodlit buildings, town and cityscapes and funfairs, because they allow you to include lots in the scene. With a telephoto or telezoom lens you can home in on specific details

Tripod and cable release Essential to avoid camera shake when using long exposures. Buy a cable release with a lock so you don't have to keep the plunger or shutter button pressed down for the whole exposure

Filters None are essential, though a starburst or diffractor can produce great effects on street scenes and seaside illuminations, plus a sunset grad or an orange 85B filter to enhance early evening sky. You can use colour compensating filters to balance the colour casts created by artificial lighting, though few photographers bother because they can look stunning

Film For general use stick to slow-speed film (ISO 50–100) for its vivid colours and fine grain. Slow films mean longer exposures, but if your camera is mounted on a tripod it won't matter. Faster film – ISO 400–3200 – can be useful when you want to take handheld shots in low light – at funfairs, carnivals and so on

much that detail is only recorded in the areas lit by the artificial lighting, while the shadows and the sky included come out black.

To make the most of this 'crossover' period, arrive on location at least half an hour early so you have time to decide where to shoot from, and to set up your equipment.

Making the most of night-time colour

One of the most exciting aspects of night photography is that when you photograph urban scenes containing man-made illumination – street lighting, office lighting, traffic head- and tail-lights and spotlighting – the colours recorded on film will be nothing like what you remembered seeing with the naked eye. This is because different light sources have their own 'colour',

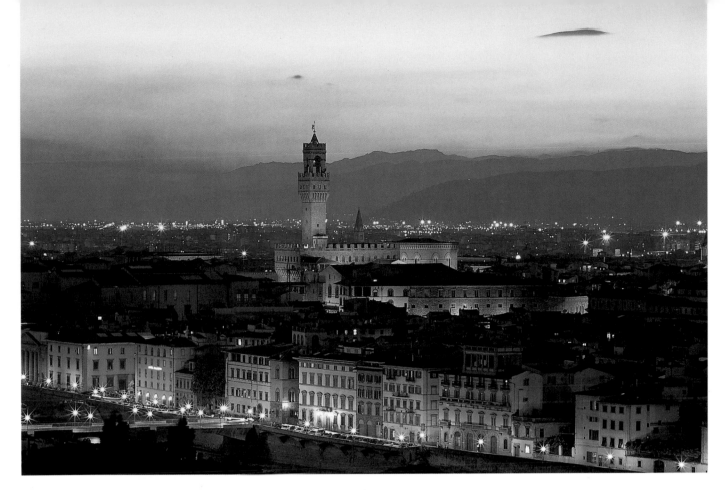

which our eyes adjust to automatically so everything looks normal, but which film records literally. Tungsten lighting comes out yellow/orange on normal film, for example, while fluorescent light adds a green cast to anything it illuminates.

Individually these colour casts can be corrected using filters, but when you are photographing a scene that contains two or more types of artificial lighting, you can't filter them out without adding other colour casts.

The solution? Ignore them. These weird colours add interest and impact to night shots rather than spoiling them, so I never try to change or get rid of them.

Getting the exposure right at night

Exposure error seems to be the biggest fear and problem photographers face when shooting at night, though in reality producing perfectly exposed results isn't as difficult as it might seem.

What you need to remember is that a typical night scene is likely to fool your camera into giving too little exposure, so your pictures come out too dark. This problem is further exacerbated by a phenomenon known as reciprocity law failure, which sounds scary but basically means that if you use exposure times of 1 sec or more, the effective ISO rating of that film is reduced and you need to expose it for longer than your camera meter says to correct any error.

Modern colour films are surprisingly tolerant to reciprocity failure, but a general rule of thumb is that if your camera meter gives an exposure of 1 sec, increase it to 1.5 sec; if the metered

▲ Florence at twilight

This view over the ancient Italian city of Florence was taken about 20 min after sunset, when the ambient (daylight) and artificial light levels were very similar. By timing the shot right I was able to record the warm glow in the sky and the effects of floodlighting on the buildings.

PENTAX 67, 165MM LENS, TRIPOD, CABLE RELEASE, FUJI VELVIA, 15 SEC AT F/11

▼ Piccadilly Circus, London

Neon signs add vibrant splashes of colour to the urban landscape. I photographed this one at Piccadilly Circus in London, using a telephoto lens to fill the frame with colour. The displays are constantly changing, so I watched them for a few minutes in order to determine the best time to shoot.

OLYMPUS OM4-TI, 135MM LENS, TRIPOD, CABLE RELEASE, FUJI VELVIA, 8 SEC AT F/11

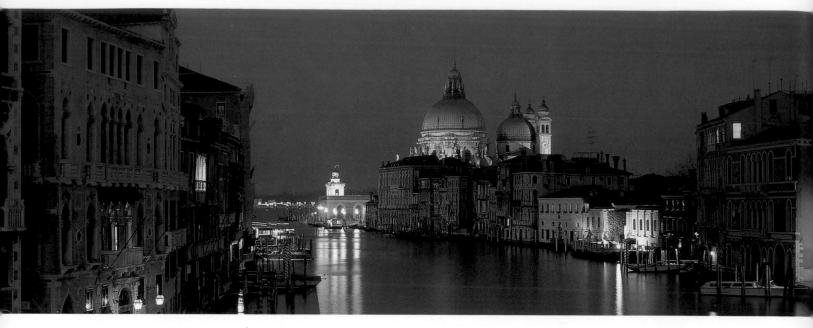

▲ Venice by night

This view along Venice's Grand Canal was taken on a dull, rainy evening. During the daytime the scene looked flat and uninteresting, but once the sun had set the grey sky turned a rich blue, the lights came on and the scene was brought to life. That's the great thing about night photography – you can take successful pictures even when the weather is horrible!

HASSELBLAD XPAN, 90MM LENS, TRIPOD, CABLE RELEASE, FUJI VELVIA, 20 SEC AT F/11

Night exposure guide

Below is a chart listing popular night and low-light subjects, along with guide exposures for different film speeds. Each low-light situation differs, so the exposures should only be used as a guide, but they will at least tell you if your metering technique is on the right lines.

Subject	Suggested exposure at f/16			
	ISO 50	ISO 100	ISO 400	ISO 1600
Cityscape in cross-over period	30 sec	15 sec	4 sec	1 sec
Traffic trails on busy road	60 sec	30 sec	8 sec	2 sec
Aerial firework display	60 sec	30 sec	8 sec	2 sec
Floodlit building	30 sec	15 sec	4 sec	1 sec
Neon sign	2 sec	1 sec	¼ sec	¹⁄₁₅ sec
Outdoor illuminations	30 sec	15 sec	4 sec	1 sec
Illuminated shop window	2 sec	1 sec	¼ sec	¹⁄₁₅ sec
Bonfire flames	4 sec	2 sec	½ sec	⅛ sec
Fairground rides	30 sec	15 sec	4 sec	1 sec
Landscape lit by moonlight	60 min	30 min	8 min	2 min
Landscape at twilight	60 sec	30 sec	8 sec	2 sec

exposure is 10 sec increase it to 20 sec, and if 40 sec is metered increase it to 90 sec.

Many photographers play it safe by taking a meter reading of the whole scene using their camera, then bracketing the exposures over this to ensure that one is perfect.

For example, if your camera suggests an exposure of 10 sec at f/11, take one shot at this exposure, then others for 15, 20, 30 and 40 sec, all at the same aperture – f/11.

You can bracket by setting your camera to bulb (B) then locking the shutter open with a cable release and counting down the exposures using a wristwatch or stopwatch, or simply by counting in your head ('one elephant, two elephants...'). Alternatively, use the camera's exposure compensation facility and set it on the following in turn: 0 (for no compensation), +½, +1, +1½ and +2.

When I'm shooting night subjects such as street scenes, neon signs or floodlit buildings with a 35mm SLR, I tend to prefer this method, setting my Nikons to aperture priority mode and bracketing up to 2 stops over the metered exposure in ⅓ stops using the exposure compensation facility. Of the seven frames exposed, at least four are usually acceptable. With colour-print film you needn't bracket in such small increments – full stops are fine, so shoot one frame at metered exposure, a second at +1 stop and a third at +2 stops.

Underexposure is more common than overexposure when photographing night scenes, so I rarely bracket exposures under the metered exposure.

Using spot metering for tricky night scenes

If your camera has a spot, selective or partial metering facility, you can use this to isolate a small section of the scene (usually 1% of the total image area with spot metering), and use the

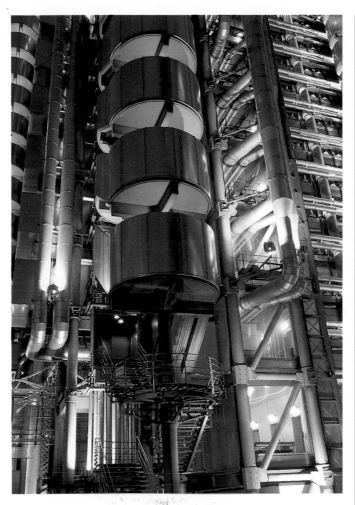

exposure reading obtained for the whole shot. To get an accurate reading, however, you need to meter from a mid-tone area that's well lit (stone and brickwork are good mid-tones), then bracket the exposures.

This technique works well if your main subject is much brighter than the rest of the scene, such as a floodlit building in the distance against a shady, unlit background. A general meter reading would be influenced by the dark surrounds and cause overexposure of the building, but with spot metering you can take an exposure reading direct from the building and ignore the rest of the scene.

If your camera doesn't have spot metering, a useful trick is to attach your longest lens, then home in on a small area of the subject or scene and take a meter reading from that. You can then switch back to the lens you need to take the shot and use the exposure obtained with the longer lens by shooting in bulb (B) mode.

Whichever method you use, bracketing is less important with colour-print film as it's far more tolerant to exposure error, so you can get away with bracketing in full stops' increments. You need to be far more accurate when shooting transparency film, however, so bracket in ⅓ or ½ stops.

◄ **Lloyds Building, London**
This modern piece of architecture was made for night photography, thanks to the clever use of artificial illumination that bathes it each night. I cropped in tight here to show the intricate design and fantastic colours.
NIKON F90X, 50MM LENS, TRIPOD, CABLE RELEASE, FUJI VELVIA, 10 SEC AT F/11

How to shoot traffic trails

A great technique to try at night is using a long exposure to record the head- and tail-lights of moving traffic as colourful trails. Here's how it's done:

• The best time of year to shoot traffic trails is when rush hour and dusk coincide – late autumn and early spring

• Find a location where you have a view over a busy road or roundabout – bridges, buildings and car parks are ideal

• Mount your camera on a tripod and compose the shot. Use a wide-angle lens to capture a broad view, or a telephoto to home in on a small part of the scene

• Set the lens aperture to f/11 or f/16 and the camera's shutter to B (bulb). When light levels are low enough so that you can clearly see the head- and tail-lights of traffic, then it's time to start shooting

• Trip your camera's shutter with the cable release and hold the shutter open for at least 30 sec so plenty of passing traffic will record – the more traffic passing while the shutter is open, the more light trails you'll get

• If there are lulls in the traffic, hold your hand or a piece of card just in front of the lens to prevent light reaching the film. When more traffic comes along, move your hand away and record more light trails

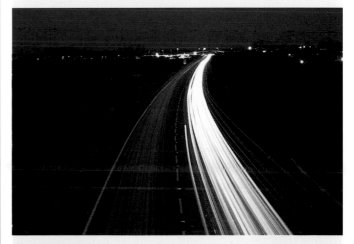

▲ **Tail-lights**
For this picture I set up my camera and tripod on a bridge overlooking a busy road and locked the shutter open for 60 sec at f/11.

Lighting for **mood**

Mood is a funny thing. You can't reach out and touch it like texture, or see it like colour. And it isn't something you can describe, like depth of field. It's a state of mind, an emotional response to the things you see, hear or experience. If you want to capture mood, let your own emotions guide you so the pictures you take reflect how you were feeling at the time.

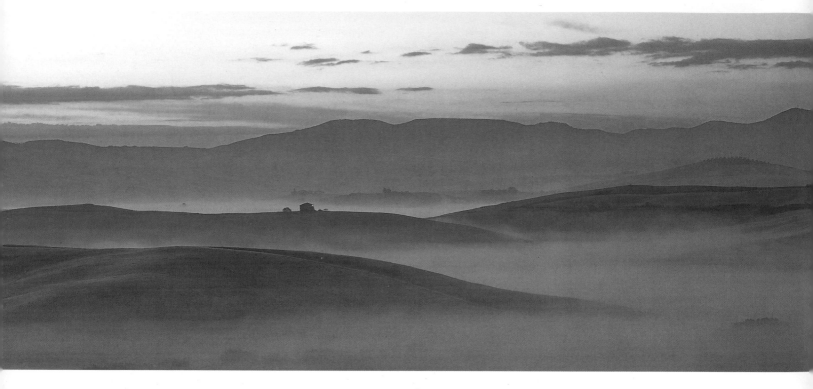

What you need
Camera A 35mm SLR is ideal, as its sophisticated metering and vast range of lenses and accessories allow you to make the most of moody light
Lenses Focal lengths from 28–200mm cover most situations, though a 50mm standard lens is particularly useful for handheld shots in low light due to its fast maximum aperture
Film For general use, film with a speed around ISO 50–100 is ideal. When light levels are low you will need something faster – at least ISO 400, preferably ISO 1000+. An added benefit of ultra-fast film is that it's very grainy, and this will enhance the mood of your pictures. Black-and-white pictures can also be very moody, so don't just stick to colour
Filters Soft-focus and warm-up filters allow you to increase the mood of a picture, as do orange 85 series filters, sunset grads, and blue filters from the 80 and 82 series
Tripod Light levels are often low in moody situations, so a tripod will be required to avoid camera shake

The lighting in a picture can control its mood
For a successful result, of course, you first need to consider the factors that will influence the mood of a picture – and the most important one is light. The quality of light has immense emotional power, simply because it dictates the physical appearance of everything we photograph – whether it looks warm, cold or neutral, hard or soft, flat or three-dimensional.

If you sit and watch the same scene from dawn to dusk on a single day it will undergo a myriad of changes as the colour, harshness and intensity of the light vary, due not only to the time of day, but also to fluctuations in the weather. And as this happens the mood of that scene, and the way you feel about it, will also change.

During early morning and late afternoon, for example, beautiful warm light bathes the landscape, and everything on it, in a golden glow, while raking shadows reveal texture and form. In these conditions you can't fail to take moody pictures. Everything looks wonderful, and the warmth of the light makes

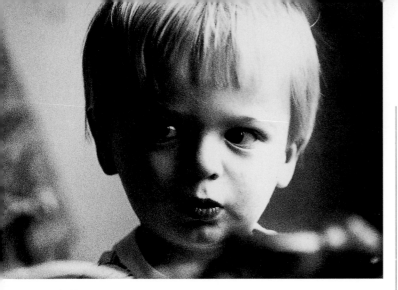

▲ Noah
Window light is a very mood-inducing and flattering form of illumination for portraiture. I noticed the quality of light falling on my son's face as he played with his toys, and couldn't resist taking a quick picture of him.

NIKON F90X HANDHELD, 80–200MM ZOOM LENS, FUJI NEOPAN, ⅟₂₅ SEC AT F/2.8

◄ Hills above mist
There are few things more moody than mist, and this photograph of Belvedere in Tuscany shows why – the softness of the light, the pastel colours of dawn and the gentle folds of the undulating Tuscan landscape combine to create an image that oozes atmosphere.

PENTAX 67, 165MM LENS, TRIPOD, CABLE RELEASE, FUJI VELVIA, ½ SEC AT F/16

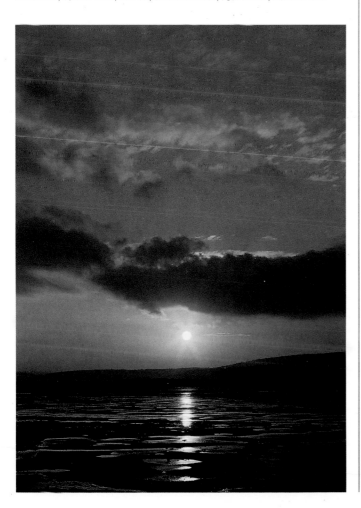

us feel cosy and comfortable. The same applies at sunrise or sunset, when even the most mundane scenes can be turned into moody masterpieces.

With the sun low in the sky you can make use of lighting direction to enhance the mood of your pictures. Keep the sun to one side of the camera, and shadows become an integral part of the scene, adding depth and modelling, whereas frontal lighting tends to look rather flat because shadows fall away from the camera. Backlighting scores even higher in the 'evoking the mood' stakes, and can be used successfully on a range of subjects.

If you're shooting outdoor portraits, position your subject with the sun behind them so the light creates an attractive halo around their hair, then use a reflector to bounce some light into their face. By overexposing by about 1 stop, the background will burn out to create an atmospheric, high-key effect.

Similarly, try photographing trees at dawn, as the first golden rays of sunlight burst through their branches. This works particularly well on misty mornings, because the light rays are more defined.

Bad weather can create moody lighting conditions
Speaking of mist, most photographers put their feet up at the first sign of bad weather, but when it comes to capturing mood you should be out there in the thick of it.

Mist and fog are great mood inducers, draining the colour from a scene, obscuring details and compressing the world into two dimensions. You can get some wonderful shots of mist hanging over rivers, lakes and valley bottoms, or old buildings like castles and churches enveloped in the cold, grey haze of thick fog.

Equally moody is dull, wet and stormy weather – think of a beautiful landscape lashed by heavy rain, or a picturesque cottage diffused by fine drizzle, a rainbow arching its way across the heavens, or an isolated farm picked out by rays of sunlight against a dark, dramatic sky. Such conditions make us feel cold, uneasy and lonely. So let your own discomfort influence the way you photograph your surroundings, and this will come across in the pictures you take.

◄ Fishguard Bay, Pembrokeshire, Wales
Sunrise and sunset are the moodiest times of day – the golden glow in the light can transform any scene and provide all the ingredients you need to take stunning pictures. For this dawn view I used a wide-angle lens to emphasize the beautiful sky.

NIKON F90X, 28MM LENS, 81C WARM-UP FILTER, TRIPOD, CABLE RELEASE, FUJI VELVIA, ⅟₃₀ SEC AT F/11

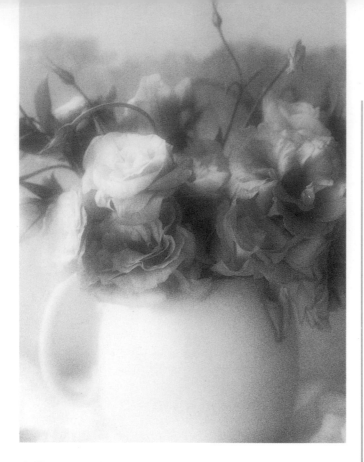

▲ Flowers and jug
Intentionally overexposing a picture can heighten its mood by lightening colour and tone to create a high-key effect. For this still life I overexposed by 1 stop. Combined with the diffuse light, the fast, grainy film and a soft-focus filter, the end result is a masterpiece of mood!

NIKON F90X, 105MM MACRO LENS, TRIPOD, CABLE RELEASE, AGFACHROME 1000RS, ⅛ SEC AT F/11

Make the most of available light indoors

Available light indoors can also be incredibly atmospheric. The flickering light from an open fire or candle flame creates a moody wash of light that adds a deep, warm cast to your subject because its colour temperature is so low – around 2000k.

You can use this as the main source of illumination for still lifes, portraits and nudes in your own home, but similar lighting can also be found in workshops, old markets and in souks, where you can photograph people in dimly lit interiors.

Light levels are low in such situations, so load your camera with fast film if you want to shoot handheld, and use fast prime lenses so you can set a wide aperture and maintain a decent shutter speed – the 50mm standard lens is ideal, typically having a maximum aperture of f/1.8 or f/1.4. This will allow you to continue shooting in situations where people with slower zoom lenses have to stop because exposure times are too long.

The warm orange cast from tungsten lighting also works well, especially in the smoky atmosphere of a dimly lit bar or restaurant. Even an anglepoise lamp can be used to great effect on simple still lifes.

Tungsten bulbs, firelight and candle flames will also add a deep yellow/orange cast to pictures taken on standard daylight-balanced colour film. This can be corrected, in the case of tungsten, and toned down in the case of the other sources, using a blue 80A or 80B filter. However, such lighting depends on its warmth to create mood, so you're better off leaving it well alone.

Finally, don't forget about window light. On an overcast day the delicate light flooding in through a large window or patio doors is perfect for moody portraits, still lifes and nude studies. Just position your subject close to the window so you get a nice fall-off in tone, then use a reflector or two to fill in the shadows if contrast is too high. To diffuse the light even more, tape a sheet of tracing paper over the glass.

▼ Bedouin guide
The warmth of firelight can be seen clearly in this picture of a native guide warming himself by a campfire in the Sahara Desert. The colour cast is much warmer than I remember because film can't adjust to changes in colour temperature – but I like it all the same.

NIKON F90X HANDHELD, 50MM LENS, FUJI SENSIA 400 RATED AT ISO1600 AND PUSHED 2 STOPS, ⅕ SEC AT F/1.8.

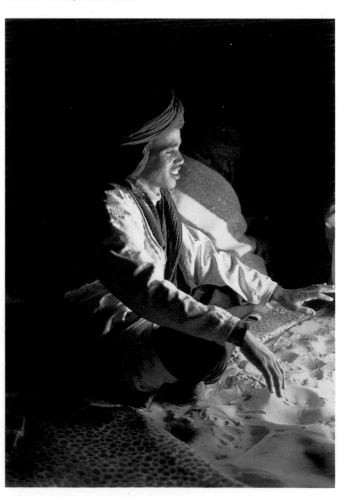

Chapter two
composition

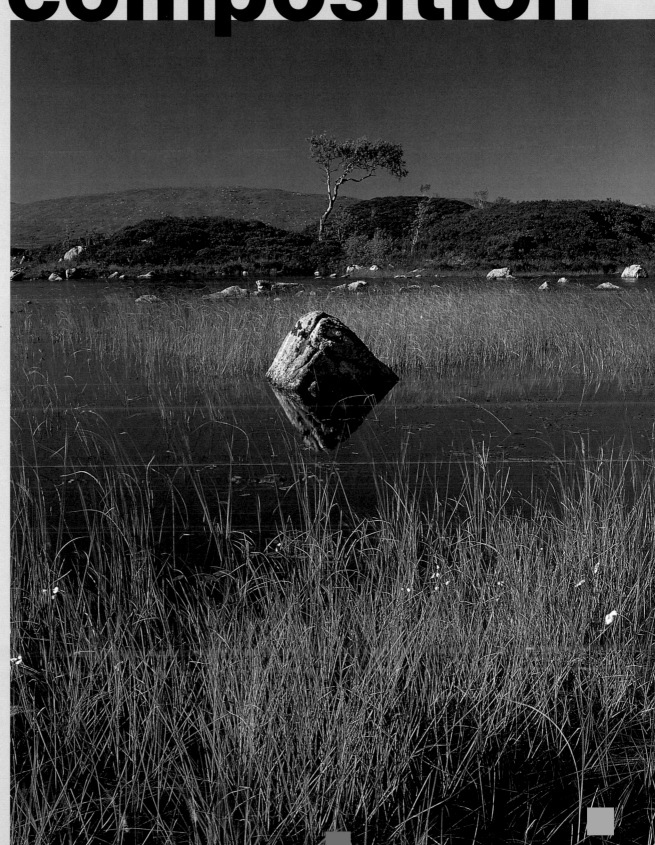

▶ **Rannoch
Moor, Scotland**

PENTAX 67, 55MM LENS,
POLARIZING FILTER,
TRIPOD, CABLE RELEASE,
FUJI VELVIA, ¼ SEC AT F/22

Learning to see

Every time we raise a camera to our eye to take a picture we're 'composing', but there's no magic formula for composing a great picture. With landscapes and architecture it's a case of looking at what's before you, then deciding how you can best capture it by choosing a suitable viewpoint and controlling what appears in the final picture by using the right lens.

A camera can only capture what you point it at

The first step towards improving your compositional skills is recognizing and accepting the limitations a camera imposes as compared to the naked eye and human brain.

When we're out and about taking pictures we respond with all our senses. As well as seeing the colours, shapes and textures of a beautiful scene, we also feel the sun on our face, hear birds singing and smell the sweet fragrances of the great outdoors – wet grass after a spring shower or the scent of blossom drifting on the breeze. Consequently, our emotional response to the landscape is based on all these things, even if we don't realize it at the time.

Unfortunately, the camera is a mechanical object that lacks any kind of emotion. It can only record what we want it to record, and the end result, a photograph, is merely a two-dimensional image of what we saw. This is why you have to work extremely hard if your photographs are to live up to your expectations – and those of other people.

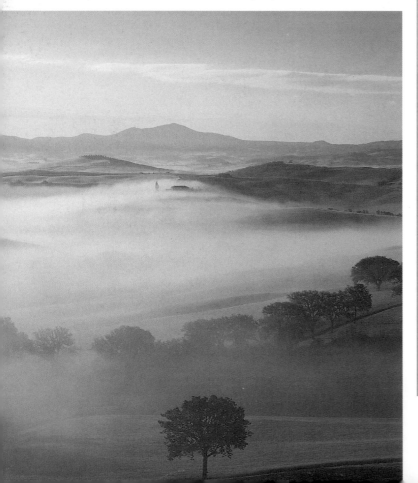

Another factor that you need to consider is that a photograph only records a tiny segment of a scene, rather like looking through a window, and offers no clues to what was going on beyond the parameters of the frame.

Our eyes work in a completely different way. For a start we have two, each offering a slightly different view which, when fused together, gives a strong impression of depth and spatial relationship. You can witness this for yourself by looking

◄ Tree and hills

I had been looking at this tree, standing alone in a misty Tuscan valley, for some time before I decided how to include it in the scene. In the end, the only place it could go without upsetting the balance of the composition is where you see it – in the centre, and close to the bottom of the frame, where it provides a focal point and adds a sense of scale. Cover the tree with your finger, and the composition doesn't work nearly as well. Some pictures are harder to take than others, but usually there's a solution that works.

PENTAX 67, 165MM LENS, TRIPOD, CABLE RELEASE, FUJI VELVIA, $\frac{1}{5}$ SEC AT F/11

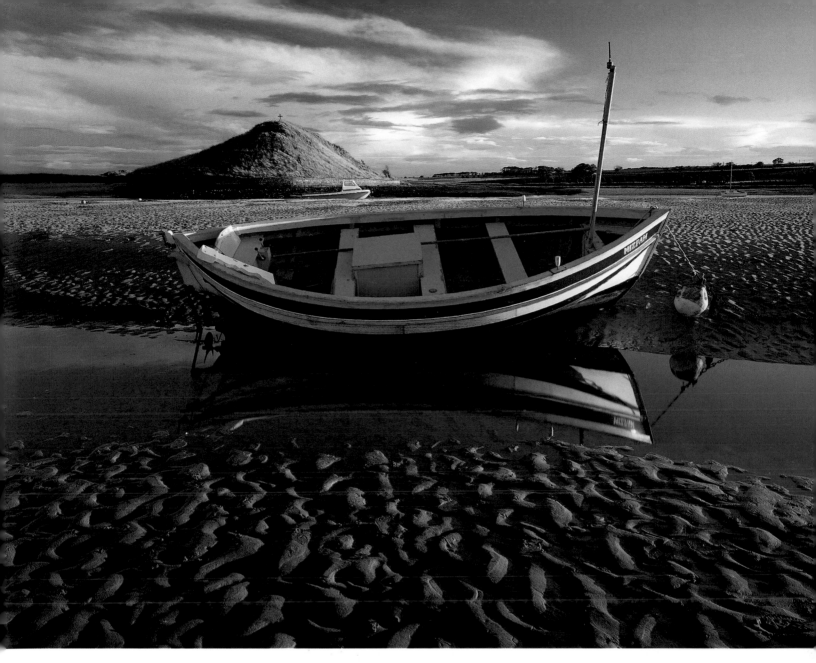

through a pair of binoculars. Try looking through them first with one eye closed, then the other, and finally with both eyes open, and the three-dimensional effect of having two 'viewfinders' will be very obvious.

Our eyes also work in harmony with the brain, constantly sending signals which generate a response based on previous experiences logged in our memory. We scan across the scene, taking in different parts of it at a time, and although the angle of view of the naked eye is relatively narrow, it's amazing how much information we can gather in the space of just a few seconds, which is then passed to our brain and processed so that a large picture of the overall scene is created.

We do this without thinking; it's a natural response. But the camera can only record what you point it at. Successful composition is therefore dependent on your ability to look at a scene and decide exactly what to point the camera at so the images recorded can capture the drama and grandeur of the broader view.

▲ Reflected boat

Composition comes easy to me these days. I usually know pretty much how I'm going to photograph a scene before I even look through the camera's viewfinder. This isn't because I have a rare gift that most photographers lack, but because I have spent a long time, and exposed a lot of film, in trying to master what it is that makes a picture work and in fine-tuning my own vision. Years of experience behind a camera also means that I instinctively complete many of the routine tasks novice photographers have to think about when setting up a shot, so I'm able to concentrate fully on the things that matter most – the quality of light and composition.

WALKER TITAN 5X4IN, 90MM LENS, POLARIZER, TRIPOD, CABLE RELEASE, FUJI VELVIA, 2 SEC AT F/32

Creating **balance**

Most scenic pictures should have a main point of interest, the focal point, which serves two important purposes. It's the element that the viewer's eye is naturally drawn to, and it adds a sense of scale and order. Also, where you position the focal point in the frame is equally important, because that will determine if the picture appears visually balanced.

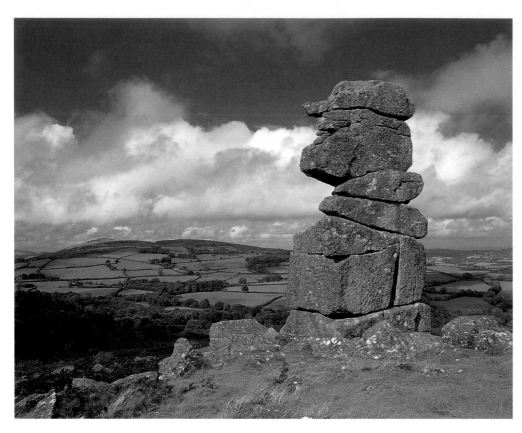

◄ Combestone Tor, Dartmoor, England

Here's a classic example of the rule of thirds being used to achieve compositional balance. The main focal point – a tor – was placed one-third in from the right side of the scene, while the top of the tor, which looks a bit like a man's profile, falls in line with the top right intersection point. Placing the tor closer to the right side of the frame works better than the left because it leaves more space for the 'face' to look into.

PENTAX 67, 55MM LENS, POLARIZER, TRIPOD, CABLE RELEASE, FUJI VELVIA, ⅛ SEC AT F/16

Using the rule of thirds

This age-old compositional device was developed by painters to help them achieve visual harmony, but it can be used just as well by photographers. All you do is divide your camera's viewfinder using two imaginary horizontal and vertical lines, so a grid is formed. You then use this grid as an aid to achieving compositional balance.

For example, the focal point may be positioned at one of the four intersection points created by the grid – although the two points on the right of the grid will give a more balanced composition than those on the left, because we tend to scan a picture from left to right so it works better if the focal point is in the part of the picture we look at last rather than first – so our eye can settle on it after looking around the picture.

Many photographers tend to place the focal point in the very centre of the viewfinder – focusing aids in SLRs don't

help, as they almost encourage this. However, doing so will produce a static, inactive composition, and unless that is what you intend, it should be avoided.

The grid can be used to aid the positioning of the horizon. If you hold the camera level, the horizon will run across the centre of the frame and divide the image into two equal sections – sky above, landscape below. If you intentionally wish to compose a scene in this way – when capturing reflections in a river or lake, for example – it can work well, but generally the 50/50 split looks static and inactive.

A slight tilt of the camera will shift the balance – move downwards to emphasize the landscape and foreground, upwards to make a feature of an interesting sky. In some situations this can be taken to the extreme, with just a tiny slice of sky visible at the top of the frame or an equally tiny area of land at the bottom; but generally the horizon is best

▼ **Cliffside village, Provence**
Faced with a scene like this, where the focal point is relatively small but is also quite prominent in the frame, you need to compose your shot very carefully. Wanting to show the church's position at the foot of the cliffs, I placed it on the bottom right intersection of the rule-of-thirds grid.

PENTAX 67, 165MM LENS, POLARIZER, TRIPOD, CABLE RELEASE, FUJI VELVIA, ½ SEC AT F/11

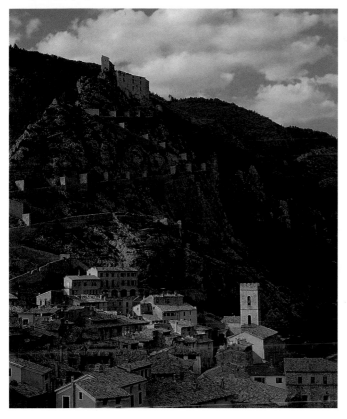

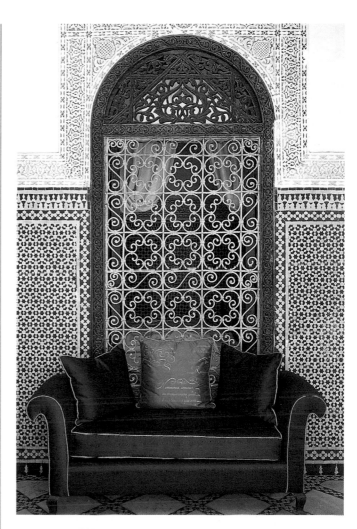

positioned either a third up from the base of the image or a third down from the top to give a more balanced image.

The rule of thirds again comes in useful here – position the horizon on the top imaginary line to emphasize the landscape, or the bottom imaginary line to emphasize the sky.

Less common but equally useful is the fact that the rule of thirds can also be applied when using frames, to direct attention towards a distant scene or the focal point. Instead of placing the 'gap' in the frame – be it space between trees or a hole in a wall – at the centre of the composition, position it a third from the left or a third from the right of the edge of the shot.

Putting all these uses together, you will see that the rule of thirds is invaluable when trying to compose a picture that's visually balanced, and although you should never try and force a picture to comply with it, more often than not you will find that it can be applied in some way.

▲ **Sofa and filigree screens**
This picture has balance through symmetry, which makes it very calming and restful to look at. But when you look closely you can see that the main lines in the scene almost form a rule-of-thirds grid, with the chair occupying the bottom third, the white wall the top third, and the ornate window screen dividing the wall into thirds vertically. It's not exact, but enough to achieve perfect balance.

NIKON F90X, 28MM LENS, TRIPOD, CABLE RELEASE, FUJI SENSIA II 100, ⅕ SEC AT F/11

TOP TIPS

• You can use the rule of thirds for any subject – portraiture, still life, wildlife photography, architecture and so on, as well as landscape
• Although the rule of thirds is very useful, don't feel that you must use it for every picture you take. Sometimes it's good to break the rules (see pages 42–43)

Leading the **eye**

Leading the viewer's eye through a picture from the foreground to the background should be one of your main priorities when composing – especially a landscape photograph – and the easiest way to achieve this is by using lines to attract and direct their gaze. Whether natural or man-made, real or assumed, lines are one of the most powerful compositional tools.

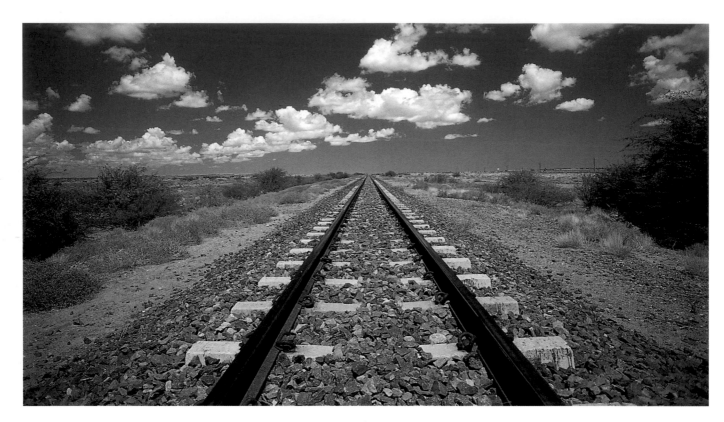

Looking for and finding lines

As well as providing a natural route into and through an image – humans are terribly inquisitive, so they can't resist following lines to see where they go – lines can also be used to divide up an image into different areas, or to add a strong graphic element. Lines can even become the main focus of the composition, not necessarily leading the eye anywhere, but being interesting to look at in their own right.

The most obvious lines are those created by man-made features, such as roads, paths, tracks, bridges, telegraph wires, walls, hedges, fences and avenues of trees. Shadows, too, can create strong lines, especially early or late in the day, when the sun is low. Natural features such as rivers and streams, although not necessarily straight, have the same effect as they wind through a scene into the distance.

Assumed lines can also be formed by the layout of features or objects in a scene, such as stepping stones across a stream.

▲ Railway tracks, Namibia

Converging lines, like the sides of this African railway track, create a strong sense of depth as they head off into the distance. Emphasize the effect using a wide-angle lens, and get in close to the lines.

NIKON F90X HANDHELD, 18–35MM ZOOM LENS AT 20MM, POLARIZER, FUJI VELVIA, 1/60 SEC AT F/8

Different lines have different uses

The direction a line travels should be considered because it can have a profound effect on how the viewer responds to an image, and the job it does as part of a composition.

• Horizontal lines echo the horizon and the force of gravity. This makes them easy on the eye, as they suggest repose and are naturally passive. Man-made boundaries in the landscape, such as walls, fences and hedges, are obvious examples of horizontal lines that help to divide up the image into definite areas, though

shadows can also be used in this way. The eye tends to begin at the bottom of a picture and work up, so horizontal lines divide it into sections that can be observed in turn.

• Vertical lines are more active than horizontals, producing dynamic compositions with a stronger sense of direction. Think of the regimented trunks of trees in a pine forest and the soaring walls of skyscrapers in a bustling city. To maximize the effect, shoot in the upright format so the eye has further to travel from the bottom of the frame to the top.

• Diagonal lines have great directional value, and add depth as they suggest distance and perspective. They also contrast strongly with the horizontal and vertical lines that make up the borders of an image, and in doing so can create tense, dynamic compositions that catch the eye and hold the attention. As the eye tends to drift naturally from the bottom left to top right, diagonal lines travelling in this direction have the greatest effect, because they carry the eye through an image from the foreground to the background. In the landscape, roads, rivers, drainage ditches, rows of trees, hedgerows and other features can be used to form diagonal lines.

• Converging lines are the most powerful of all. If you stand in the middle of a long, straight road and look down it, you'll notice that as distance increases, the parallel sides of the road appear to move closer and closer together until they eventually seem to meet at a place in the distance that is known as the 'vanishing point'. The same effect occurs with railway lines, paths, avenues of trees, bridges, the furrows in a ploughed field, rows of crops and so on. When included in a composition, converging lines immediately add a very strong sense of depth because you know the road, for instance, is the same width along its length; so if it appears to become narrower it must be travelling away from the camera.

TOP TIPS

• Lines aren't always obvious in a scene, but if you get used to looking for them, it's surprising how often you will find them
• Lines don't have to be real – assumed lines formed by the way the elements in a scene link together can be just as effective

▶ **River Aln, Northumberland, England**
The gold meander of this river creates a strong lead-in line that carries the eye through the scene. I discovered the view earlier that day but decided it would work better at sunset. It did!
PENTAX 67, 300MM LENS, 81C FILTER, TRIPOD, CABLE RELEASE, FUJI VELVIA,
⅕ SEC AT F/16

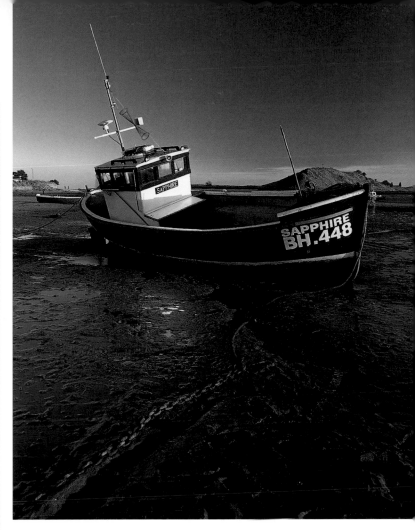

▲ **Trawler at low tide, Northumberland, England**
A diagonal line travelling from the bottom left corner of a picture is a strong compositional aid because the eye will naturally follow it – in this case towards the fishing trawler, which itself creates a diagonal line travelling in the opposite direction.
PENTAX 67, 45MM LENS, POLARIZER, TRIPOD, CABLE RELEASE, FUJI VELVIA,
½ SEC AT F/22

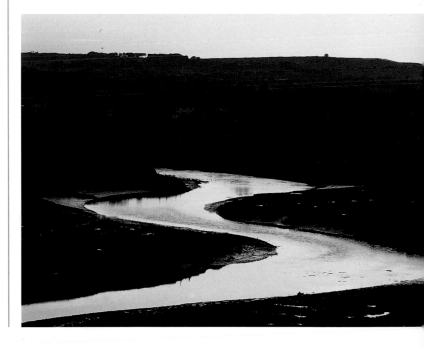

Filling the **foreground**

One of the most important elements you can exploit to create a dynamic composition is the foreground – the area of a scene closest to the camera. Emphasizing the foreground will help to give your photographs a strong sense of distance, depth and scale, due to the effects of perspective, as well as providing a convenient entry point into the picture.

How to make the most of foreground interest

The strength of the foreground can be controlled by both lens choice and viewpoint.

Wide-angle lenses are the most popular choice, as they allow you to include elements in a photograph that are literally at your feet. The wider the lens (shorter the focal length) the more this effect is revealed, until with ultra-wide and fisheye lenses, actually keeping your own feet out of the picture can become a problem.

The way wide-angle lenses appear to 'stretch' perspective also makes those elements loom large within the frame, while everything else seems to rush away into the distance – the lower the viewpoint you adopt, the more the foreground will dominate. It's this factor more than any other that creates a feeling of depth, simply because if the rock near the camera looks much bigger than the building in the distance, you know the building must be a long way from the camera – hence depth is implied.

What you need

Camera Any type of camera that has a wide-angle lens or accepts interchangeable lenses

Lenses Wide-angle lenses are generally more useful for emphasizing the foreground, simply because they allow you to include more in a picture. Focal lengths around 28mm or 24mm are ideal for general use, though wider lenses of 17–20mm can produce really dramatic effects when used with care on the right type of scene, as you can move in really close to the foreground

Tripod You generally need to shoot at small apertures to keep everything sharp, which means shutter speeds will be slow, even in bright sunshine. Avoid camera shake by mounting your camera on a tripod

A moderate wide-angle lens around 28mm, or the equivalent in other formats, is ideal for including foreground interest, being wide enough to be dynamic but not so wide that everything but the immediate foreground appears tiny and distant, which tends to be the effect you get when using lenses wider than 24mm. When using ultra-wide lenses there's also a tendency for the foreground to end up looking quite empty, because everything in it seems further away that it really is.

A further benefit of wide-angle lenses is the fact that they give you lots of depth of field to work with, making it relatively straightforward to keep everything in sharp focus from the immediate foreground to the furthermost point in your picture. A 28mm lens set to f/22 will provide depth of field from under 2m to infinity, for example.

What can you use as foreground interest?

Pretty much anything can be used as foreground interest – roads, fences, rivers, streams and paths work well because,

◄ Desert, Namibia
If you tilt your camera down when using a wide-angle lens and shoot in portrait (upright) format, you can include the foreground literally to your own feet. This produces dynamic pictures with a strong sense of depth.
PENTAX 67, 55MM LENS, POLARIZER, TRIPOD, CABLE RELEASE, FUJI VELVIA, ¼ SEC AT F/22

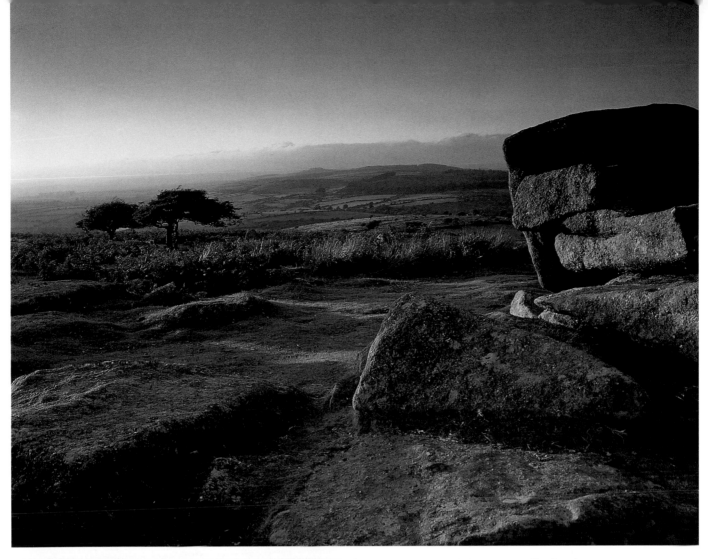

▲ Rocky ground, Dartmoor, England

This picture shows classic use of foreground interest. The granite rocks are not only integral to the character of the scene but also add a sense of depth and scale that landscape photographs need. It was one of the first landscape pictures I took where I finally felt that my compositional skills were coming together.

PENTAX 67, 55MM LENS, 0.6ND GRAD AND 81C WARM-UP FILTERS, TRIPOD, CABLE RELEASE, FUJI VELVIA, ¼ SEC AT F/16

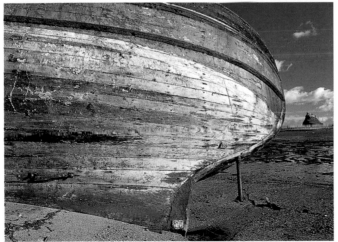

◄ Old fishing boat, Northumberland, England

Foreground interest is used in a different way here. The huge old boat looked amazing with its peeling paintwork and wonderful shape that I decided to let it dominate the picture – including distant Lindisfarne Castle as scale, and also to offer a clue about where the photograph was taken.

PENTAX 67, 55MM LENS, POLARIZER, TRIPOD, CABLE RELEASE, FUJI VELVIA, ⅛ SEC AT F/16

in addition to allowing you to fill the foreground, they are also useful in creating strong lines that lead the eye through the scene (see pages 38–39).

That said, anything of interest that's close to the camera will work – rocks on a lake shore, a flower bed, a tuft of grass swaying in the breeze or a piece of driftwood on a beach – the key is to keep your eyes peeled as you explore a location so that you can nominate different things for possible use as foreground interest.

TOP TIPS

• Include things in the foreground of your pictures that relate to the rest of the scene
• When shooting landscapes, a person admiring the view can provide foreground interest, though natural features tend to make the composition more interesting
• Shadows can be used as foreground interest if you can't find anything else – you could stand in the shadow of a tree, for example, and use that

Breaking the **rules**

You need to know and understand the so-called 'rules' because they provide the foundations, but once mastered they can be committed to your subconscious, leaving you to follow your own instincts. Often you'll get a far better picture by intentionally breaking the rules because doing so produces pictures that are surprising and challenging to look at.

▲ Near Pienza, Tuscany

Here's a classic example of the so-called 'rules' of composition being broken. The main subject – the farmhouse – has been positioned in the centre of the frame, an act that produces static, lifeless compositions. However, I felt the centre was the best place because it added to the symmetry of the scene, with the cypress trees in front of the building and the path leading the eye to it. Also, I was happy for the composition to be static because the scene is restful. Never be afraid to break the rules – that's what they're there for.

PENTAX 67, 105MM LENS, POLARIZER, TRIPOD AND CABLE RELEASE, FUJI VELVIA, ⅛ SEC AT F/16.5

Put your main subject in the centre of the picture

One of the first rules novice photographers are taught is to avoid putting your main subject in the centre of the picture because it makes the composition static and boring. The same applies with the horizon – don't position it across the centre of the frame.

In some cases, however, the dead centre of the picture is the best place for both your main subject and the horizon, so never be afraid to do that if you feel it will make the composition work for you. Placing the horizon across the centre of a picture is necessary if

▲ Statues askew, Florence

Intentionally tilting your camera over to one side can make everyday subjects much more interesting because the unusual angle makes the picture more dynamic – and helps to hold the viewer's attention for longer.

PENTAX 67, 165MM LENS, POLARIZER, TRIPOD, FUJI VELVIA, ⅛ SEC AT F/16

▶ Handbags

Excluding information that we would normally expect to see is a great way to inject a sense of mystery and intrigue into your pictures. In this case, for example, inclusion of the legs, shoes and handbag is enough to tell us that the subject is an elderly lady, but excluding the rest of her body and, most important of all, her head, leaves us wanting.

OLYMPUS OM2N HANDHELD, 85MM LENS, ILFORD HP5, ½₂₅₀ SEC AT F/5.6

you are shooting near water and the bottom half of the composition is a reflection of the scene above the waterline. The symmetry achieved by placing the horizon centrally is what makes the picture work, adding a sense of balance and calm. If you put it anywhere else, then balance would be lost.

Similarly, putting your main subject in the centre of a picture is advised against because it makes the composition static and lifeless. But sometimes that may be exactly what you want. A single tree in the middle of an empty landscape looks a little lost and forlorn, for example, and by placing it in the middle of the picture you are emphasizing that.

Leave the viewer wanting more

Another approach worth trying is to exclude information from a composition that you would normally include, so it leaves the viewer wanting more and asking questions.

You could crop out a person's head from a portrait, fail to include what they are looking at, or obscure their face in some way – perhaps with a mask or their own hands. Photographing a person from behind is another approach that can work, because we then see the back of their head and can only imagine what their face looks like – by not seeing their face,

in particular their eyes, we're also denied any information about their emotional state, facial expression or physical appearance. Are they happy or sad, ugly or beautiful? Because this isn't clear from the picture, we are forced to spend longer looking for clues and finding answers to those questions.

You see this kind of thing going on all the time in today's magazines, particularly those dealing with fashion and lifestyle that traditionally have a young, visually aware readership. Photographers often go to great lengths to produce images that are different, and in doing so break every rule in the book.

Choose a different viewpoint

Shooting from an unusual viewpoint is another option, because it captures a view of the world we're not used to seeing and therefore offers a visual surprise to the viewer. So experiment with tilting the camera to a funny angle so everything in the picture is leaning over to one side, shoot from a low viewpoint by lying on the ground on your back, and crop important elements in the picture in an unusual way.

If you do this kind of thing by accident it usually looks like a mistake, but when used creatively and intentionally it can work brilliantly, so never be afraid to take the odd risk.

Composing for **impact**

'If a picture's not good enough, you probably weren't close enough.' Although Robert Capa was referring to combat photography, his maxim could be applied to any subject. Wasted space in a picture serves no purpose other than to make the composition 'windy', so keep things tight and make full use of the image area.

What you need

Camera Any, though the 3:2 ratio of a 35mm SLR, and the vast range of lenses available, makes it the most versatile choice

Lenses Any lens can be used to take powerful pictures, but ultra-wide-angle and long telephoto lenses are ideal

Accessories A polarizing filter makes the most of colour

Take a few steps closer

Get into the habit of asking yourself if a composition could be improved by taking a few paces forward before you trip the camera's shutter. More often than not it can, and if you take those steps you will see a big improvement in the overall standard of your work. Your pictures of people will be more intimate, your action shots will be full of drama, and your landscapes will lack empty space. Force yourself to use every last millimetre of that picture area.

Prints can be cropped in the darkroom, of course, so if you're not happy with the composition of a picture you can tighten things up when you're in the darkroom. But using an enlarger to improve the composition of a picture is a poor excuse for not getting it right in the first place, so if you shoot and print black-and-white, why not discipline yourself by using the film rebate as a border for your pictures, so that you have to print full frame? This forces you to compose each shot in-camera as you want it to be on the final print, and eventually you will do that instinctively.

Explore your subject from all angles

Don't automatically assume you have to take pictures with the camera at eye-level, either. Try shooting from a slightly higher position every now and then, by standing on a wall or climbing up a stepladder. Some photographers carry a stepladder in the boot of their car for this very purpose, because you can see far more from an elevated position and it changes the way the elements in a scene relate to each other.

Alternatively, bend down or stretch out on your stomach so you get a worm's-eye view of the world. By doing this you can create stunning pictures of the most mundane subjects, because we're not used to seeing things from such an odd position.

◀ Seth
Shooting from odd angles and breaking the rules is a sure-fire way to add impact to your compositions. Using a wide-angle lens for close-range portraits is normally to be avoided, but here I used it to intentionally distort the size of my subject's head in relation to his body and create a portrait with a difference. Cross-processing the film in C41 chemistry produced vibrant colours.

NIKON F90X HANDHELD, 28MM LENS, AGFACHROME RSXII 100, ½₅₀ SEC AT F/4

▲ Railway bridge, Newcastle-upon-Tyne, England
'Fill the frame' is a maxim you should commit to memory if you want to produce pictures with impact. For this shot I used a telephoto lens to crop the scene and emphasize the contrast between the arch of the bridge and the straight lines of the buildings. An added bonus was that the lens also compressed perspective so the bridge appears to be literally on top of the buildings.

PENTAX 67, 200MM LENS, POLARIZER, TRIPOD, CABLE RELEASE, FUJI VELVIA, ½ SEC AT F/22

Remember, composition begins with your feet. Only when you've discovered the best viewpoint can you start making other important decisions.

Make the most of your lenses

Pictures that pack a punch tend to do so because there's something different about them, so they catch the eye and hold our attention. One of the easiest ways to make your pictures different is by exploiting the characteristic of different lenses.

We're talking extremes here. On a day-to-day basis you're probably shooting with lenses from 28–200mm, but once you go wider and longer than that, interesting things start to happen.

As lenses become wider they offer several benefits:
• You can get more into a shot, so it's possible to take pictures in situations where normally you would struggle, such as confined spaces. Also, by getting more into a picture that we can see with our eyes, the effect is visually exciting because it offers a view of the world we're not used to seeing.
• Ultra-wide-angle lenses distort reality. They stretch perspective so that elements close to you appear big and bold while elements just a few metres away seem tiny. This dramatic rendition of scale looks stunning when used on the right subject.

▲ La Digue, Seychelles
Be bold with your compositions. Break convention, try something new – make it your goal to produce original pictures that no one else would have thought of. I like to think I went some way towards achieving that when I photographed this scene on a tropical island in the Seychelles. I loved the strong, graphic shapes of the granite outcrops and the overall simplicity of the scene. Having set up my camera, I then waited for the white cloud to drift into a position where it helped to balance the composition and added an extra point of interest.

PENTAX 67, 45MM LENS, POLARIZER, TRIPOD, CABLE RELEASE, FUJI VELVIA, ¼ SEC AT F/22

• The wider the lens, the more depth of field you get at any aperture, so with something like a 17mm lens stopped down to f/22 you can shoot just centimetres away from something, and not only get it sharp, but the rest of the scene as well.

With telephoto lenses the opposite applies:
• The longer the lens the more it magnifies your subject, thus allowing you to be very selective about what you include in a picture. For sport and action subjects long lenses are essential if you want to take dramatic, frame-filling shots, but they can be used for any subject with the same effect.
• Perspective is compressed or 'foreshortened' so that the

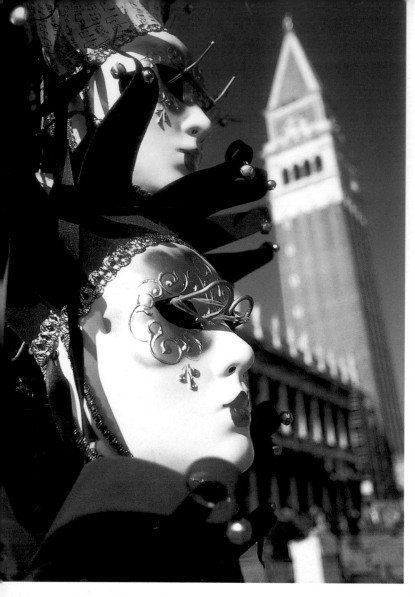

▲ Venetian masks

This powerful composition was created by moving in close to the masks with a wide-angle lens on my camera, focusing carefully on the mask nearest to me and setting the lens to its widest aperture so the background was thrown out of focus. The image still says 'Venice', but it's an unusual depiction of a much-photographed location.

NIKON F90X HANDHELD, 28MM LENS, FUJI SENSIA II 100, 1/500 SEC AT F/2.8

elements in a scene appear to be closer together than they are. The longer the lens, the more pronounced this effect is, and when used creatively it can produce pictures with great impact.
• The longer the lens, the less depth of field you get at any aperture – a 400mm or 500mm lens used at its maximum (widest) aperture will only record a very narrow zone in sharp focus, while everything else is reduced to a blur both in front of and behind the main point you focus on.

Compose with colour

As you will discover in Chapter Four, colour can lend great aesthetic power to your compositions due to the way people respond to it, so this important factor should be considered when trying to give your pictures impact.

If you fill the frame with bold, contrasting colours such as blue and yellow or red and green, you will immediately produce a picture that's exciting and dynamic to look at, and impact is achieved. Concentrating on a single colour can work well, too. Red is the most dominant colour of all, though any deeply saturated colour that fills all or most of the frame will add impact to your pictures.

Use your camera on its side

Most photographers automatically use the camera horizontally when composing a picture, mainly because it's designed to be held that way and is easier to use. However, turning the camera on its side can make a vast difference to the composition.

By using your camera in the vertical, 'portrait', format you can include far more foreground or sky; because the eye has further to travel from top to bottom a stronger sense of vertical direction is created, leading to active, dynamic compositions.

▼ Skyscraper

Wide-angle lenses used from low angles always produce dramatic results – especially if you move in close to things like tall buildings, then look up so vertical lines converge.

NIKON F90X, 17–35MM ZOOM LENS AT 17MM, TRIPOD, CABLE RELEASE, FUJI VELVIA, 20 SEC AT F/11

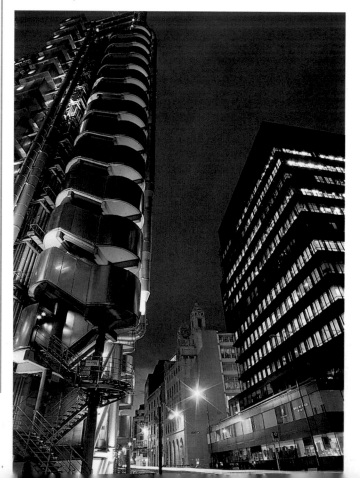

Chapter three
focusing

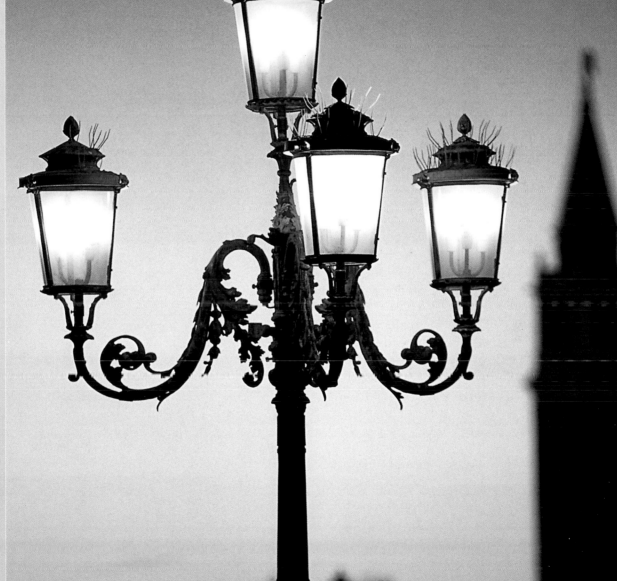

► **Venice**

NIKON F90X, 80–200MM
ZOOM AT 200MM, TRIPOD,
CABLE RELEASE, FUJI
VELVIA, ⅟₁₅ SEC AT F/2.8

Look **sharp**

When shooting landscapes, do you know where to focus the lens to ensure everything is in sharp focus? Many photographers stop the lens down to its smallest aperture – usually f/16 or f/22 – set the focus at infinity, and then hope for sufficient depth of field for front-to-back sharpness. However, a much safer method is to use the technique of hyperfocal focusing.

What you need
Camera Hyperfocal focusing can be used with any type of camera, providing its lens or lenses can be focused manually
Lenses The most suitable lenses for hyperfocal focusing are those with a depth-of-field scale on the barrel, but as a minimum they must have a distance scale – which some modern autofocus lenses don't have

How to use hyperfocal focusing
The name alone sounds quite complicated, which is why many photographers find the technique confusing, but hyperfocal focusing is, in fact, very straightforward. Here's how it works…

• If you look at a typical lens barrel you will see that on either side of the main focusing index there's a series of f/numbers. This is the lens's depth-of-field scale.

• To maximize depth of field, focus the lens on infinity, then check the depth-of-field scale to see what the nearest point of sharp focus will be at the aperture set – the distance opposite the relevant f/number on the scale. This is the hyperfocal distance.

In the picture above, of a 45mm lens for a Pentax 67, at f/22 with focus set at infinity, the hyperfocal distance is about 2m (6ft), so with the lens focused on infinity, depth of field will extend from around 2m (6ft) to infinity.

• By re-focusing the lens on the hyperfocal distance, the depth of field extends from half the hyperfocal distance to infinity, and is thus maximized. In this case, if we focus the lens on 2m (6ft) then check the scale, the depth of field extends from 1m (3ft) to infinity at f/22.

• Having done that, if you do this, then peer through your camera's viewfinder, pretty much everything appears to be

blurred. Ignore this – what you are seeing is how the picture would record if you took it with your lens set to its widest aperture, but when you trip the shutter release, the aperture will stop down to the small f/number you have set it to and everything will pop into sharp focus.

Do all lenses have depth-of-field scales?
Most manual focus lenses for 35mm and medium-format cameras have good depth-of-field scales. Unfortunately, many modern autofocus lenses don't, or if they do, they're very basic and not particularly useful – especially on zoom lenses.

The easiest way around this is to use the table below, which shows the hyperfocal distances for various lenses and f/numbers.

Aperture (mm) (F/stop)	20	24	28	35	50	70	100	135	200
f/11	1m	1.5m	2m	3m	6.3m	12.3m	25m	46m	100m
f/16	0.7m	1m	1.4m	2.1m	4.3m	8.5m	17.5m	31.5m	70m
f/22	0.5m	0.7m	1m	1.5m	3.1m	6.2m	12.5m	23m	50m
f/32	0.35m	0.5m	0.7m	1m	2.2m	4.2m	8.5m	16m	35m

All you do is find the focal length you're using along the top, and the aperture you want to use down the side, then read across to find the hyperfocal distance.

For example, if you're using a 24mm lens set to f/22, the hyperfocal distance is 0.7m (2ft 4in). By focusing the lens on 0.7m, the depth of field will extend from half the hyperfocal

TOP TIPS

• Hyperfocal focusing is much easier to use if your camera is mounted on a tripod because you can make adjustments to focus without having to keep re-composing the picture
• Always make sure that the nearest point of sharp focus you will achieve is less than the closest point to the camera in your picture
• If you can't achieve sufficient depth of field to keep everything in sharp focus, even with your lens set to its smallest aperture, try using a wider lens, which will give more depth of field, or change the composition of the picture

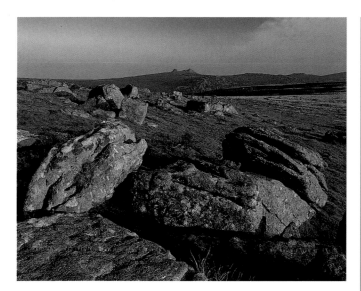

▲ Rocks, Dartmoor, England
Hyperfocal focusing is invaluable for landscape photography and is well worth learning if you want to be confident of achieving front-to-back sharpness whenever you take a picture. I use it as a matter of course, and it never lets me down.

PENTAX 67, 55MM LENS, POLARIZER AND 81B WARM-UP FILTERS, TRIPOD, CABLE RELEASE, FUJI VELVIA, ½ SEC AT F/16

▶ Palm leaf and yacht, Praslin, Seychelles
Hyperfocal focusing was essential when I took this picture if I wanted to be sure that everything would be in sharp focus, from the palm leaf, less than 2m (6ft) from the camera, to the distant background. Using a 45mm lens on my Pentax 67 (equivalent to around 24mm on 35mm format) I was able to achieve that by stopping right down to f/22 so depth of field extended from around 1m to infinity.

PENTAX 67, 45MM LENS, POLARIZING FILTER, TRIPOD, CABLE RELEASE, FUJI VELVIA, ¼ SEC AT F/22

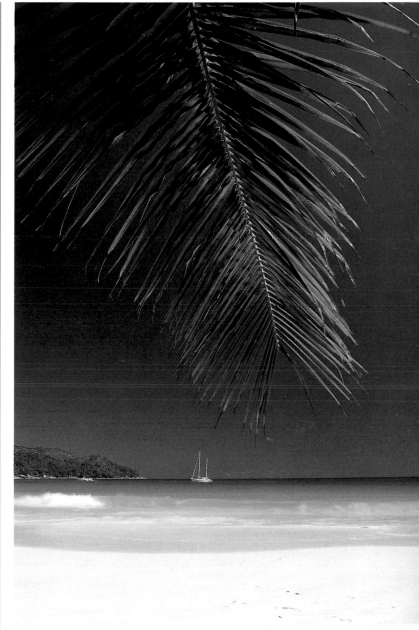

distance (0.35m/1ft 2in) to infinity. In order to check that this is sufficient, focus on the nearest point you want to include in the picture, then look at the distance scale on the lens barrel to see just how far away that point is.

If it's more than the nearest point of sharp focus you've just determined, you can fire away safe in the knowledge that you will get front-to-back sharpness. If it's less than the nearest point of sharp focus, then there's a danger that the immediate foreground won't be sharp, so refer back to the table and stop your lens down to a smaller aperture.

This probably sounds very complicated right now, but if you read through the information several times and refer to the table while handling your own lenses, it will soon become clear. In fact, why not copy the table onto a sheet of white card, or photocopy this page then slip it into a clear plastic wallet so you can refer to it in the field?

Not all lens scales are accurate

The distances on the table are only intended as a guide, so conduct tests with your lenses to make sure the focusing scales are accurate. The same applies when using depth-of-field scales if your lenses have them – they are unlikely to be 100% accurate, so don't follow them too strictly, otherwise you could find that the nearest or furthest points in your pictures aren't quite in focus.

I tend to use the hyperfocal distance for the next widest aperture so there's a margin of error. For example, if I am shooting at f/22, I calculate the hyperfocal distance for f/16 and focus the lens on that, or use the chart and read off the distance for the next widest aperture.

Less is **more**

Although in most pictures you want to keep everything pin sharp, sometimes you will want to do exactly the opposite and limit depth of field so that only a very selective part of the scene is recorded in sharp focus while everything else records as a fuzzy blur. This technique is known as differential focusing, and when used creatively it can produce stunning results.

What you need

Camera A single-lens reflex (SLR) camera is the most suitable, as you can see through the lens and gauge the effect that will be obtained on the final picture

Lenses Telephoto lenses set to their widest aperture are best for general use, though wide-angle lenses can give shallow depth of field when used 'wide open' if the point of focus is close to the camera, as can macro lenses

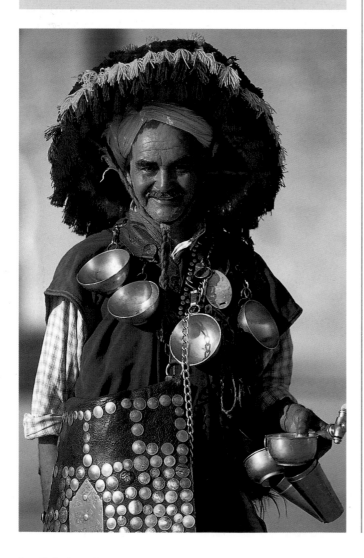

Use long lenses and wide apertures

The two main factors that allow you to control depth of field are the focal length of the lens and the aperture (f/number) you set that lens to. If you want extensive depth of field, wide-angle lenses and small apertures are the order of the day, but if you want minimal depth of field, a telephoto lens set to a wide aperture is required.

In the case of differential focusing, the longer the focal length and the wider the aperture, the less depth of field you will get. A fast 600mm f/4 lens used wide open at f/4 will record literally just a few centimetres or inches in sharp focus, for example, whereas a 70–200mm f/4–5.6 telezoom set to 200mm and f/5.6 will record a couple of metres or a few feet in sharp focus. The difference may not seem that significant, but it is, so for the best effect use your longest lens at its widest aperture setting.

The great thing about shooting with your lens at its widest aperture is that what you see through the viewfinder – assuming you're using an SLR camera – is what you will get on the final picture, so you can immediately gauge what will be in and out of focus before you take the shot.

This is because lenses with an automatic aperture stopdown – which is pretty much all lenses for SLRs these days – stay 'wide open' at the maximum aperture for viewing, then when you trip the shutter release to take a picture, the aperture in the lens stops down to the f/number set.

Move closer to your subject

Another factor that can make a difference is how close to the camera your subject is – the closer it is, the less depth of field you get, so a 70–200mm telezoom set to 200mm and f/5.6, as above, will give far less depth of field if you focus it on a point 2m (6ft) from that camera than it will if you focus it on 10m (32ft) or infinity. This means that you can achieve minimal

◄ Water seller
A classic use of differential focusing is when photographing people, to throw potentially distracting backgrounds out of focus. In this case, a zoom set to 200mm and its widest aperture reduced the depth of field sufficiently to give the desired effect.
NIKON F90X HANDHELD, 80–200MM ZOOM LENS AT 200MM, FUJI SENSIA 100, ½₅₀ SEC AT F/2.8

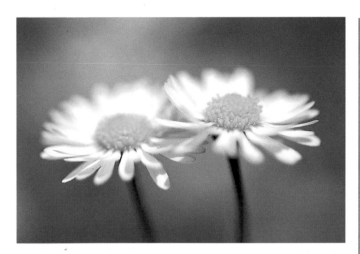

When shooting close-ups, depth of field can be reduced to just a few millimetres, especially if you use a macro lens set to its widest aperture. For the picture of a stargazer lily the shallow zone of sharp focus resulted in a pleasing abstract image, while the pair of daisies have been isolated from the grassy background.

NIKON F5 HANDHELD, 105MM MACRO LENS, FUJI SENSIA II 100, $^1/_{125}$ SEC AT F/2.8

If you have a camera that offers movements, such as a large-format monorail camera, you can achieve extremely shallow depth of field with any lens – focal length becomes almost irrelevant. All you do is compose the shot, focus on your main subject, then tilt or shift the front or rear standard to throw everything else out of focus. You can also see exactly the effect you will obtain.

Which subjects suit differential focusing?

The technique is used when shooting portraits, to throw the background out of focus so it doesn't take attention away from the main subject; and sport and action photographers who work with long telephoto lenses use it routinely.

However, differential focusing can work well on pretty much anything. To show the effect at its best, include something in the foreground of the picture that will also be thrown out of focus, and you have a narrow band of sharpness further into the scene. Like most techniques, the key is to experiment and see what you can come up with.

▼ **Tower Bridge, London**
To create this effect I placed a 6x7cm colour slide on a lightbox in a darkened room and then re-photographed it using a 35mm SLR and macro lens. To minimize depth of field the macro lens was set to its widest aperture, and I also shot from an acute angle to reduce the depth of field even more. The same effect can be achieved with a large-format camera, using movements to minimize the depth of field.

NIKON F90X, 105MM MACRO LENS, TRIPOD, CABLE RELEASE, LIGHTBOX, FUJI VELVIA, $^1/_{15}$ SEC AT F/2.8

depth of field with a moderate telephoto lens by keeping your main subject close to the camera.

This effect can also be put to very good use in close-up photography: if you use a macro lens to focus on subjects that are just a few centimetres or inches away, and set the widest aperture – usually f2.8 on macro lenses – depth of field will be reduced to just millimetres or fractions of inches.

For subjects such as flowers, this effect can produce truly stunning results. Focus on the edge of a petal, say, and everything except the point you focus on will be thrown totally out of focus to give a wonderful impressionistic effect, where colours, shapes and details merge into a gentle blur.

TOP TIPS

- A benefit of shooting with your lens at its widest aperture is that shutter speeds will be high so you won't need a tripod in most situations, though one is still advised when shooting close-ups
- Remember that the less depth of field you have, the more accurate your focusing must be – especially when using telephoto and macro lenses
- If you have an autofocus camera and your subject is off centre, focus on it, then lock focus with a half depression of the shutter button, re-compose, and take the shot

De-focusing for **effect**

Although photographers put a lot of effort into making sure their pictures are as sharp as they can be, it's possible to produce interesting images by shooting with everything purposely out of focus. This technique, usually referred to as de-focusing, isn't something you could use on a regular basis, but on the right subject it can work well.

What you need

Camera Ideally, a camera with a multiple-exposure facility so you can combine two images on the same frame of film
Lenses Pretty much any – telephoto, wide-angle, prime or zoom in any focal length can be used
Tripod This is essential to keep your camera in exactly the same position for each exposure when shooting double exposures

Stick to bold subjects for the best results

If you compose a picture and focus the lens as normal, then slowly de-focus it, two things happen. First, everything in the viewfinder appears blurred – the more you de-focus, the more blur you get until you can no longer identify what you're actually looking at. Second, as you slowly de-focus the lens, details begin to blur until all you're left with are the main elements, which you can identify only because they have familiar shapes.

The key when de-focusing, therefore, is to make sure there are bold elements in your picture that will be identifiable when they're blurred, otherwise the final image will have nothing to hold the attention, and also to de-focus the lens to a point where the main subjects are only just identifiable, so the viewer is forced to look and think a little harder than normal.

People are ideal subjects, because even when quite a long way out of focus it's still possible to make them out. The way de-focusing distorts shapes can produce interesting effects with people – necks, arms and legs appear very slender, for example. A further benefit is that your subjects cannot be identified, so a sense of intrigue and mystery is added.

Shooting against light backgrounds gives the best results because the blurred shapes stand out boldly. To enhance this effect, overexpose the picture by a stop or two so that the lighter tones burn out, leaving only the bolder areas of colour to form the building blocks of the picture.

De-focus to create soft focus with double exposures

Another use of de-focusing is when creating double-exposure images. If you take the first exposure with the picture fully focused, then re-expose the same frame of film a second time with the lens de-focused, the out-of-focus image will create a dreamy halo effect around the sharp image. This is similar to using a soft-focus filter, but the effect is more interesting because

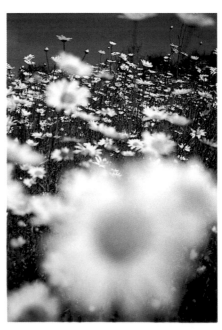

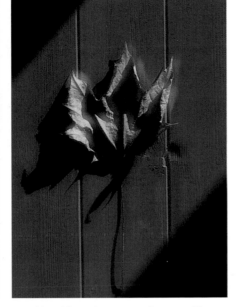

◄ Autumn leaf

This set of pictures by Simon Stafford shows how combining sharp and de-focused images of the same subject on a single frame can create interesting effects. Top left is the sharp image, below left is the de-focused image, and on the right the two images are combined via a double exposure.

NIKON F5, 50MM LENS, TRIPOD, CABLE RELEASE, FUJI VELVIA, ⅕ SEC AT F/8

▼ Autumnal woodland

This effect was created digitally, by making a copy of the original scan, softening it using Gaussian Blur in Adobe Photoshop's Filter menu, then combining the two images in Layers.

MAMIYA 645, 45MM LENS, POLARIZING FILTER, TRIPOD, CABLE RELEASE, FUJI VELVIA, ½ SEC AT F/11

there's a pin sharp image with a blurred one over the top of it, so you get plenty of detail showing through the gentle diffusion.

Here are some tips that can help to put the odds of success in your favour:

• Mount your camera on a tripod so it's fixed in the same position for both exposures – it must not move between exposures.

• When you take the sharply focused pictures, stop your lens down to a small aperture, then open the lens up to its maximum aperture for the de-focused shot.

• Overexpose each exposure so that when they're combined on the same frame you get a perfectly exposed picture. Experiment with overexposure from ½ to 1 stop.

◄◄ Blurred guardsmen

While lining up this shot of Changing the Guard at Buckingham Palace in London, I noticed that the guards looked interesting when out of focus because they were reduced to simple, colourful shapes that were still easily identifiable. Keen to come away with something different from a much-photographed event, I decided this was the one!

NIKON F90X HANDHELD, 80–200MM ZOOM LENS AT 200MM, FUJI VELVIA, ½₂₅₀ SEC AT F/2.8

◄ Daisy field

The normal procedure when shooting scenic pictures with a wide-angle lens is to maximize depth of field (see pages 48–49) so everything is sharp. But who says you have to? On this occasion I decided to break the rules and throw the flowers nearest the camera out of focus by moving in really close to them, focusing on infinity and shooting with my lens at its widest aperture. The result is unusual and eye-catching. Well, I think so!

NIKON F5 HANDHELD, 28MM LENS, POLARIZER, FUJI VELVIA, ½₂₅₀ SEC AT F/2.8

• Experiment with different levels of de-focus on the second exposure. Shoot a variety of pictures, starting with the lens just out of focus and gradually throwing the image out of focus.

• Also, experiment with de-focusing by focusing the lens closer to the camera than it needs to be, and further away.

If your camera doesn't have a double exposure facility, take two shots of the same scene on slide film, one sharp and one de-focused, then sandwich the two slides together in the same mount. Remember to overexpose each slide as you would if producing a double exposure.

TOP TIPS

• Experiment with different levels of de-focus, as this can make a big difference to the final image
• Focus the lens closer, and also further away to see how it produces a different effect
• Stick to bold subjects and bright colours when shooting normal de-focused pictures, and set your lens to its widest aperture so depth of field is minimal

Focus on **action**

The two most important skills you need when shooting action are timing and focusing. There's little point in timing a shot to perfection only to find that your subject is out of focus. Accurate focusing is difficult because you will often be using a telephoto lens at its widest aperture. Two different focusing techniques can be used: pre-focusing and follow-focusing.

What you need

Camera A 35mm SLR is the best type of camera to use for action photography
Lenses Long lenses are often required for sporting events, though you can take stunning pictures of everyday action subjects with moderate focal lengths and wide-angle lenses
Accessories A monopod is handy for supporting long telephoto lenses

Pre-focus on subjects that follow a predictable path

This technique involves focusing on a point that you know your subject will pass, such as a bend in a racetrack, a hurdle, a canoeist's slalom gate, or the crossbar on a high jump. All you do then is wait until your subject approaches and trip the shutter just before it reaches that point and snaps into sharp focus.

It's important to shoot just before your subject snaps into focus because your brain takes a fraction of a second to tell your finger to hit the shutter release, then there's another fractional delay before the shutter opens and the exposure is made. Therefore if your subject is already sharp when you decide to fire, by the time you do, it may well have passed the point you pre-focused on. The faster the subject is moving, the more likely this is.

The points generally chosen for pre-focusing tend to be places where the pace of action is slowed down, so you stand a better chance of capturing a perfect shot and can use a slower shutter speed. Motorcyclists often travel at 150mph on a straight section of track, for instance, but at a corner that speed will be halved so they're easier to capture on film – and many subjects look more dramatic when they're cornering.

Follow-focusing keeps your subject in focus at all times

Where the movement of your subject is less predictable, and therefore pre-focusing is out of the question, you will need to employ follow-focusing.

This option involves tracking your subject with the camera and continually adjusting focus to keep it sharp so that when the action reaches its peak you're ready to capture it on film.

Follow-focusing may sound straightforward enough, but it's actually quite difficult and takes lots of skill to do consistently well – you need to know which way to adjust focus on the lens if your subject moves towards or away from you, and you must regulate the pace of adjustment to keep up with your subject.

The only way to master this is by practising. You could stand by the edge of a busy road and spend a while follow-focusing cars coming towards you. Some photographers do

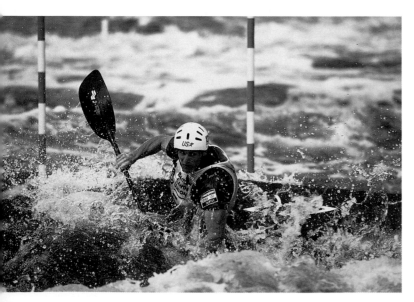

◄ White water
Although the photographer could roughly predict the course of the kayaker as he negotiated the slalom circuit, he still had to follow-focus in order to keep his subject sharp in the viewfinder until the crucial moment. Pictures like this make follow-focusing look easy, until you try it and realize it's far from that!
NIKON F90X HANDHELD, 300MM LENS AND 1.4X TELECONVERTER, FUJICHROME PROVIA 100, 1/750 SEC AT F/4

► Motocross
If you can predict where your subject is going to be at a certain time with a reasonable degree of accuracy, you can pre-focus on a point and wait for your subject to reach it. Taking frame-filling pictures like this still requires great skill, though, because with any sporting event things don't always go to plan and a fraction of a second can make all the difference.
NIKON F4S HANDHELD, 400MM LENS, FUJICHROME RDP100, 1/500 SEC AT F/5.6

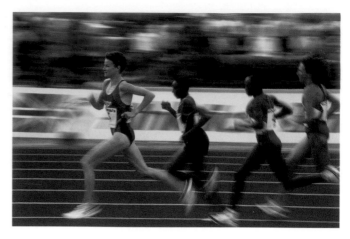

▲ **Runners**
Panning shots like this often require you to follow-focus in order to keep your main subject sharp, and to trip the shutter while moving the camera and focusing. Naturally, practice makes perfect.

NIKON F90X HANDHELD, 300MM LENS, FUJI PROVIA 100, ⅟₃₀ SEC AT F/8

◀ **Cricketer**
Autofocusing can come in handy for some sport and action subjects. Here, for example, the cricketer was running in a straight line, so providing the photographer kept the focusing sensor in his camera's viewfinder over the main subject, the autofocusing would have been able to keep up with the action.

NIKON F4S, 500MM LENS, FUJICHROME PROVIA 100, ⅟₅₀₀ SEC AT F/5.6

this with no film in the camera, though the problem with this is you have no way of telling if what you're doing is working.

A better option is to load up with the cheapest black-and-white film you have, then process it and examine the negatives with a magnifier to see if you managed to keep your subject sharp. You needn't go to the expense of making prints.

Is autofocusing any good for action?

If you own an autofocus SLR you can always make use of the autofocusing to increase your chance of success. The latest AF SLRs, especially professional models such as the Nikon F5 and Canon EOS 1V, boast superb autofocusing that's both fast and accurate – which is why just about every pro sports photographer you're likely to meet will have one or the other.

In situations where you need to follow-focus, a good AF system should be able to track your subject in Servo mode, keeping it sharply focused at all times so you can capture the peak of the action or shoot sequences of pictures using the camera's motordrive. That said, don't expect them to be totally foolproof. If you're tracking a soccer player, for example, and

another player runs across his path – or he changes pace and moves outside the camera's focusing sensors – then there's a strong possibility that the autofocusing will hunt or lock on to something else and you'll miss the shot.

In situations where you need to pre-focus, manual focusing is still the best option because it means you don't need to be locked on to a specific point, and having determined the point of focus and focused on it, you're then free to re-compose the shot as required once your subject heads towards you.

TOP TIPS

- Taking perfectly focused pictures of fast-moving subjects is tricky, so don't expect to become an expert overnight – practise, practise and practise some more
- Don't think that by using a fast motordrive you are guaranteed to get a perfect shot – you still need to get your timing spot-on
- Local sporting events offer great opportunities to get close to the action and perfect your focusing skills

Chapter four
colour

▶ **Sunflower**

PENTAX 67, 135MM
MACRO LENS,
EXTENSION TUBE,
TRIPOD, CABLE RELEASE,
FUJI VELVIA, ⅛ SEC AT F/4

Harmony and **discord**

The easiest way to understand colour is by studying a colour 'wheel' which contains all the colours of the spectrum. Primary colours are pure hues – red, green and blue. If you have a light source in each of these colours, it's possible to create any other colour. If you combine all three, the result is white light.

Complementary and secondary colours

Complementary colours lie opposite the primaries on a colour wheel – cyan, magenta and yellow. Mixing a primary colour with its opposing complementary colour creates grey. Secondary colours are formed by mixing two other colours together to form shades like orange and violet.

When you take a picture these colours are formed by colour layers in the emulsion. The layers comprise the primary colours of cyan, magenta and yellow, so these colours in reality record the brightest because they require only one dye layer. Complementary colours are formed by the combination of two layers – yellow and magenta form red, for example – so a wide variety of shades is possible. Secondary colours are formed by a combination of all three layers, so their brightness is never as strong. They're also the most difficult to record – violet often comes out pink, for example.

▲ Colour wheel
This illustration of a colour wheel shows where different colours are in the spectrum in relation to each other. Those near each other harmonize, and those opposite contrast.

What you need

Camera Any type of camera can be used – you just need to find the colours

Lenses Use wide-angle lenses to fill the frame with colour from close range, or juxtapose different elements in a scene to create the effect you want. Telephoto or telezoom lenses allow you to pick out colours that are further away, or to compress perspective so that areas of colour appear closer together

Film Use slow-speed film (ISO 50–100) to make the most of bold, contrasting colours, and faster films (ISO 400+) for more evocative images that use harmonious, limited and monochromatic colour

Accessories Use a polarizing filter to maximize colour strength, plus warm-up and cool filters to emphasize monochromatic colour

Colours that harmonize

Those colours that lie close to each other on the colour wheel harmonize. Blue and green, green and yellow, red and magenta, orange and yellow – all are immediate neighbours so they harmonize. Also, any of the colours on the warm side of the colour wheel – magenta, red, orange and yellow – work well together, as do all colours on the cooler side – blue, violet, green. Pictures containing harmonious colour are more relaxing to look at and easier on the eye – they have a calming effect, rather than challenging our visual senses.

You can also take successful pictures of scenes that comprise just one colour, or the same colour but in different shades. Soft, hazy light tends to create this effect in nature by bringing the colours in a scene closer together – especially during early evening, when the light is warm.

Before sunrise and also in dull, overcast weather you can witness a similar effect, only this time the light is diffuse, so colours appear more muted, and they tend to take on the cool colour temperature of the light itself. You can also find man-made evidence of this – a building painted in different shades of the same colour, for example, can make a great study in colour harmony.

In situations where colour saturation is reduced, either by the quality of light or through use of soft hues by man, even

▲ Woodland with river

Similar colours harmonize beautifully to produce very soothing, restful images. The greens, yellows and soft browns in this autumnal woodland scene are all close together on the colour wheel, so the overall effect is one of harmony.

HORSEMAN WOODMAN 5X4IN FIELD CAMERA, 90MM F/4.5 LENS, POLARIZING AND 81C WARM-UP FILTERS, TRIPOD, CABLE RELEASE, FUJI VELVIA, 1 SEC AT F/22

◄ Tulips

Whether colours harmonize or contrast is often dependent on how strong those colours are. In this delicate, backlit picture of tulips the colours harmonize because they are weak, but had the colours been much stronger it would be a different story – especially given the blue in the background and the warmer colours in the flowers.

NIKON F90X, 105MM MACRO LENS, FUJI PROVIA 400, TRIPOD, CABLE RELEASE, 1/250 SEC AT F/4

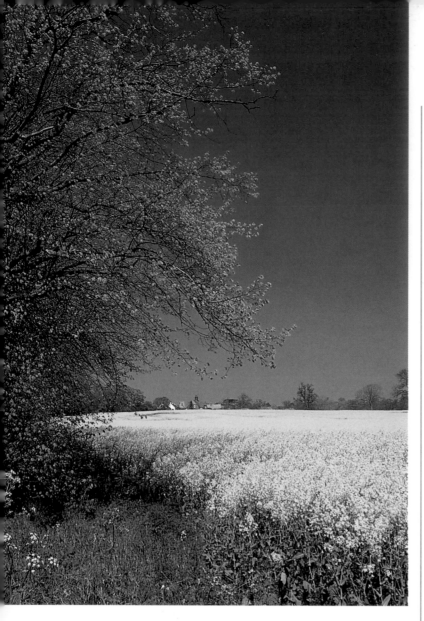

those colours that normally contrast will appear to harmonize because the feeling presented is usually one of tranquillity and calm – so we are encouraged to feel relaxed by the colours rather than challenged and tense.

The softer the colours, the more pronounced this harmony becomes, until we reach a stage where the overall effect is almost monochromatic. Pictures that make use of this have a compelling simplicity that can be highly evocative.

Weather conditions create this effect more than anything else in the natural world. When the sun is obscured by haze or pollution in the morning or evening, the landscape takes on a delicate golden glow that looks beautiful in its subtlety.

Mist and fog have a similar effect, draining strength from the colours in a scene – although the tone created is usually cool rather than warm, because light at the red end of the spectrum is filtered out.

Of course, in these situations, where colour is naturally reduced to monochromatic tones, you can emphasize the effect using filters. Keep them subtle, though, otherwise you will destroy the effect – 81-series warm-up filters are ideal for adding to the warmth of a scene, while the 82 series of pale blue filters will do the same job on cooler scenes.

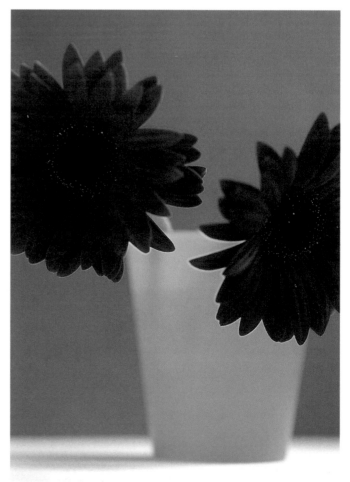

▲ Tree in yellow field

One of the strongest colour contrasts are created when blue and yellow appear together and both colours are strong and deeply saturated. In the landscape, this potent combination can be found on a sunny day when vibrant oil-seed rape or mustard flowers bask beneath a deep blue sky. Use a polarizer to maximize colour saturation.

OLYMPUS OM4-TI HANDHELD, 21MM LENS, POLARIZER, FUJI VELVIA, ⅟₆₀ SEC AT F/8

► Red flowers in green vase

Colours opposite each other on the colour wheel contrast, and the brighter those colours are, the greater this is. Knowing that green and red are opposites, I set up this shot specifically to create a colour contrast, using green – a receding colour – as the background, and red – an advancing colour – in the foreground. The result is a simple, bold and striking picture.

NIKON F90X, 105MM MACRO LENS, WINDOW LIGHT, TRIPOD, CABLE RELEASE, FUJI VELVIA, ⅟₃₀ SEC AT F/4

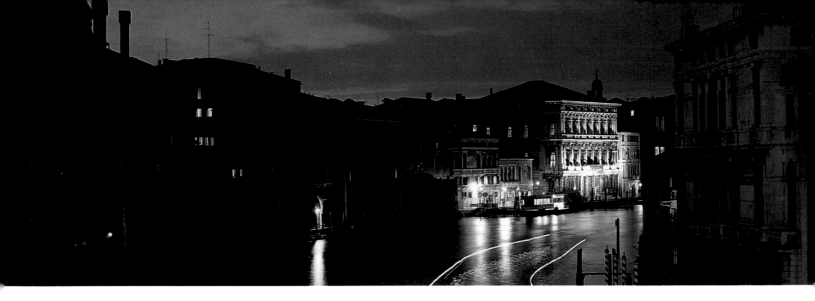

Colours that contrast

While colour harmony helps us to produce soothing, relaxing pictures, contrasting colour does the opposite – it produces bold, dramatic effects that attract our attention and challenge our visual senses. Strong colours excite and stimulate, so when you include two strong colours that clash and compete for attention, the effect is amplified and startling pictures result.

The key is to keep things simple. Ideally, stick to just two colours – certainly no more than three – otherwise the effect will be weakened. And make sure those colours are opposite each other on the colour wheel – any warm colour, such as red or yellow, will clash violently with any cool colour, such as blue or green. The strongest colour contrast you can get is blue and green, but with any combination, the more vibrant and saturated those colours – especially if all are of the same or a similar brightness – the more potent the contrast will be. For example, deep blue against pale yellow won't work as well as deep blue against deep yellow, and vice versa.

These contrasts are usually the easiest to find on a small scale – a red flower surrounded by the lush green of sunlit grass; a yellow door or yellow car against the bright blue sky. You can also set them up easily – place a yellow bucket against a blue door, or a red car against a green hedge.

The effect works best when the cooler colour is in the background and the warmer colour up front. This is because cooler colours are said to recede, because they remind us of the sky, sea and open space, whereas warmer colours advance and appear to leap from the picture towards us.

For the best results, shoot in bright, sunny weather and use a polarizing filter to reduce glare so saturation is increased (see page 62). The light around midday is the harshest and most intense, with short, black shadows, but colour contrast at this time of day can be most effective – especially in towns and cities, where you will find colour in bold, graphic blocks.

Make the most of unreal colour

The visual impact of a photograph can be great if the colours contained in it neither harmonize nor conflict but are unusual.

▲ The Grand Canal, Venice

One of the great joys of night photography is that you can never tell how certain light sources will record on film, and the results are often a pleasant surprise. In this view along Venice's Grand Canal we have greens, reds, and yellows, all competing for attention and adding interest to the picture.

HASSELBLAD XPAN, 90MM LENS, TRIPOD, CABLE RELEASE, FUJI VELVIA, 30 SEC AT F/11

This is often the case when you're shooting outdoors at night – the use of artificial illumination in towns and cities creates a surreal palette of colour that would never occur naturally, no matter how hard you looked. In a single street scene you can find the vivid green of fluorescent lighting, the yellow of tungsten, the red of neon and so on, all of which appear vibrant against the ever-fading ambient light, all competing for equal attention.

Our eyes adapt to these different types of lighting, so a floodlit building or a shimmering cityscape may seem quite normal when we look at it. But film records the colour of each source as it really is, so when our pictures come back from the processing lab we're often surprised to see vivid colours that we never expected. This is one of the things that makes night photography so interesting.

Make the most of this by using viewpoint and different lenses to juxtapose different colours in an effective way. A telephoto lens stacks up illuminated signs along a busy street, while a wide-angle lens allows you to pull different elements together in the same shot – a spotlit statue against a floodlit building, or a street light next to a brightly lit tower.

TOP TIPS

- You're more likely to find vibrant colour contrasts in urban areas, where scenes are ever-changing and there's always lots of colour around
- The countryside and coastline are where to look for harmonious colour combinations – most of nature's colours harmonize
- Most colours will contrast with each other when they are strong, and harmonize when they are weak

Saturation **point**

Strong colours make for powerful images, especially with bold, graphic subjects such as architecture, abstracts and flowers. The question is, what can you do to make sure the colours in your pictures are as rich and saturated as possible? Film choice and quality of light play an important role, but there are other techniques at your disposal, too.

Choose a colourful film

The type of film you use can have a big impact on how strong the colours in a picture are, simply because different brands of film record colour in different ways. Film speed should also be considered – the slower it is (the lower the ISO), the stronger the colours will usually be – and it's generally accepted that colour slide (transparency) film will give richer colours than colour print film.

In terms of specific films, Fujichrome Velvia is considered the ultimate when it comes to strong colours, so if you stick to this film you won't go far wrong. Others that you could try out are Fujichrome Provia 100F and Sensia II 100, and Kodak Elitechrome 100 Extra Colour and Ektachrome E100VS (VS stands for 'very saturated').

The quality of light can help

In bright, sunny weather, colours will look much more vibrant than they do on a dull, overcast day. Similarly, if a scene is lit frontally, with the sun beaming down over your shoulder, the colours will look stronger than if that scene is side-lit or backlit.

The time of day makes a difference, too. Colours look far stronger during early morning and late afternoon when the sun is low in the sky, than they do at midday. That's because the

light at midday is much harsher so there's more glare, and with the sun almost overhead, the shadows are dense and the highlights very bright, making it difficult for the camera to record a full range of detail.

Bright overcast weather works well on subjects that rely on delicate colours and fine details, such as autumnal woodland scenes or close-ups of foliage and flowers.

Expose for maximum saturation

If you use colour slide film, slight underexposure of $\frac{1}{3}$ or $\frac{1}{2}$ stop can increase colour saturation, so it's always a good idea to bracket exposures when you're photographing an interesting subject or scene – especially with a film like Fujichrome Velvia. You can do this using your camera's exposure compensation facility – after taking a picture at the metered exposure, set $-\frac{1}{3}$ or $-\frac{1}{2}$ and take another shot.

Use a polarizing filter

A polarizing filter can make a significant difference to colour saturation. This is because it eliminates glare on non-metallic surfaces, such as foliage or paintwork, as well as deepening blue sky and reducing reflections.

◄ Beach hut
The graphic simplicity and bold colours in this picture were emphasized first by shooting from a low angle so the beach hut was positioned against the blue sky, then by using a polarizing filter to deepen the sky and reduce glare on the painted boards.
NIKON F90X, 50MM LENS, POLARIZING FILTER, FUJI VELVIA, HANDHELD ON $\frac{1}{60}$ SEC AT F/5.6

▲ Aldeburgh, Suffolk, England

Photograph the right subject in suitable light on the best film, and vibrant colours are guaranteed. These houses on the Suffolk coast were already colourful in their own right, but bright morning sunlight, use of a polarizing filter to deepen the blue sky and reduce glare, and Fujichrome Velvia slide film made the most of the situation to produce a striking image.

NIKON F90X, 80–200MM ZOOM LENS, POLARIZER, TRIPOD, CABLE RELEASE, FUJICHROME VELVIA, ⅟₁₅ SEC AT F/11

► Rape field

This picture of an oil-seed rape field shows how the technique of duplicating the original colour slide (above) onto another roll of slide film can boost colour saturation significantly (see below).

OLYMPUS OM4-TI, 28MM LENS, JESSOP ZOOM SLIDE COPIER, OLYMPUS T32 FLASHGUN, TRIPOD, FUJICHROME VELVIA, ⅟₆₀ SEC AT F/11

▲ Poppy meadow, Tuscany

The majority of photographers still agree that if you want optimum colour saturation, there's only one film to choose – Fujichrome Velvia. It's slow at ISO 50, which means you'll be using a tripod even in bright sunlight, and especially if you're shooting through a polarizing filter. But the richness of colour, as you can see from this picture, is amazing.

PENTAX 67, 45MM LENS, POLARIZER, TRIPOD, FUJICHROME VELVIA, ¼ SEC AT F/22

The level of improvement depends mainly on the weather and lighting conditions. For the strongest effect, use your polarizer in clear, sunny conditions when there's more glare and polarized light for the filter to eliminate. Blue sky will be made deeper during the morning or afternoon, when the sun is low in the sky and when it is at 90° to the camera so you are pointing it towards the area of sky where the effect of polarization is at its maximum.

A polarizer won't do much to the sky on a dull day, but it can dramatically improve colour saturation elsewhere in the scene. I always use one when I am photographing woodland scenes, especially in autumn, because the damp atmosphere increases glare on the foliage – a polarizer cuts through it to make colours much richer.

Copy the original slide to increase colour and contrast

A drawback of duplicating colour slides onto conventional colour slide film is that you get an increase in contrast, which makes the colours in the duplicate look richer. Under normal circumstances, when you want an identical match to the original, this is an unwelcome characteristic. However, when used creatively, this boost to colour saturation can work well, allowing you to inject new life into slides that appear rather dull and uninspiring, or to really pump up the colours in slides that are already saturated.

For the best results, choose a film renowned for its rich colours, such as Fujichrome Velvia. To make the duplication use either a purpose-made slide copier and a dedicated electronic flashgun as your source of illumination, or place the original slide on a lightbox (see page 14), turn off the room lights and copy it using a 1:1 macro lens.

Try push-processing film

If you uprate a roll of colour slide film to a higher ISO you must then have it push-processed to compensate, and as with slide copying, a side effect of pushing is that you get an increase in contrast, which makes colours look punchier. This effect is particularly noticeable on films that aren't normally renowned for vibrant colours, and is a great way of giving them a much-needed boost. However, you can also use this technique on vibrant films too, such as Fujichrome Velvia, Provia and Sensia – Velvia, in particular, works well.

Doubling the recommended film speed and then having the film push-processed by 1 stop is usually enough to make a difference, so you could rate ISO 50 Fujichrome Velvia at ISO 100, or an ISO 100 film such as Kodak Elitechrome 100 at ISO 200. But you need to take care with exposure when uprating, because the increase in contrast also means that shadows will block up and highlights will burn out much more easily.

Cross-process film for stronger colours

Processing a roll of colour film in the wrong chemistry is one of the best ways to produce images with extreme colour saturation – especially if you want the pictures to look a little wacky. The effect only works if you cross-process colour slide film in C-41 chemistry, though, so don't bother processing print film in E6 slide chemistry. Any colour slide film will produce good results – my favourite is Agfachrome RSXII 100, though I have also used Fujichrome Velvia with just as much success. Experiment and see what you come up with. The technique works well both indoors and out in bright, sunny weather.

You don't need to bother with a polarizing filter, as the colours will be strong enough. In addition, because you get increased exposure latitude when treating a slide film as a print film, there's no need to bracket exposures – just rely on the exposure your camera sets, and fire away.

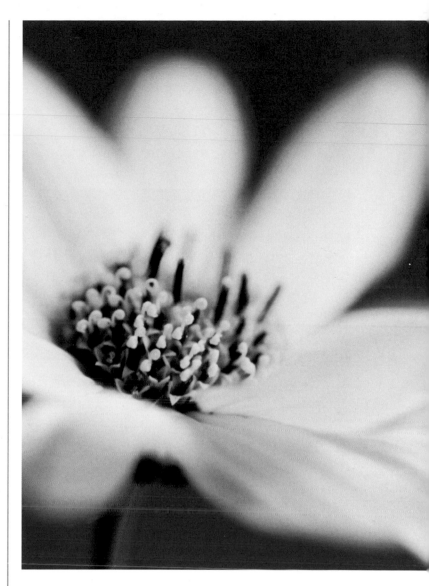

▲ Push processing

You can increase colour saturation by uprating and push-processing colour film. This shot shows the type of results you can expect by rating Fujichrome Velvia at ISO 100, then asking your lab to push it by 1 stop. The increase in contrast that results makes colours look bolder, and though grain size is increased a little too, the difference is negligible.

NIKON F90X, 105MM MACRO LENS, FUJICHROME VELVIA RATED AT ISO 100 AND PUSHED 1 STOP, 1/60 SEC AT F/2.8

TOP TIPS

- Stick to bold, graphic subjects that suit strong colours
- Combine several of the techniques outlined in this chapter – Fujichrome Velvia exposed in bright sunlight with a polarizer is hard to beat
- Look for subjects that are naturally colourful, then set about making those colours as saturated as possible
- Shoot contrasting colours such as blue and yellow for maximum impact (see page 61)

Symbolic **colour**

One of the most useful properties of colour is its power to convey different moods and emotions. Like music, colour is an instantaneous experience – the hues and shades are just like the chords and scales that tap into our psyche and control our emotions – and photographs that exploit colour symbolically can have a very powerful effect.

▲ Venetian columns
Despite the fact that it occupies a small part of the picture area, the vivid blood red of the costume stands out boldly.

NIKON F90X, 80–200MM ZOOM LENS AT 135MM, TRIPOD, CABLE RELEASE, FUJI VELVIA, ¹⁄₆₀ SEC AT F/4

What you need
Camera Any type of camera can be used to capture colour – your eye for a picture is more important
Lenses Any focal length – use wide-angle lenses to fill the frame with colour from close range, and telephotos or telezooms to pick out splashes of colour that are further away from the camera
Film Slow-speed colour slide film is the best choice
Accessories Polarizing filter, red, blue, green and yellow filters add colour casts

Red is for danger, anger, excitement, sex...
Red is the loudmouth colour. It stands out like a sore thumb against any other in the spectrum. Red reminds us of blood, passion, danger and heat, and leaps out wherever it appears.

From a positive photographic point of view, red attracts attention and it can dominate a picture, even in very small amount. A single red tulip among a sea of yellow flowers will be the most obvious element in the picture, providing a useful focal point. Equally, if you include something in a shot that's red, it can spoil the whole picture because the minute you realize it's there, you won't be able to take your eyes off it.

Pictures that are composed mainly or totally of red create tension and excitement because they set subconscious alarm bells ringing – think of 'red with rage' or 'like a red rag to a bull'.

▶ **St Mark's square, Venice**
A blue 80A filter added to the blue colour cast to this scene, transforming the mood of the image and giving it a much more sombre feel.

NIKON F5, 80–200MM ZOOM LENS AT 85MM, BLUE 80A FILTER, TRIPOD, CABLE RELEASE, ⅕ SEC AT F/16

▶ **Spring scene**
This lush spring landscape is bursting with life and vitality thanks to the vibrant green of the fields and trees – it makes you want to jump with joy.

OLYMPUS OM4-TI, 200MM LENS, POLARIZING FILTER, TRIPOD, CABLE RELEASE, FUJI VELVIA, ⅛ SEC AT F/16

Blue is a colour with two faces...

Blue can mean different things. On the one hand it's a tranquil, serene, self-assured, regal, authoritative, stable colour – 'blue blood' is a term used to describe royalty; a policeman's uniform is blue. It's also symbolic of freshness, the sky, the sea, and wide open spaces.

On the other hand, blue can be a cold, sad colour symbolic of depression, loneliness and coldness. It can be a moody, mysterious, secretive colour. Think of the way blue is used to express our senses – 'feeling blue', or 'blue with cold'.

A polarizing filter is ideal for enhancing the colour of sea and sky in sunny weather. Use a blue filter such an 80A or 80B to give pictures taken in mist, fog and low light a cold blue cast.

Green is the colour of nature...

Green suggests freshness, new life and purity. It's a relaxing, soothing colour that reminds us of forests, fields and rolling hills. Again, a polarizing filter will saturate the greens in the landscape and woodland to emphasize this effect – spring is an ideal time of year to photograph the greens of nature as new growth bursts forth with freshness and vitality.

A green filter that is normally intended to control contrast in black-and-white photography, can be used to give your pictures a deep green cast. This can work well on shots that

consist solely of green subject matter – such as the patchwork effect of green fields in the landscape. But use it with caution, as the natural colour is often rich enough and the addition of a colour cast can produce an effect that's over the top.

Yellow is the colour of the sun...

It's also the colour of corn, gold and lemons. It's a powerful, comforting colour, symbolic of joy, happiness and richness, and it advances, like red, so that photographically it's a very potent colour – think of the yellow orb of the setting sun.

A yellow filter can be used to emphasize the warm glow at sunrise or sunset. The effect will be strong, but it won't appear unnatural. But you don't need to use filters to make the most of this colour because it's eye-catching enough all on its own. So keep your eyes peeled for yellow – a crate of lemons or bananas in a market, a door painted bright yellow, a bright yellow taxi in the bustle of a hot city.

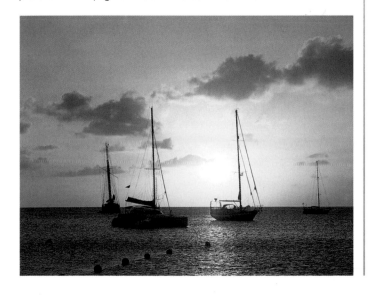

◀ **Fishing boats**
Yellow and orange make us feel warm and cosy because they remind us of the sun and heat. Pictures taken at sunrise and sunset therefore have a guaranteed feel-good factor.

PENTAX 67, 165MM LENS, 81C WARM-UP FILTER, TRIPOD, CABLE RELEASE, FUJI VELVIA, ¹⁄₁₂₅ SEC AT F/11

Abstract **colour**

Every time we lift a camera to our eye we create an abstract because we are consciously deciding which part of the bigger scene to frame and photograph. However, the term 'abstract' is normally applied to photographs and paintings that gain appeal not from the subject matter depicted, but from the colours, shapes, patterns and textures contained within them.

What you need

Camera Any type – it's your eye for a good abstract that counts
Lenses Use wide-angles and telephotos to fill the frame with blocks of colour that are both nearby and in the distance
Film Use slow-speed colour film (ISO 50–100) to make the most of abstract colour, and colour infrared film to create bizarre abstract images
Accessories A polarizing filter to saturate colours

Using colour creatively

Being able to identify the subject of the picture is secondary to the visual appeal of the elements from which it is created. Colour is one of the most powerful tools available to the abstract photographer because it can produce great pictures in its own right. And this opens up a whole new avenue of creativity because it allows you to capture colour on film for colour's sake, looking into scenes and seeing things that other people have missed – a red bicycle leaning against a white wall, or the vivid yellow of a crane against deep blue sky.

Take a step back from reality

A good way to put this into practice is by composing your pictures in a more unconventional way. We normally frame a subject or scene so there's a sense of balance and logic to it – the viewer can look at the picture and identify the contents.

However, by breaking the rules and framing more tightly so there's no context, or cropping so that part of the subject is missing, you immediately add intrigue to the picture and give it a more abstract feel.

The key is to make the colours more important than the subject. An obvious example of this would be to photograph colourful, rippled reflections in water but exclude the very thing that's causing the reflection. Suddenly, the colours and shapes in the reflection become the whole focus of the photograph and we take a step away from reality.

Towns and cities are great places to look for abstracts, simply because the streets are an ever-changing palette of colour. Markets are worth checking out, too, for their colourful displays, and busy harbours where fishing nets, orange buoys, brightly painted boats and vivid reflections all make

great subjects. Some places are also purpose-made for colourful abstracts – the island of Burano in the Venetian lagoon and the village of Oia on the Greek island of Santorini are just two examples of where locals paint their homes in brilliant colours, and you can't fail to take great shots just by spending an hour or two wandering around the streets with your camera at the ready.

Sometimes the pictures will be obvious, but often you have to seek them out, shooting from high or low viewpoints so as to juxtapose certain colours in the way you want, or using different lenses – telephotos to compress perspective and pull colours together, wide-angles to exploit colours at closer range or to capture colours against the sky.

The soft light of overcast days can work in your favour, reducing everything to two dimensions so scenes lack depth and you can capture blocks of colour with no obvious space between them. That said, nothing beats full sun to make colours come to life, and you are more likely to notice abstract colour in sunny weather because it will stand out.

In terms of using specific colours together, you have a free rein when shooting abstracts. It doesn't matter if the colours harmonize or contrast. In fact, you can ignore all the rules of colour photography because the whole point of producing abstract images is that you want to excite, challenge, disturb and stimulate the visual senses of the viewer.

TOP TIPS

- Keep an open mind – abstract photography is about seeing the potential in things that other people miss
- Try to take a step back from reality and look at colours instead of objects
- Don't worry about being able to identify the subject matter in your pictures – that's not the point of abstract photography

▶ Colourful world

This collection of pictures shows how colour can be used in an abstract way. In some cases the subject matter is obvious, in others not so. But that's irrelevant – it's the colours that count, and whether you look at each image individually, or all eleven as a single abstract image, the effect is striking.

NIKON F90X AND F5, 50MM, 80–200MM AND 105MM MACRO LENSES, TRIPOD, CABLE RELEASE, FUJI VELVIA, VARIOUS EXPOSURES

▲ ▶ Beach houses (above) and boy with mask (right)
These pictures show the kind of bizarre effects that can be produced using Kodak Ektachrome EIR colour infrared film. In both cases the subject matter is nothing unusual, but the pictures are, thanks to the wacky way in which the film records colour.

NIKON F90X, 28MM LENS, YELLOW FILTER, TRIPOD, CABLE RELEASE, KODAK EKTACHROME EIR COLOUR INFRARED, ⅟₆₀ SEC AT F/11

Using colour infrared film

Loading your camera with colour infrared film is a great way to create colourful abstract images. Being sensitive mainly to infrared radiation, which we can't see with the naked eye, it captures colours in a completely different way to that we're accustomed to. Green foliage comes out bright magenta or deep blood red, water goes black, pale colours turn a ghostly white – everything you need to produce striking images that make the viewer do a double-take and wonder how you achieved such bizarre results.

Only one type of colour infrared film is available – Kodak Ektachrome EIR. Load and unload it in complete darkness, rate it anywhere between ISO 400 and ISO 640, and use a yellow filter to get the best results, metering with it on the lens. Shoot in bright sunlight for the strongest effects, and bracket exposures at least 1 stop over and under the metered exposure. A polarizer used with a yellow filter will produce even bolder colours, and you can also experiment with red, orange and sepia filters .

Chapter five
darkroom

▶ **Bait digger,
Teign Estuary,
Devon**

OLYMPUS OM1N, 135MM
LENS, ILFORD FR4,
HANDHELD ON ½₅₀SEC
AT F/8

Image **interpretation**

While colour photography offers little room for change (unless you use digital manipulation), when working in black-and-white you can achieve a range of different interpretations of an image in the darkroom. You may have already visualized how you want a print to look, but you can change your mind and come up with something completely different.

What you need

Negative A black-and-white negative that has been well exposed and correctly developed so it contains a good range of detail and tones
Materials Variable contrast printing paper, toning kits (sepia, selenium, gold, blue), dodging and burning aids

One negative, four prints

The way you print a negative depends on many factors, not least the type of subject or scene you have photographed, the quality of the light at the time the picture was taken, the contrast of the negative and, most important of all, the mood that you wish to convey. With a little imagination and a willingness to experiment, however, you can produce a whole range of images, all with a completely different feel, from a single negative. This is achieved using basic darkroom controls and techniques:

1. Print exposure

'Correct' exposure is a subjective term, because the exposure you feel gives the best print isn't necessarily the correct one from a technical point of view. Giving a print more exposure so that it comes out darker will add drama, while giving it less exposure will produce a more high-key, tranquil effect. Make a series of prints at different exposures, then decide which one you prefer. They may all work in their own way.

2. Contrast grade

The aim of most photographers is to produce negatives that print well on a 'normal' paper grade – usually grade 2 or grade 2½. Reducing the grade to 1½ or 1 will lower contrast to give a flatter tonal range with no pure blacks or whites, while printing harder – anything from grades 3 to 5 – will increase contrast so you get deeper blacks, brighter highlights and fewer mid-tones.

3. Dodging and burning in

Dodging and burning in, to darken or lighten certain parts of an image, is often necessary in order to record a full range of detail, or to achieve tonal balance. However, you can also use these techniques for effect, burning in a sky much more than

necessary so it appears darker and more dramatic, or dodging highlights so they come out even lighter. Either approach can significantly alter the mood of an image.

4. Print toning

Toning adds the final touch to a print, but the type of toner you choose can change the mood of that print completely, as can the density of tone. Partial toning has a more gentle effect, while using toners at full strength to add stronger colours gives a bold feel. Similarly, the warmth of toners such as sepia, selenium (with some papers), gold and copper adds a soothing, tranquil feel, while blue toner is cooler and more mysterious.

TOP TIPS

- Be willing to experiment with different contrast grades – this can have a significant effect on the mood of the final print
- If you make prints that you feel are too light or too dark, try to rescue them by toning. Sepia toner will slightly lighten a print that's too dark, while blue toning makes light prints appear a little darker
- Intentionally over- or underexpose a print to change its mood, and burn in the sky to give a more dramatic effect

▶ Derwentwater, Lake District, England

These photographs were all printed from the same negative during the same darkroom session, but are different in terms of mood and impact.

From the top down, initially I printed the image at grade II to record a soft range of tones with no pure blacks or whites. This is how the scene appeared to me when the photograph was taken. I partially bleached, then toned the print in weak sepia to add the warm colouring.

Feeling that a more dramatic effect was possible, I then made a series of prints at grade IV. This boosted the contrast considerably to give the impression of stormy weather. I then went even further by giving the print about 50% too much exposure at grade IV, to produce a much darker, more threatening image. This was partially bleached and toned in sepia before being toned in gold.

Finally, returning to one of the earlier prints that had been partially sepia toned, I immersed it in gold toner for around 30 min until the whole image had taken on this rich tone.

HASSELBLAD XPAN, 45MM LENS, TRIPOD, CABLE RELEASE, AGFAPAN APX25, 1 SEC AT F/22.

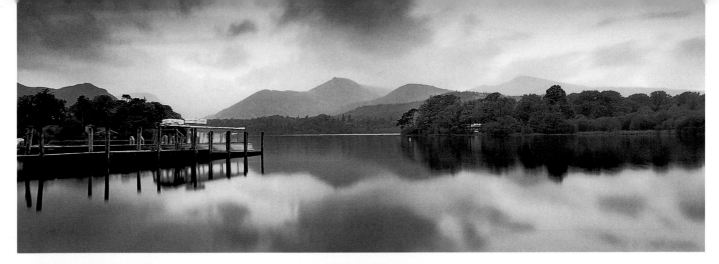

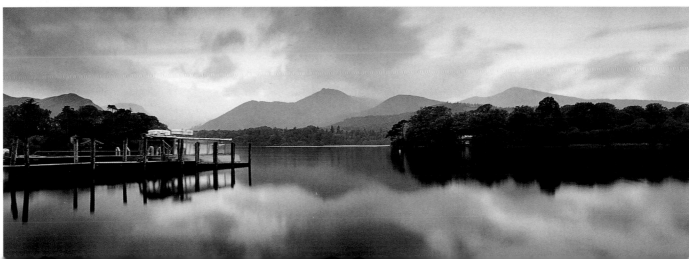

Print-**toning**

Although I love working in black-and-white, many of my prints end up being toned in various ways because I feel the addition of subtle colours can enhance a monochrome image. A range of different toners is available to do this. The effect produced depends partly on the way the toner is used, but also the printing paper, so they offer lots of scope for experiment.

Which toner should you use?
• Selenium toner
This makes the print archivally permanent, but the toning effect can be very subtle.

With normal bromide papers there's little or no colour shift, but shadow density (D-max) is improved to give richer blacks, while warm-toned chlorobromide papers, such as Agfa Multi-contrast Classic and Ilford Multigrade Warm Tone, give much warmer results. Start with the manufacturer's suggested dilution, but then vary it to see what happens. It works best with fibre-based (FB) papers.

• Sepia toner
This toner creates a warm/brown hue. Modern sepia kits are thiourea-based and use an additive that allows you to vary the depth of tone from very subtle to dark brown. It's a two-bath process – the print is bleached, then after washing is immersed in the toner bath for a few minutes.

For very subtle toning, use the bleach made up at half the recommended strength. This is necessary if you want to tone in another colour after sepia. Prints toned in sepia appear a little lighter than the original untoned print.

Sepia toning is is at its most attractive when it is used to produce very subtle toning.

What you need

Prints Both fibre-based and resin-coated papers can be toned, but the effects vary from paper to paper

Print trays You need one tray for each toner bath plus two for water baths

Timer Toning by eye is fine, but a timer will tell you how long a print has been in the toner or other baths

Toning kits Take your pick – most colours are readily available from high street photo stores

• Blue toner
A one-bath process that adds a blue colour to your prints. Just place the print in the bath of toner, and when you're happy with the colour, remove and wash. The longer you leave the print in the toner, the deeper the blue. Blue-toning affects the shadows first, then the highlights, so it's a good choice for split-toning (see below). It also makes the print appear a little darker than the untoned original.

• Gold toner
This toner works by coating the silver in the print emulsion with gold, making the image archivally safe. It's an expensive toner and comes as a working solution already mixed up.

Bromide prints that have previously been untoned tend to go a little cooler in gold, while chlorobromide papers develop a cool blue colouring in gold – the warmer the original print, the bluer the tone.

• Copper toner
The colouring you get can be anything from pink to red, depending on the type of printing paper you use, the dilution of the toner, and the amount of time the image is toned for. The longer you leave a print in the toner, the richer the colour will become. Like sepia, copper toner tends to lighten the image, so begin with a print that's darker than you would normally use.

◄ **Thatched cottage**
Copper toner produces an attractive pinky-red tone when it is used on a previously untoned print. To cool the shadows, place a copper-toned print in a tray of print fixer. In order to create a reddish tone, place the copper-toned print in sepia toner without bleaching first.
OLYMPUS OM4-TI HANDHELD, 28MM LENS, ILFORD HP5 PLUS, ⅟₆₀ SEC AT F/11

▼ Wet promenade

Blue toning adds a stark coldness to black-and-white prints. For a subtle effect like this, use double the recommended amount of water so the toner bath is dilute and takes longer to tone the print.

NIKON F90X HANDHELD, 28MM LENS, FUJI NEOPAN 1600, ⅟₁₂₅ SEC AT F/8

TOP TIPS

- Always wash a print thoroughly after fixing to prevent staining during toning
- Soak fibre-based prints in clean water for a minute or two prior to toning, and wash prints for at least 5 min after toning – especially those made on fibre-based papers

Split-toning a print

Don't feel that you must tone a print to completion – by partially toning it so some areas are affected and others not, you can produce more subtle results.

When sepia-toning, for example, the highlights are affected first by the toner, then the mid-tones and finally the shadows; so if you bleach the print partially rather than fully, so that only the highlights begin to fade, when the print is toned it means that only the highlights and lighter mid-tones will warm up while the shadows are left alone. This is best achieved by diluting the bleach bath with at least double the amount of water than recommended, so the bleaching is slowed down, then removing the print from the bleach after maybe just 30 sec.

Selenium toner affects the darkest areas of the image first and the highlights last, as does blue toner, while copper and gold toners work in the same way as sepia and affect the highlights first.

Using more than one toner

If you know which areas of the print will be affected first by different toners, you can use two together for attractive effects.

▲ Derwentwater, Lake District, England

Sepia toner is ideal for adding warmth to an image, though the most attractive results are produced when you bleach for just 25% or so of the time that is recommended, so only the highlights and lighter mid-tones are affected, and add a small amount of toner to the bath so the colouring is quite subtle. After partial sepia-toning of this print, it was washed then immersed in blue toner for 1 min or so to cool down the shadows.

NIKON F90X, 17–35MM SIGMA ZOOM LENS AT 20MM, TRIPOD, CABLE RELEASE, ORANGE FILTER, AGFAPAN APX 400, ¼ SEC AT F/22

Partial sepia-toning followed by blue gives cool blue shadows, warm highlights and blue/green mid-tones.

Partial sepia followed by selenium gives an attractive duo-tone effect on chlorobromide (warmtone) papers.

Partial sepia followed by partial gold gives pinky highlights and warm mid-tones, and then when immersed in blue gives cool shadows.

Copper-toning followed by blue gives reddish highlights and blue shadows.

The key is not to overdo any one toner, otherwise the others may not work. You should also wash the print thoroughly between toners to prevent contamination.

Hand-colouring **prints**

Hand-colouring is a fascinating technique. It has a unique ability to give modern subjects a wonderful old-fashioned feel, and the subtlety and delicateness of a well-produced hand-coloured print just can't be matched by anything colour film has to offer. The process also offers tremendous scope for creativity – you can totally alter the mood of a picture.

▲ After the harvest

This is the kind of wonderful effect you can achieve by hand-colouring black-and-white prints with oils. The photographer, Kathy Harcom, chose strong colours to convey the life and energy of summer sunshine in the hayfield on the day she took the picture.

OLYMPUS OM2N HANDHELD, 28MM LENS, KODAK HIE MONO INFRARED, RED FILTER, ⅟₆₀ SEC AT F/16

Choosing the right kind of print

The first step is to select a suitable print. Ideally it must exhibit a full range of tones but not have too much solid black, which is difficult to colour. Making prints specifically for colouring is a good idea, because that way you can print them a little lighter than normal. Toning the print with sepia or selenium toner to give it an overall background warmth can also help.

Matt or semi-matt fibre-based papers are the best because the colour bleeds into the emulsion, whereas with glossy and resin-coated products it forms a separate layer on the surface and can look odd. In terms of print size, many photographers prefer to use 40.5x30.5cm (16x12in) or 51x40.5cm (20x16in) because it gives them a larger 'canvas' to work on.

Which materials should you use?

Water-soluble photographic dyes are the most popular materials for hand-colouring because you can dilute them easily in water to obtain very subtle shades. They also have a special delicacy and luminosity that make them ideal for the job. The only disadvantage with dyes is they soak into the print emulsion very rapidly and can't be removed if mistakes are made.

A cheaper alternative is to use food dyes. Only a few colours are available, but you can mix them to obtain a wider variety of shades, and they can be washed off with a sponge if you make a mistake.

Other materials to try include oil paint, gouache, pencils, coloured inks, crayons and felt-tipped pens, the latter being ideal for adding vibrant dashes of colour.

How to hand-colour a print

If you're using dyes, soak the print in water for 1 min or so and put a drop of wetting agent in the water so the print stays wet for longer. This assists the absorption and distribution of the colour. Once you've done that, tape the print down on a solid, flat surface to keep it still, and place it under good lighting so you can see everything clearly and don't get eye strain.

With dyes the best method is to apply light tints and build up the colour density in thin layers. So add just a couple of drops to a small saucer of water, along with a drop of wetting agent to keep the wash wet, dip the brush in and spread the colour as quickly and evenly as possible.

Start with the large areas like the sky or background and use a medium-sized brush like a 2, or a cotton-wool bud. Test the colour on a scrap of paper first, though, and if you've got to cover large areas, mix up enough colour, as it's difficult to

achieve an identical match later. Once the large areas are complete, you can then swap to a finer brush and start tinting the smaller details, still building up the colour in thin layers.

Oils are more subtle than dyes, and you get more of the print detail showing through. They're also more forgiving, because they sit on the surface of the print and can be rubbed off if a mistake is made.

Place tiny dabs of colour on a palette then moisten a brush in turpentine, pick up some paint and mix it to the density required – the more paint you have, the stronger the colour will be. To get a different shade simply mix two or more colours together, being careful to clean your brushes between each colour.

Apply the paint carefully using a brush or cotton-wool bud, covering larger areas first. To tone down colours and give the paint a more even finish, rub it into the print with a cotton-wool bud. Oil paint takes at least 24 hours to dry.

▲ **Romany Church**
The subtle colours reflect the tranquillity of this church as Kathy Harcom photographed it. Marshall's oils were applied to Kentmere Art Classic paper.
OLYMPUS OM2N HANDHELD, 28MM LENS, KODAK HIE MONO INFRARED, RED FILTER, 1⁄15 SEC AT F/16

Creating lith **prints**

Lith printing is a fascinating technique that many photographers consider trying, but avoid because it seems shrouded in mystery and very hit and miss. Although it does require a different approach to conventional printing and demands lots of patience, it's actually quite straightforward, and after your first few attempts it's possible to produce successful results.

Overexpose then underdevelop

The basic approach to lith printing is that you grossly overexpose a black-and-white print then process it in very dilute lith developer until an image appears. You have to watch the print carefully as it develops, then when you feel the image formed is acceptable, snatch the print quickly from the developer and place it into a tray of stop bath to stop the development.

What makes lith printing tricky is the fact that you may wait for 5 min or more for any image to appear on the print, but then it progresses at an alarming rate, starting with the darkest areas first, and you may have just a second or two to snatch it from the developer and get it into the stop bath before the image is too dark. This process is known as infectious development, and the reason why lith printers use very weak developer is so that the process is slowed down sufficiently to give them a chance to snatch the print before it's too late.

How to make a lith print

Having set up your darkroom equipment as normal, select a negative you want to work with, clean and place it in the enlarger. Any type of film suits lith printing – including colour negative film – though mono infrared works particularly well.

Step 1 Mix up the lith developer, which comes in two parts. The manufacturer's recommendation may be one part A to four

parts water and the same for part B. Try one part A plus nine parts water, the same with part B, then mix the two together.

Step 2 Mix up a smaller quantity of normal print developer and place it in a measuring jug or graduate. This is for your test strip.

Step 3 Taking a strip of the paper you're going to use for lith printing, make an exposure test strip as normal and develop it in the standard print developer you have mixed. After fixing, turn on the room lights, look at the strip, and then choose an exposure that's roughly correct for the highlights or mid-tones.

Step 4 If the 'correct' exposure for a normal print is 8 sec at f/8, for the lith print increase this by 3 or 4 stops initially – to 64 sec or 128 sec at f/8 – and use that as your starting point. You needn't be too exact here, and can adjust the exposure for subsequent prints if necessary.

Step 5 Expose the print, then slide it into the tray of lith developer and agitate continuously throughout development. It may take 5 min or more for an image to begin to appear. Watch for dark areas to begin to emerge. Deciding when to snatch the print is tricky under a safelight, so I use a small torch with a red gel taped over it to check occasionally.

Step 6 When you feel the image has sufficient density, quickly remove it from the developer and put it straight into the stop bath without waiting for the print to drain, otherwise it will continue to develop.

◀ **Gondolas**
Lith printing can also produce delicate, dreamy effects – you just need to get the balance right between print exposure and development. To reduce contrast so the lighter tones emerge with, or very soon after the blacks, increase the print exposure time.

NIKKON F5 HANDHELD, 17–35MM ZOOM LENS AT 35MM, AGFAPAN APX 400, ⅟₂₅₀ SEC AT F/11

Step 7 Once it is in the fixer the image may go lighter as any milkiness clears, so the chances are your first print will be too light. You will get used to making an assessment under safelight conditions, however, and will build in a factor for this lightening.

Step 8 Once the print has dried it will appear slightly darker than when wet. You will also notice that the print colour has changed, perhaps from buff to pinky. This varies depending on the paper.

TOP TIPS

• Don't expect perfect results straightaway – experiment by making sets of prints from the same negative, varying the print exposure time and the length of time the prints spend in the developer to see how this affects print colour, contrast and image density

• The longer the print exposure, the lower the contrast; the shorter the print exposure the higher the contrast

• You will get better results from lith developer after you've made a few prints rather than when it's fresh. Alternatively, mix some exhausted developer with fresh at a dilution of 1:4 or 1:5

• Lith prints respond well to toning, producing some amazing colour changes (see pages 74–75)

▲ Staithes, North Yorkshire, England
These pictures show the kind of bold, dramatic effect you can achieve with lith printing. The smaller picture was made on normal Ilford Multigrade paper, while the bigger picture was made on Kentmere Kentona paper and developed in Fotospeed Lith Developer diluted Part A and Part B both 1:10 with water. Print exposure was 32 sec at f/8, and development time was around 5 min.

NIKON F90X, 28MM LENS, TRIPOD, CABLE RELEASE, ILFORD HP5 PLUS, 1/30 SEC AT F/8

Soft-focus **printing**

Although you can add soft focus effects to black-and-white pictures at the taking stage, the results are far more pleasing – and infinitely more controllable – if you do it at the printing stage instead. This allows you to tailor the effect to suit each specific photograph, rather than being limited to one effect for everything.

▲ Holy Island 1

This is a dreamy effect you can achieve by printing through a soft-focus filter. The filter – a Cokin Diffuser 1 – was left in place for the duration of the exposure, and the print was then split-toned in sepia then gold.

HASSELBLAD XPAN, 45MM LENS, TRIPOD, CABLE RELEASE, ILFORD HP5 PLUS, ½ SEC AT F/22

What you need

Darkroom All the usual equipment required to make black-and-white prints

Accessories Various types of purpose-made or DIY soft-focus filters, large sheets of tissue paper and a sheet of clean glass slightly bigger than the print size you will be working with

How to add soft focus to a print

The procedure I use to make a soft-focus print is very straightforward. The negative is selected and cleaned, and the enlarger set up as it would be for any printing session. My Durst enlarger has a swing-in red safety filter that you can position under the lens. However, as I never use this I removed the red filter lens some time ago, so I'm left with a circular frame that sits under the enlarger lens and provides a platform on which I can rest a soft-focus filter.

Having selected the filter I want to use – I prefer a Cokin Diffuser 1 for general use – it's placed on the swing-in filter frame so the negative is projected through it onto the masking frame. I then focus the image as normal using a focus finder, and make a test strip to determine correct exposure.

▲ **Holy Island 2**
Printing through tissue paper, the pattern of the creases and the fibres in the paper add a wonderful textural quality to the picture.
OLYMPUS OM2n, 50MM LENS, TRIPOD, CABLE RELEASE, ILFORD PAN F,
⅕ SEC AT F/4

Printing through tissue paper

Another option is to print the image through tissue paper. Take a large sheet of white tissue paper, screw it into a tight ball, then unfurl the ball and flatten it out. This gives you a flat sheet full of fine lines and creases. Lay the tissue paper on top of the printing paper, keeping the two in contact with a sheet of clean glass, and expose as normal so the final print is diffused and also shows the pattern of creases from the tissue paper.

What I have found when printing through a soft focus filter is that image contrast is reduced a little, as you would expect – so to avoid wishy-washy prints I tend to increase the contrast by half to a full grade.

I usually leave the filter in place for the full exposure, but for a more subtle effect it can be removed partway through the exposure. To gauge the effect of doing this, make a series of test strips but instead of varying the exposure time, vary the length of time the filter is in the enlarger's light path for each one, then choose the one you prefer for the final print.

Using different soft-focus materials

Purpose-made soft-focus filters designed primarily for use on your camera lens are the easiest option. I use a Cokin Diffuser

1 as I like the effect it produces, though any soft-focus or diffusion filter from any manufacturer will work – it just depends on what effect you want.

If you don't have a soft-focus filter, make your own. A piece of black stocking material stretched over the enlarger lens or a card frame will give an attractive effect. Another technique worth trying is to apply some hair spray or some Spraymount adhesive to a clear filter, such as an old skylight filter or a small piece of clean glass or clear plastic. If you have several blank filters, vary the amount of spray on each to give different results. I also like the effect you get using the frosted half of an anti-Newton glass slide mount – GePe 6x6cm glass mounts are ideal. The frosted back of a polyester slide mask sleeve gives a similar effect.

Part two
creative subjects

Chapter six
people in camera

► **Ruis**

NIKON F5, 28MM LENS,
AGFACHROME RSX II 100
CROSS-PROCESSED,
1/500 SEC AT F/4

Capture **emotion**

What's the most memorable picture you've ever seen? Whatever your answer, the pictures that make an indelible impression will almost certainly share two common factors – people and emotion. Emotion is the most powerful tool at your disposal as a portrait photographer, simply because it's a universal language we can all relate to.

Emotion is everywhere

The situation your subject is in tends to dictate the kind of emotions that are likely to be witnessed. If you go along to a political demonstration, anger, shock, surprise and confusion can be expected, while a wedding, birthday or family get-together will be filled with joy and happiness. Sporting events are also great places to see the whole gamut of human emotions on display, the crowd's mood swinging like a pendulum depending upon how the game is going.

You can capture a wide range of emotions on an everyday level. Just going for a walk down the street can be a very rewarding experience if you keep your eyes peeled and your camera at the ready. Look for people greeting each other, couples hugging and kissing, old men chatting on a street corner, kids playing, an irate motorist arguing with a traffic warden. Take the time to do a little people-watching and you'll see emotion is everywhere, every minute of the day.

Don't smile – you're on candid camera

If you're photographing strangers, the easiest way to capture emotion is by taking a candid approach. You need to keep a low profile, wait for the right moment, then grab the shot without anyone realizing what's going on.

A telephoto lens comes in handy here, allowing you to shoot from a distance and reduce the risk of being spotted. For

What you need

Camera Any type is suitable – the most important factor is being able to capture brief moments before they're lost forever, and a 35mm SLR or compact is idea for that

Lenses A short telephoto (85–135mm) is ideal for posed portraits, while longer telephotos and wide-angle lenses are useful for street and reportage photography

general use a 200mm lens or a 70–210mm telezoom should be fine, although something a little longer wouldn't go amiss.

Wide-angle lenses can also be useful in crowds for taking more intimate, close-range pictures. Often there's less chance of being spotted if you adopt this approach, because you won't stand out, and if you are seen, the people whom you're photographing will also tend to accept your presence.

Timing is crucial. We identify emotion through our facial expression and body language, so you need to be ready to quickly trip the shutter when your subjects are at their most expressive. To concentrate all attention on your subject, set your lens to a wide aperture such as f/4 or f/5.6, so that the background is thrown well out of focus, and compose the shot so any distracting details are excluded from the frame.

Capturing emotion in posed portraits

In a more formal portrait situation you have to encourage your subject to display emotion, rather than simply waiting for something to happen. Professional models can change their emotions quickly and effortlessly, but the kind of people we are likely to photograph won't have the same ability, so you will need to help them along.

◄ Candid camera
If you wander the streets with your camera you will see all manner of emotions on display, both positive and negative. This man in London's Trafalgar Square was clearly unhappy about something, and photographer Chris Rout was ready to capture his animated expression on film without him even realizing there was a camera pointing in his direction.
CANON EOS1N HANDHELD, 70–200MM ZOOM LENS, FUJI VELVIA, 1/250 SEC AT F/2.8

Communication is the key. Your subject's emotions can be controlled to a certain extent by the things you say and the topic of conversation, so try to find out what they're interested in, what they dislike, or what upsets them. If a person admits to being passionate about animals, for example, you can generate positive or negative emotions by the way you talk about them.

Communication is also important because it helps your subjects relax and takes their mind off the camera. Most people tend to be very nervous when they're being photographed, but once that barrier has been broken down their emotions will flow much more freely, giving you the chance to capture their natural expressions.

Seize the moment and shoot portraits when your subject is in particularly high spirits – they may have just received some wonderful news, won an award, or decided to get married. In those situations you won't have to try very hard to capture emotion, because it will come over naturally.

▶ Joyous bride

Weddings provide you with lots of opportunities to capture emotion because they're such happy events – though tears tend to flow as much as smiles. All you have to do is keep a low profile, watch the goings on and grab pictures when you can. Here, Paul Cooper captured a wonderful expression on the bride's face as a wedding guest whispered something in her ear.

NIKON D1X DIGITAL CAMERA HANDHELD, 28–70MM ZOOM LENS AT 70MM, CHIP SPEED SET TO ISO 400, ¹/₁₀₀ SEC AT F/9, IMAGE CONVERTED TO BLACK AND WHITE IN ADOBE PHOTOSHOP

▲ Mother and baby

Love is the strongest emotion we display, and in this tender portrait it shines through in both the baby's and mother's faces. The interaction between people – especially babies or children with adults – offers great opportunities to capture emotion, and even though you may need to set up the situation, what happens after that is usually completely natural – as here.

OLYMPUS OM2 HANDHELD, 135MM LENS, ILFORD HP5 PLUS, ¹/₁₂₅ SEC AT F/8

Portraits that **tell a story**

Most of the portraits we take are shot from close range so the subject fills all or most of the frame. This is a logical approach – the person depicted is the main subject, so we don't want other things in the picture to take attention away from them. However, you can produce more interesting and revealing portraits by taking a step back and including the environment.

Capturing character

By adding the surroundings you will tell the viewer a lot about your subject, especially if they are photographed in a location of their choosing, because it will reveal clues about their character, personality and lifestyle.

For example, if you photograph a teenage girl in her bedroom, surrounded by all her personal possessions, we can immediately see if she's tidy or organized, who her favourite pop idols are, if she fancies football stars, and so on. Similarly, a head-and-shoulders portrait of an old man, while interesting in its own right, will take on a different meaning if you pan out to show his chosen environment, whether it is his allotment, workshop, garden or whatever.

◀ **Nib**
This is Nib, a tractor breaker from Lincolnshire. Photographer Rod Edwards was in the area taking pictures when he got chatting to the owner of the business and spotted Nib having a quiet cigarette. After a little cajoling, Nib agreed to be photographed, and Rod captured this wonderful study in black and white.
MAMIYA 645 SUPER, 55MM LENS, TRIPOD, CABLE RELEASE, AGFAPAN APX 25, ⅛ SEC AT F/8

What you need
Camera Any type or format of camera can be used for environmental portraits, from a compact up
Lenses Wide-angle lenses are ideal because you can shoot from closer range to maintain contact with your subject, but still get a lot in the shot. A 35mm or 28mm is perfect. A 50mm standard lens can also be used if you don't want such a wide view
Film Black and white is a great medium for environmental portraits, as it will give your pictures a raw simplicity. There will be lots going on in the picture anyway, and colour can sometimes push it over the edge. That said, you can take great portraits in colour as well. Use slow-speed film outdoors (ISO100) and faster film indoors (ISO400+)

The environment is all-important

Taking environmental portraits is actually easier than conventional pictures of people because your subjects' surroundings contribute as much to the success of the picture as they do. Also, people tend to feel more relaxed in a familiar environment, and you don't need to work from such close range, so the whole process is less intimidating for them.

The best way to get started in environmental portraiture is by setting yourself a project that involves shooting in an interesting location – you could make regular visits to your local allotments over a period of time, for example, and photograph the people there in their treasured plots of land. Or why not visit a harbour and photograph the fishermen at work on their boats on the quayside?

Choosing the environment and then finding potential subjects in it tends to be the most productive way of working because the environment is the key, and by choosing one that you know will make an interesting backdrop, half the battle is

won. In addition, by shooting in a place where there are plenty of people you will have a good choice of subjects.

Having decided where to shoot, your next step is then to look for specific areas that would make good backdrops to your portraits, before asking anyone if they would mind posing. Alternatively, you could approach the person, then quickly try to find a good spot.

Most people will be flattered by your request, especially if you're polite and offer them a print for their co-operation. At the same time, be aware that in working environments people are also busy and may not take too kindly to a photographer pestering them. If you choose such an environment, it might we worth going along without a camera first and asking if it would be OK to take some pictures.

▲ **Moroccan man**
While exploring the souks of Marrakech, I came across an area known as Rahba Kedima, where there are numerous herbal and apothecary stalls displaying and selling all manner of goods – including dead animals! While taking a look at this stall, the owner wandered out, so I asked if I could photograph him. He said yes, but wasn't really interested and let me get on with what I was doing while he looked around. Using a wide-angle zoom, I was able to compose the scene, so I got much of the stall in the picture, as well as its characterful owner. The resulting portrait is much more interesting than if I'd simply taken a head-and-shoulders picture of the man.

NIKON F90X HANDHELD, 17–35MM ZOOM LENS AT 28MM, FUJI SENSIA II 100, 1/60 SEC AT F/8

TOP TIPS

- Why not shoot a series of environmental portraits showing people in their place of work? By depicting your subject at work you can say a lot about them, and the environment will make for interesting pictures
- Everyone has an environment they feel most comfortable in, so use this as the basis for your portraits – a teenager in his bedroom, an old farmer outside his cottage, a scrap merchant surrounded by crushed cars
- Although you are including your subject's surroundings, make sure they don't intrude too much and overshadow the person

Keep it simple
Try to keep the composition fairly simple, but don't be afraid to include things that tell a story about your subject – that's the whole point of environmental portraiture. It comes down to the usual rules, really – avoid having things growing out of your subject's head or body, such as trees or lamp-posts, and if you're using a wide-angle lens to include a lot of information in the picture, keep your subject away from the edges of the frame, where distortion is at its worst – with lenses wider than 28mm, your subject's body will look very strange indeed. The central part of the picture area is the best place for wide-angle portraits, as distortion is minimal.

Indoors, use available light where you can. Windowlight is ideal, as it's often very atmospheric, though the poor lighting you get in old workshops and storerooms – such as a single bare lightbulb overhead – can produce really effective results. The warm glow cast from furnaces and fires can also add interest to your pictures.

If you need to add your own light in really dim interiors, a flashgun bounced off a wall or ceiling can work well, though if you're shooting on colour film remember that flash bounced off a coloured surface will take on that colour, so stick to white surfaces wherever possible. Outdoors, overcast days produce wonderful light for portraiture – especially if you're shooting in black and white.

Shoot for **sex appeal**

Sex has never gone out of fashion. It's virtually impossible to pick up a men's or women's magazine that doesn't have at least one lavishly illustrated article on sex inside, or glossy spreads full of sexy pictures of beautiful people. The way in which sex and eroticism is being depicted and promoted has changed dramatically in recent years, however, and photography is hugely responsible for this.

The changing scene
Gone are the days when the main credentials a model needed were a big chest and come-to-bed eyes. We're now in an era of creative and wonderfully evocative images that portray the human body as a beautiful object of desire, rather than a means of cheap titillation. Even black-and-white photography is enjoying a new-found popularity, as more and more people discover its artistic merits.

What you need
Camera A 35mm SLR is ideal because it's so flexible and quick to use. Medium format is useful if you intend making big enlargements, but it's not essential

Lenses A 50mm standard and 85mm or 105mm short telephoto are the most useful

Film Fast film (ISO 400+) is often preferred for erotic photography because the coarse grain and muted colour rendition adds lots of atmosphere, while the high ISO gives reasonable exposures in low light. Black and white is an ideal medium for erotic and nude photography

Accessories Warm-up filters to make your subject's skin more attractive, soft-focus filters to add mood, a tripod to keep your camera steady, and reflectors to control the light

The underlying message is the same, of course, but it's delivered in a much more tasteful and imaginative way. And that's the key to success with erotic and nude photography – imagination and curiosity. It's easy to take cheap pictures of a model baring all for the camera -– you only have to look at the top shelf of any newsagents to see that. But to capture the power of sexual desire without being blatant or offensive is much more challenging, and at the same time gives you endless creative options.

Photographing the human body
The nude is a subject that has inspired and challenged photographers ever since the birth of photography itself. There's something very sensual about the human body, with its gentle curves, shady hollows and soft texture, and when

◄ Less is more
Nudity doesn't always mean sexy. Often a picture is much more evocative if your model is partly dressed, because it leaves more to the imagination – especially if she's wearing sexy underwear to show off her beautiful body, as here. Photographer Bjorn Thomassen used windowlighting for this picture, posing the model in front of a large window so the light flooding in reduced her body to a semi-silhouette.
BRONICA ETRS1, 150MM LENS, TRIPOD, CABLE RELEASE, KODAK TMAX 100, 1/30 SEC AT F/11

photographed carefully it has both immense erotic power and great aesthetic beauty. This is life in its most basic form, with no hidden agenda.

To take successful nude pictures your subject needn't be blatantly naked, although if you examine the work of the great nude photographers you'll notice that often their subjects adopt a pose which conceals their genitals, simply because it isn't necessary to see them. Alternatively, if they are visible they're played down, so the rest of the body becomes the focus of attention.

With its many different elements you can photograph the nude in a number of ways, and still end up with an erotic image. Your subject could simply be one feature in a large and elaborate set, for example, or you could make their body the basis of the whole shot.

Then there's the abstract approach, where different parts of the body are isolated: the breasts, the buttocks, the legs, the graceful sweep of the back, the neck. With careful lighting and composition, even the simplest shots can have great erotic power.

Just remember that most people, professional models excluded, feel incredibly vulnerable and nervous when they're being photographed in the nude. So make an effort to keep the shoot relaxed, offer your subject plenty of feedback, and

▲ Reclining nude

Nudes don't have to be explicit or gratuitous to be sexy, as this beautiful study in light and shade by Umit Ulgen shows. The gentle curves of the woman's body have been emphasized by simple lighting, and the fact that her face is hidden lends a certain anonymity to the picture, which allows the viewer to imagine it being anyone. Shooting in black and white has also distilled the image down to its simplest form, while printing through greaseproof paper added a fine-art feel to the print. All in all, a picture that oozes sex appeal.

NIKON F501, 35–70MM ZOOM LENS, TRIPOD, CABLE RELEASE, ILFORD HP5, 1/30 SEC AT F/8

TOP TIPS

- It's not how much your subject shows that makes a great erotic picture – it's the lighting, facial expression and pose that count
- Try to keep things simple – unnecessary props or complicated lighting set-ups make your life more difficult
- Don't stick with one idea for too long. Vary the pose, location and lighting so you produce a varied selection of pictures

▲ Covering up

If your subject feels uncomfortable about posing nude, drape a translucent material, such as voile, net curtain or muslin, over her body. She will feel less vulnerable, but the pictures you take will still hint at nudity because we can see through the material. Here, Umit Ulgen went for a high-key effect, and the result is a wonderfully delicate figure study that makes the model look as if she were fashioned from porcelain.

SINAR 5X4, 150MM LENS, TRIPOD, CABLE RELEASE, POLAROID 55, 1/60 SEC AT F/16

take regular breaks – it can get mighty cold when you're standing around for ages in your birthday suit.

Leave something to the imagination

Erotic photography is by no means dependent on your subject being completely naked. In fact, in many ways the opposite holds true – by leaving something to the imagination you can produce a far more evocative result.

Underwear can be incredibly erotic without looking cheap and tacky. A woman wearing sexy lingerie, or just a baggy mans' shirt, for example, can look far more alluring than one who's wearing nothing at all. With men a pair of designer briefs or a strategically held towel will have a similar effect, revealing enough but leaving the viewer wanting more.

Clothes can also be highly erotic if your subject has an attractive body. Many men dream about women in short, tight-fitting dresses, while lots of women love men in tight jeans and casual shirts that show off their torso – they're the ideal image of how most of us would like to look.

Finally, you can create erotic results by using props to partially hide your subject. A veil of delicate fabric, such as organdie or muslin, will reveal the curves and outline of a woman's body beautifully, but at the same time obscure detail so you know there's a naked body beneath it, though you can't actually see anything.

Suggestion is the key to success – tell half the story, then leave the rest to the viewer's imagination.

Experimenting with light

The quality of light contributes an enormous amount to the mood and look of an erotic picture, so it needs to be given serious consideration from the very beginning.

As a general rule, if you keep it warm, soft and simple you won't go far wrong. Indoors you can produce beautiful results using nothing more than the light flooding in through a window. Shoot on an overcast day, and pose your subject side on or facing the window so the diffuse light emphasizes the gentle curves of the body. A couple of white reflectors will come in handy here, for bouncing light into the shadows, and a warm-up filter gets rid of any coolness in the light.

Early morning or late afternoon windowlight is equally effective. Not only does the warm cast make your subject's skin glow, but raking shadows can be used to add mystery and mood. If the light's too harsh, soften it by covering the window with muslin, net curtains or tracing paper.

Taking warm light a few steps further, you can produce superb results by using just a couple of unfiltered tungsten spotlights or reading lamps. The warm, cosy glow from an open fire or candle flame also creates the perfect setting in which to shoot nudes or erotic portraits.

If you have access to studio lighting your options are broadened, but avoid the temptation to be too clever. Most photographers use just one or two lights fitted with large softboxes to imitate the gentle effect of windowlight. Snoots and spotlights can also be used for more directional illumination that picks out certain parts of your subject's body.

Shooting outdoors is another option, but you're at the mercy of Mother Nature and you need to be very discreet – photographing a nude model in the full gaze of the public could land you in trouble. Avoid this by choosing locations where you're unlikely to be disturbed, such as private gardens, woodland and open countryside.

The soft light of a dull, overcast day is ideal for portraits and nude studies. Working in the shade is another option – the light there will be more flattering than out in the open.

The only time bright sunlight is worth pursuing is early or late in the day, when its sumptuous warmth can be used to great effect. The first couple of hours after sunrise and the last hour before sunset are the most fruitful, so make sure you're on location and ready to take advantage of them.

Think about backgrounds

What appears behind your subject in a picture can make all
the difference. Fussy backgrounds should be avoided because
they take attention away from your subject, whereas simple
backdrops will do the opposite.

If you're shooting indoors, plain walls in muted colours are
ideal because they're unobtrusive. The texture of peeling
wallpaper or crumbling plasterwork inside old buildings can
also make excellent backgrounds.

Alternatively, create your own background. A sheet of
black velvet will prove invaluable if you don't want anything but
your subject's body to be seen. White or pale colours will lift
the tonal range of the picture for more dreamy, high-key
results. Use anything from sheets of background paper to
fabrics such as muslin, gauze, an old parachute or just a
simple cotton sheet. Fabrics work particularly well because the
gentle folds make the background more interesting and will
add to the mood of the picture. Old canvas is another option –
either the real thing or purpose-made photographic backdrops.

▲ Simple and sexy

Had the model posed topless for this picture, the end result would have been
a tasteful glamour shot. However, the addition of a gossamer-thin top changes
the mood of the picture completely. We can still see her breasts, even though
they're covered up, and this makes the picture far more alluring. Note how the
model's face is also hidden. This simplifies the image and forces us to
concentrate on her body.

POLAROID 600SE, 75MM LENS, TRIPOD, CABLE RELEASE, POLAROID 665,
$\frac{1}{60}$ SEC AT F/11

◄ Parts of the body

Concentrating on specific parts of the your subject's body can produce great
pictures. This simple shot of a woman's buttocks and thighs has a wonderful
abstract quality. The effect has been enhanced by high-key lighting and high-
contrast printing that has reduced the image to a very limited range of tones –
only the shadow areas have recorded, while the mid-tones and highlights
are pure white.

NIKON F501, 35–70MM ZOOM LENS, TRIPOD, CABLE RELEASE, ILFORD FP4,
$\frac{1}{60}$ SEC AT F/16

Put yourself **in the picture**

Photographers are a funny bunch. We ply our kids with promises of sweets so they will pose for the camera. Family and friends have to sit patiently for hours while we try to capture their character on film. The one person we rarely photograph is ourselves – but self-portraiture can be a fascinating challenge, allowing you to depict yourself in a way no one else ever could.

Deciding how to depict yourself
The kind of portrait you produce will depend to a greater or lesser extent on how you see yourself.

You might be a deep and meaningful sort of individual, for instance, who likes to sit in a dark room contemplating the universe. Or in total contrast, maybe you're into outrageous clothes, unusual hair styles and contemporary music; the kind of person who likes to be noticed. Between these two extremes there are endless permutations. But that's the great thing about portraiture – we're all different.

Originality's the name of the game here, so don't just shoot the first ideas that come to mind. Instead, stretch your imagination to the limits and come up with something that not

What you need
Camera Any type will do, from a simple compact to the latest hi-tech SLR
Lenses There's no ideal focal length, and your choice will depend upon the idea you have in mind. For standard portraits a short telephoto is recommended, but you could also use a wide-angle or even a fish-eye lens for something more unusual
Film Black and white is the preferred medium because it's one step from reality and offers lots of potential for creative interpretation. Colour is far more literal, but it may suit your character perfectly, or the idea you have in mind. Infrared film and cross-processing are two more techniques to consider

only impresses you, but also the people who see the picture.

Think about the clothes you might wear – remember, 'we are what we wear'. Or why not pose in the nude? Think about a suitable location – indoors, outdoors, where exactly? Also, think about including any props that might offer clues about your personality. Are you a sporty type? Do you read a lot of books? Do you enjoy pottering around in a workshop or garden?

You could always ignore all the things that are normally associated with your personality and lifestyle, and go for something completely different. You might decide to hide your face and add a touch of anonymity. You could even shoot your own shadow, reducing your body to a two-dimensional shape. The choice is yours.

Choose the type of lighting
If you're going to take the picture indoors, electronic flash can help, though placing the flash on one side of the camera and firing it into a brolly or softbox will produce a better quality of light

◄ Karaoke queen
Photographers Sue Evans and Tim Robinson have produced dozens of self-portraits over the years, many of them in a tongue-in-cheek style. This picture was taken on black-and-white film and after scanning the negative into a computer it was hand-coloured digitally using Adobe Photoshop software.
MAMIYA 645, 50MM LENS, TWO TUNGSTEN LIGHTS, TRIPOD, ILFORD HP5, $\frac{1}{60}$ SEC AT F/8

► Snapshooter

The key to self portraiture is not to take yourself too seriously – fun shots tend to be far more interesting than serious studies. This is Tim posing as a tourist with his snapshot camera. The original black-and-white print was sepia-toned, then hand-coloured using food dyes (see pages 76–77).

MAMIYA 645, 50MM LENS, TWO TUNGSTEN STUDIO LIGHTS, TRIPOD, ILFORD HP5, 1/60 SEC AT F/8

than mounting the flash on your camera's hotshoe. Windowlight is another source worth using. On a dull day it's very soft and moody, while in bright, sunny conditions it's much harsher.

Getting the composition right will be your biggest problem, because once you're in front of the camera you can't really tell where you'll appear in the viewfinder, or if you're in it at all!

Placing a chair or some other prop where you intend to be in the final picture is one solution. Using a wide-angle lens is another, because its wider angle of view will give you more room for compositional error.

The easiest way, of course, is to photograph your reflection in a mirror because this allows you to see exactly what you're going to get on the final picture. It's not particularly original, though, so if you do, at least try to make the shot unique in some way. You could also photograph your reflection in other things – a car's paintwork or wheel hubs, windows, puddles and so on. To guarantee sharp results, make sure you focus on your reflection – not the surface of whatever it is that contains the reflection.

In terms of actually tripping the shutter, most cameras have

a self-timer with a delay of at least 10 sec, so you could activate it, then dash into position. The only problem with this approach is you don't have long to settle down, and unless your camera has a flashing indicator it's difficult to predict exactly when the shutter will fire.

A much better method is to get in position and trip the shutter when you're ready using a long release, which is fitted to your camera's shutter release button. Pneumatic releases are particularly useful because they extend 5m (16ft) or more. Alternatively, use an electronic release, or if your camera has one, a wireless remote release.

▲ Park portrait

Here's a much simpler approach to self-portraiture. Sue Evans held a compact camera at arm's length with the zoom set to wide-angle, and took a picture of herself. Using the camera's built-in flash brightened up the shot and made the colours bolder.

MINOLTA RIVA 70W COMPACT WITH ZOOM LENS HANDHELD, ISO400 COLOUR PRINT FILM, AUTOMATIC EXPOSURE

TOP TIPS

● Self-portraiture is supposed to be fun, so don't take it too seriously, and let your imagination run riot

● Plan each shot carefully so you know exactly what you need to do and how to overcome any problems

● Try not to compose the shot too tightly so there's less chance of you being half in and half out of the picture

● If you're having problems with the composition, ask a friend to help you out

Shoot the kids

Kids are no fools. Even toddlers of two or three know how to twist adults around their little finger, and if they don't want to do something, nothing in the world will change their mind – as you'll know to your peril if you've ever tried photographing them against their will. But it is exactly this mischievousness and unpredictability that makes kids such a rewarding subject to photograph.

Patience is a virtue

Patience is something you can never have enough of when it comes to photographing children. Lightning-quick reflexes also come in very useful, because the most rewarding photo opportunities tend to occur when you least expect them. That's why it's always a good idea to keep a camera ready, so you can grab it and fire without hesitation.

Equally important is that you let photographing your kids be an enjoyable part of family life, rather than a special occasion which involves dragging them away from what they're doing – which is usually far more fun – and dressing

What you need

Camera Keep a compact handy so you can take pictures whenever the chance arises. A 35mm SLR is better for general use

Lenses For head and shoulders portraits a short telephoto of 85–135mm is the best choice. Use a longer lens for candid and action shots, and a standard or wide-angle lens for environmental portraits

Film ISO 100 is a good speed for general use. In low light you will need faster film, ISO 400+

Filters An 81A or 81B warm-up and a soft focus will come in handy for moody portraits

Accessories A flashgun for daylight fill-in and use indoors, and a reflector to control the light

them up in their Sunday best. If you fail today there's always tomorrow, or next week.

Because children have a short attention span – particularly toddlers and infants – it's vital that you give them something to keep their active minds occupied. If you just expect them to stand around while you take pictures they will quickly lose all interest, and it will show on their faces.

Often all you need to do with toddlers is take them into the garden and give them a favourite toy to play with, or an ice-cream to lick. Pets can also work wonders and will keep a young child occupied for ages, as well as providing a source of wonder that will generate some lovely expressions.

Children through the ages

As children grow up their personalities change dramatically, so the way you approach your subject, and the type of pictures you're likely to take, depends mainly on their age.

◀ Seth

The easiest way to take natural, relaxed pictures of your kids is when they're having a good time, such as on holidays or days out. In this case my subject was enjoying a sunny summer's day on the beach, so when I approached with a camera he was more than happy to show off his sandy face. Tilting the camera to an angle added an extra twist that makes the shot fun.

NIKON F90X HANDHELD, 50MM STANDARD LENS, FUJI SENSIA II 100, ½₅₀SEC AT F/4

▲ Ruis

Babies and toddlers are easily distracted by parents or toys or things going on around them, allowing you to fire away and capture intimate portraits. Here, I asked my subject's mother, a family friend, to talk to her son and attract his attention while I moved in close with a macro lens. Diffuse sunlight outdoors created perfect illumination for his delicate skin.

NIKON F90X HANDHELD, 105MM MACRO LENS, FUJI SENSIA II 100, ¹⁄₂₅ SEC AT F/4

▼ Noah

Often the best pictures of children are those that are taken on the spur of the moment. Seeing my son having fun with his toys, I grabbed a camera that was loaded with fast film and photographed him candidly in window-light. The coarse grain of the image gives it a gritty feel that suits the situation perfectly.

NIKON F90X HANDHELD, 80-200MM ZOOM LENS, FUJI NEOPAN 1600, ¹⁄₂₅₀ SEC AT F/2.8

Babies are a joy to photograph, simply because they aren't fully aware of what you're doing so they can't lose interest or play up to the camera. Try making funny noises, pulling faces or shaking a rattle so your subject looks at the camera. You may be able to capture a smile or a look of dismay.

Babies look very beautiful and peaceful when sleeping, so as this happens a lot in the first few months you have no excuses for not taking some great pictures. Move in really close with a macro lens to fill the frame with your subject's face, and use very diffuse light and a soft-focus filter to add mood. A baby's tiny hands and feet also make great shots, and are easier to photograph when your subject is sleeping.

Nappy changing, feeding and bathtime also provide many opportunities to take interesting pictures.

Toddlers tend to make the most of the fact they can walk, and enjoy nothing more than wobbling around the house, seeing what kind of mischief they can find. Get down on your hands and knees and follow them around, snapping away as you go. They will be highly amused by your antics, so you should be able to capture a whole lot of natural, relaxed expressions.

▲ Kitty

Getting down to a child's level is a great way to capture the world from their perspective. For this shot of my daughter learning to crawl, I stretched out on the ground then waited until she reached me. She wasn't quite sure what was going on, but her perplexed expression is what makes the picture.

NIKON F90X, 28MM LENS, VIVITAR 283 FLASHGUN, AGFA SCALA BLACK-AND-WHITE TRANSPARENCY FILM, HANDHELD ON ¹⁄₁₅ SEC AT F/5.6

If you manage to get your subject relaxed – or if they're feeling tired – you may also be able to keep them in one place long enough to take some proper portraits. Keep a studio light set up in a spare room so you can use it at short notice, or make use of windowlight.

Infants By the age of five or six most children are incredibly mischievous and really don't like being told what to do, so an informal approach is recommended. Their attention spans are short, so don't expect total co-operation for more than a few minutes, but their basic lack of inhibitions will help you to capture happy expressions. Be patient, let your subject have fun, and provide something to keep them occupied.

Children of this age usually begin to develop hobbies and interests, such as fishing, collecting things, arts and crafts and so on – use these as the basis of your pictures. Infants also respond well to animals and pets.

Older children of nine or ten won't take too kindly to being bossed around, or dragged away from what they're doing, so take the camera to them. If you want their full attention, treat them as an equal and take an active interest in what they're doing. Talk to them about school, TV and hobbies, and let them get involved in the shoot.

Adolescents are at a stage in life when they're undergoing many changes, both physically and emotionally, so they tend to be the most sensitive group to photograph. You need to treat your subject with respect and understanding. Both sexes are concerned about their image, and may find posing for the camera quite daunting in all but the most informal situations.

Things like spots or possible weight problems don't help, but you can actually build your subject's self-confidence and self-esteem significantly if you take pictures that show what they would really hope to look like. Basically, make boys look tough and girls look gorgeous!

Deciding where to shoot

Placed in a formal portrait situation, surrounded by lights and staring down the black hole of your camera lens, most children tend to feel very uneasy. It's far easier to take relaxed portraits if you photograph them in a more natural environment.

Their bedroom is a perfect place because it's their own territory. Posters on the wall tell us about their heroes, while the clutter of possessions reveals their hobbies and interests. They will also feel more comfortable surrounded by their own favourite things, and be eager to show them off.

The great outdoors is another good bet, because that's where the vast majority of kids spend their free time. Anywhere from the back garden to the local park or playground can be used as a location – just look for a quiet spot where there's a simple, uncluttered background and flattering light.

As a general rule, keep the lighting soft and simple. Both daylight and windowlight are ideal. Shoot on a slightly overcast day, when the light's soft and shadowless, or during late afternoon when its warmth will make your subject's face glow. If you're forced to work in bright sunlight, step into the shade where the light will be much more flattering. Alternatively, pose your subject with their back to the sun and light their face with a burst of fill-flash or a reflector.

TOP TIPS

• Never lose your patience when photographing kids, no matter how frustrated you're feeling. If things aren't going too well, stop and take a breather, or try again another day

• Try to shoot from the child's eye-level rather than your own. The pictures will look far more natural, and your subject is likely to feel much more relaxed

• Help your subject relax by chatting to him or her, fooling around and telling jokes – become a child yourself, in other words

► Rock star

As children begin to grow up they become more self-conscious of the camera, so you need to give them a reason to pose for you. Role playing is one option – most boys want to be soccer players or rock stars. Tim Robinson's young subject went for the latter option in this picture, turning his tennis racket into a makeshift guitar and his bed into a stage. Hand-colouring the picture gives it a humorous twist.

PENTAX ME SUPER HANDHELD, 28MM LENS, TUNGSTEN LIGHT, ILFORD HP5, ¹⁄₆₀ SEC AT F/11, IMAGE HAND-COLOURED IN PHOTOSHOP

Travel **portraits**

The local people we encounter on our travels are as much a part of the country as the buildings and the landscape, so the urge to want to take pictures of them can be hard to resist – particularly in countries where the culture and dress are very different to our own, so the people look more exotic and interesting as a result.

Approaching total strangers and asking if they'd mind being photographed is quite a difficult thing to do, and even the most experienced travel photographers will often admit to feeling nervous about doing this. Fortunately, most people will be flattered by your request and more than happy to pose for pictures – especially if you promise to send them a print or two when you return home.

The key is to be polite. Also, instead of simply walking up to someone and asking them if you can take their picture, it will pay dividends if you chat to them first – talk about their country and how beautiful it is, the weather, what their name is and so on. Also tell them about yourself and where you come from. Maybe carry a few family photographs on your travels, so you can show people pictures of your children.

Breaking the ice in this way works wonders. It also gives your potential subject the chance to say no, because you need to remember that for cultural or religious reasons, some people do not like being photographed, and if you try to take pictures without their permission they may become very angry

– and you may be on the receiving end of a severe telling-off.

Once your subject has been won over, politely ask if they would mind being photographed. If they say yes, try to explain what you would like them to do, where you would like them to pose and so on. If you don't speak the language, gestures will help. In fact, using gestures and hand signals to communicate can work in your favour because most people end up laughing, and any nerves about being photographed soon disappear.

◀ Bedouin guide
On a previous trip to Morocco I was staying in a village on the edge of the Sahara Desert. While inside a local building I noticed light flooding in through an open door and realized it would be perfect for available light portraits. This local man in his blue robes happened to be passing, so I asked if he'd pose for a picture. Light levels were low, but the wide maximum aperture of a 50mm standard lens made it just possible to shoot handheld (I'd left my tripod in my room).
NIKON F90X HANDHELD, 50MM LENS, FUJI SENSIA II 100, 1/30 SEC AT F/1.8

▶ Water seller
While I was shooting the Koutoubia Minaret (in the background) early one morning in Marrakech, this water seller arrived to feed a bunch of stray cats. Seeing the potential for some great portraits, I asked if he'd mind being photographed, to which he agreed, so I spent 20 min or so taking a range of different pictures, from tight headshots to low-angle portraits like this. His colourful outfit and drinking bowls make the shot – and his smiling face.
NIKON F90X HANDHELD, 50MM STANDARD LENS, FUJI SENSIA II 100, [1]
/250 SEC AT F/4

Plan the shot before you start

It's at this point that many photographers mess up. Having found a willing subject, they shoot off a few quick pictures without thinking about the background, their subject's expression, what to include in the shot, the quality of light and all the other things that would instinctively be considered when shooting portraits back home. So before firing away, try to forget your own nerves, and think. A couple of minutes setting up the shot will be rewarded by pictures that are infinitely better.

If the light is harsh, ask your subject to step into the shade or turn their back to the sun. If the background is cluttered, look for one that isn't. Try and do as much groundwork as you can – including having the right lens on your camera, and making sure there's plenty of film left on the roll – before asking your subject to pose.

A short telephoto lens with a focal length of 85–135mm is ideal for head-and-shoulders portraits. And remember to set a wide aperture – f/2.8 or f/4 – so the background is thrown out of focus. Alternatively, switch to a wide-angle lens and include your subject's surroundings in the frame so your pictures tell a story – this 'environmental' approach to portraiture can work brilliantly (see pages 88–89).

If you intend shooting a lot of portraits on your travels, carry a small folding reflector so you can bounce light onto your subject's face – or do the same thing with a burst of fill-in flash. A newspaper can work just as well as a reflector if you're pushed, or a white wall.

In many countries the local population has realized that they can make money by posing for tourists. Whether you feel it's right to pay for pictures is a personal decision, but if you approach someone and they ask for money, be sure to agree a price first if you're to avoid problems later.

Respecting your subject

The most important thing of all is to treat your subject with both dignity and respect. A ragged shoeshine boy may look like a colourful character to you, but he'll still be a ragged shoeshine boy working hard to earn a meagre living when you're back home enjoying your holiday snaps over a glass of wine and a nice meal – so don't exploit or patronize people.

If you do, then you'll simply make it more difficult for the next photographer.

TOP TIPS

- Always treat your subjects with dignity and respect. They are human beings, just like you, and not a sideshow for travellers and tourists
- Think about your pictures before taking them if you want more than just snapshots
- Plan ahead and work quickly so your subject isn't left sitting around while you get your camera equipment ready

▲ **Seizing the moment**
While enjoying lunch by the sea on the Caribbean island of St Lucia, this young boy came paddling past on a rubber tyre innertube with a huge grin on his face. Realizing that he'd make a great subject, I grabbed my camera and took a quick shot.

NIKON F90X, 80–200MM ZOOM LENS, FUJI VELVIA, 1/250 SEC AT F5.6

Candid camera

Taking the candid approach to people photography is probably more appealing if you're nervous about approaching strangers. In some situations, such as busy markets, carnivals and processions, it may also be the only viable way to take people pictures.

A longer lens of 200–300mm will allow you to take frame-filling pictures from a reasonable distance, and you can throw cluttered backgrounds well out of focus by shooting at the widest aperture. Wide-angle lenses can also be effective in crowded situations, allowing you to shoot intimate candid shots from close range.

The key with candid photography is to be discreet. Keep a low profile, shoot quickly – and don't advertise the fact that you're a photographer.

Chapter seven
scenics

▶ **Buachaille
Etive Mor,
Scotland**

PENTAX 67, 45MM LENS,
TRIPOD, CABLE RELEASE,
POLARIZER, FUJI VELVIA,
¼ SEC AT F/22

Classic views

Name any popular travel destination in the world, and there are always classic views of it that photographers make a beeline for. Taking original pictures of these places is becoming harder and harder, but if you put your creative head on and try to see beyond the obvious, it may not be as difficult as you imagined.

Finding new ways

The key to photographing famous views and monuments is to think laterally rather than literally, and see beyond the obvious.

First, try to avoid the clichés and popular viewpoints and look for something new. That may mean doing a little walking to get away from the crowds, but your efforts will be rewarded.

Look for ways of showing your subject in a different context: frame through an archway, shoot under a tree or get down to ground level. Your lenses can be an invaluable ally here. If the classic shot is taken with a wide-angle, use a long telephoto for a more selective composition – or vice versa. Try extra-wide or extra-long lenses as well in your search for an original image, or shoot from a more adventurous viewpoint by getting down to ground level or looking for a high vantage point. Shoot from anywhere but eye-level, in other words.

The time of day that you visit can make a big difference, especially in cities. Most tourists tend to be fairly inactive until 9–10am, so set your alarm and get there at dawn. If you need access to take pictures, then obviously you'll be stuck until opening time, but most famous views are accessible at all hours.

Early morning light can put a whole new perspective on a much-photographed scene. Failing that, return at dusk. Again,

TOP TIPS

• Look at pictures in books and magazines or on websites of the location you will be visiting to see what has been done before. This will give you an idea of the classic shots and may spark fresh ideas

• There's nothing wrong with taking classic views from the same place as everyone else, but use light, lenses, filters, and film to stamp your own interpretation on them

• Don't get so wrapped up in producing original pictures that you end up with nothing that pleases you – photography is supposed to be fun!

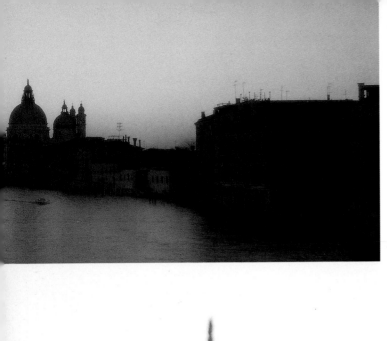

What you need

Camera A 35mm SLR is the ideal tool for creative image-making as you can use it with a wide range of lenses and accessories, plus a broad selection of film types

Lenses Take a full range, from wide-angle to telephoto. Specialist lenses, such as fisheyes, ultra-wides and long teles, can be useful for producing alternative images

Film As well as your usual stock, try something different – fast film for grainy images, colour or mono infrared, black-and-white, or cross-process colour film

Filters Again, along with polarizers, warm-ups and graduates, pack some alternative filters such as soft focus, starburst, strong colours and so on

there will be fewer people to get in your way, and the last hour or two of daylight can be stunning. Or why not take some night pictures? Many famous monuments and buildings are floodlit at night, and captured against a glowing night sky they can look stunning.

Turning to technique, why not experiment with some different filters? Use that sunset grad you've been itching to try, shoot some soft-focus pictures if the subject suits it, or use a starburst at night to turn bright points of light into dazzling stars. Zooming your lens through its whole focal length range during the exposure can produce some eyecatching results, and intentionally tilting the camera makes everything appear to lean to one side.

Alternatively, load up with a different type of film. Try some fast colour for grainy images, black-and-white or infrared, or cross-process a roll of colour film in the wrong chemicals – slide film in C41 to get contrasty colour prints, or print film in E6 to get slides with unusual colour casts.

If you know you're going to be visiting famous sights while on your travels, think carefully about how you might shoot them long before leaving home, so you can make sure you have all the right gear and materials to do a good job.

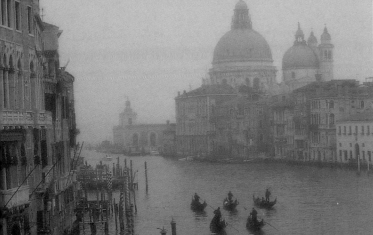

◄ Santa Maria Della Salute church, Venice

This is one of the most photographed buildings in Venice, and over the years I have taken literally hundreds of pictures of it at all times of day, in all weathers and using numerous different photographic techniques, filters and films. Here is just a small selection to give you an idea of what's possible if you put your mind to it.

NIKON F90X WITH 28MM, 50MM AND 80–200MM LENSES, AND PENTAX 67 WITH 55MM AND 165MM LENSES, TRIPOD, CABLE RELEASE, FUJICHROME VELVIA, SENSIA 100 AND SENSIA 400 RATED AT ISO 1600 THEN PUSH-PROCESSED, VARIOUS EXPOSURES AND APERTURES

The intimate landscape

When we talk of landscape photography, the images we conjure up are of pictures taken on a grand scale that capture immensity and glory. But what of the landscape at our feet? What of the many patterns, textures and details in nature – the small-scale subjects that make up the very scenes we try so desperately hard to photograph? They, too, can be the source of fascinating pictures.

Get rid of the horizon

The first step in focusing your vision to smaller aspects of the landscape is to exclude the horizon from your field of view. Including the horizon in a photograph immediately defines it as a vista because it suggests open space, and all sense of intimacy is lost. But once the horizon is gone, so too is that sense of space. Instead you are concentrating the view – and to what extent you do this is down to you.

That's the great thing about photographing the landscape on a smaller scale. One minute you can be capturing an area on film that covers many square metres; the next you are down on your hands and knees composing a detail that's just a few centimetres in size.

Scale and size no longer matter – you are entering the realms of the abstract image, where colour, texture, pattern, shape and form are the primary elements, and subject recognition takes a back seat. In fact, the picture will be more effective if the subject matter isn't recognizable, because recognition tends to make us focus on what the picture is of, rather than the elements contained within its boundaries.

Excluding any sense of scale from your pictures forces the viewer to try and imagine it, and this can lead to all sorts of fascinating interpretations. A close-up of the patterns in a rock may appear like an aerial photograph taken from thousands of metres above the earth, yet it's no bigger than your hand; the ripples in a sandy beach look surprisingly like a vast desert; a small trickle in a river could be a grand waterfall cascading over towering cliffs.

Clearly your intention is not, and should not be, to fool anyone, but by removing any sense of scale from your pictures that's exactly what can happen, and it makes those pictures all the more interesting.

Making good use of bad weather

On a more practical level, photographing details in the landscape frees you from many of the limitations imposed by the grand view.

For a start, the quality of light becomes less important. Landscape photographers often say that the focal length of their lens, or the scale of their subject, is directly proportional

What you need

Camera Any type of camera that allows close-focusing for small details
Lenses A telephoto or telezoom for isolating larger details within the landscape, and a lens that allows close focusing for smaller details. A macro lens is ideal, though close-focusing zooms are useful, too
Film Keep it slow – ISO 50–100 – for sharp, fine-grained images
Accessories A tripod and cable release for close-ups

to the weather conditions. In other words, when the weather's good and the light great, they photograph the grand view, but when it's not, they concentrate on smaller details.

Obviously, the quality of light is important when you shoot certain details – if you want to record the rough texture of tree bark, or capture the delicate ripples in sand, you need sunlight glancing across it to cast shadows. In some cases it's also the light that creates the picture – as is the case with ripples in sand, which disappear when the sun is overhead or obscured by cloud.

More often than not, however, you don't need strong, directional light to take successful pictures of details in the landscape, so when the weather takes a turn for the worse and those grand views are out of the question, you can start taking a more intimate look at the things around you.

When you do this you will also find that many different pictures can be taken in one small area. Even a single tree can be the source of numerous shots – close-ups of the tree bark, the pattern of fungi growing on its trunk, leaves backlit against the sky, gnarled roots at its base. You only have to take a few steps back and suddenly a pattern emerges in the group of trees before you.

Wander along a beach and you could spend the whole day photographing details – pebbles, driftwood, seashells, the shapes of rocks on the shore worn smooth by the action of the sea, the lines and swirls within those rocks.

Whichever way you look, there are intimate details in the landscape that can be the source of pictures just as evocative as those grand views – and, best of all, they will be unique and original to you.

▲ Landscape details

Keep your eyes peeled when you're out photographing the landscape and you will find interesting details in all manner of places. Here are just a few I've discovered myself, clockwise from top left: ripples in sand, Namibia; dry stone wall, Dartmoor; cracked mud in a dried river bed, Namibia; blades of grass in my garden; bark of the quivertree, Namibia; frosted leaves, Lake District.

NIKON F90X, 105MM MACRO OR 50MM STANDARD LENS, TRIPOD, CABLE RELEASE, FUJICHROME VELVIA, VARIOUS EXPOSURES AND APERTURES

TOP TIPS

• Get into the habit of looking for smaller details whenever you visit a location – often the discovery of one will lead to many others

• Instead of seeing details in the landscape as a less interesting alternative to vistas, make an effort to go out specifically in search of details and ignore wider views

• Learn to look at things in terms of pattern, colour, texture and form, rather than what the subject matter is

Changing **seasons**

One of the most significant factors affecting the physical appearance of the landscape, as well as prevailing weather conditions and the quality of the light, is the seasons. Spring, summer, autumn, winter – each season in our calendar brings its own unique blend of characteristics, especially in the northern hemisphere, and makes landscape photography throughout the year a joy.

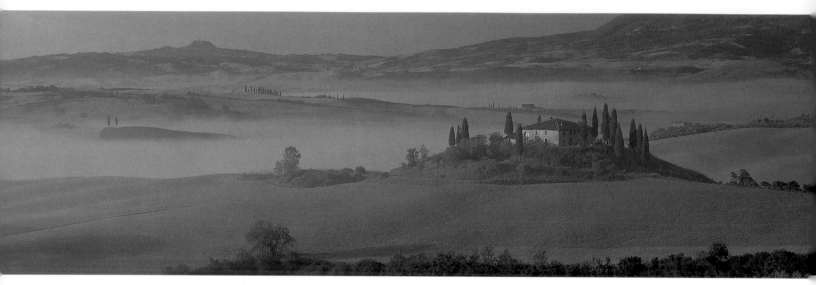

The effects of seasonal changes

It's the movement of the earth towards and away from the sun that causes seasonal changes, and these are most marked in temperate regions. The timing of the seasons is also reversed as you travel from the northern to the southern hemisphere – midsummer in the northern hemisphere falls in mid-June, but in the southern hemisphere it's midwinter at this time. Countries closest to the equator see the smallest amount of change between seasons.

The number of hours of sunlight present each day also changes throughout the year, increasing steadily each day from midwinter to midsummer, then gradually reducing again from midsummer through autumn into winter.

In the south of England the period between sunrise and sunset in midsummer can last up to 17 hours, whereas in Iceland the sun stays above the horizon for 24 hours. Similarly, in London during midwinter, daylight lasts for perhaps eight hours, but only five in northern Scotland. Countries above the Arctic Circle are in perpetual darkness throughout the winter.

The height to which the sun climbs in the sky should also be considered, as this affects the quality of the daylight and the number of hours you can be out shooting.

Contrary to popular belief, summer isn't the best season in this respect. The days may be long and the weather generally

▲ Belvedere, Tuscany

Misty mornings are common during spring, and there's no better place to capture them than Tuscany. For this picture I set out at 4.45am, then waited for over an hour for the landscape to appear as the rising sun began to burn away the all-enveloping mist lying in the valley below.

FUJI GX617 PANORAMIC CAMERA, 300MM LENS, TRIPOD, CABLE RELEASE, 81B WARM-UP FILTER, FUJI VELVIA, 1 SEC AT F/45

What you need

Camera Any type that allows you to fit different lenses and offers good exposure control. As usual, the 35mm is the most versatile choice
Lenses Carry a range of focal lengths from 28–200mm, plus a macro lens or accessories for close-ups
Film Slow-speed film for optimum image quality
Filters Polarizer, warm-ups, neutral density graduates, soft-focus
Accessories Tripod and cable release

brighter and warmer, but because the sun climbs so high in the sky and the light is so harsh, the middle hours of the day are generally unsuitable for landscape photography.

In winter, however, the sun rarely climbs more than 20° above the horizon, so although you have far fewer daylight hours, the light remains attractive throughout the day, and you

▶ **Near Montechiello, Tuscany**
Spring flowers carpet the landscape and create a riot of colour that makes perfect foreground interest for wide-angle pictures. In situations like this you can't really go wrong.

PENTAX 67, 45MM LENS, TRIPOD, CABLE RELEASE, POLARIZING FILTER, FUJI VELVIA, ¼ SEC AT F/22

can generally shoot from dawn to dusk without a break. During early spring and late autumn you can also shoot non-stop and enjoy good quality light. Visibility tends to be better than during summer too, due to the lack of haze in the atmosphere caused by high temperatures. More changeable, stormy weather also creates exciting photo opportunities at this time of year.

Spring – the dawn of new life

As the landscape awakens from the dormant months of winter, new life is evident wherever you turn. Barren trees burst with buds and blossoms, wild flowers carpet meadows and woodland floors, new crops turn fields into a patchwork quilt of lush green. Scenes that looked grey and lifeless just a few weeks ago are totally transformed.

As the weeks pass the days grow gradually longer. The sun rises at around 6am and sets at 6pm, with the sun reaching its maximum intensity between 10am and 2pm. To make the most of these conditions, rise early – dawn on a clear spring morning can be truly magical.

To capture the vibrant colour of spring flowers, shoot on a bright overcast day, rather than in full sun. The same applies with woodland scenes. In such conditions the light is soft and shadows are weak, so contrast is lower and you can record a wider range of colour and detail.

Summer – long, hot days of sunshine

Summer weather conditions vary enormously from country to country. In the UK we dream of day after day of clear blue skies

and unbroken sunshine, but rain is common and can come at any time. Head south to the Mediterranean countries, however, and the weather is more predictable – and far hotter.

Despite the fact that generally the weather is better during summer and days are longer, it's still the least popular season for landscape photography.

This is mainly because the light can be rather bland. The sun often rises and sets into a clear sky, so it's intense and there are no clouds to pick up colour from the sun's orb when it's beneath the horizon. The sun also climbs high into the sky very quickly, so within an hour or two of sunrise the light can be harsh and intense, while heat haze makes the sky look washed out rather than blue. Consequently, the number of effective hours available for landscape photography each day is reduced.

To make the most of summer you really need to be on location very early, and be prepared to stay out very late so you can take advantage of the light at either end of the day, when it's at its most attractive. During midsummer first light may appear as early as 2am, with the sun rising at 4am and setting as late as 10.30pm.

During the middle of the day the landscape tends to look rather scorched, and with the sun overhead, the light lacks modelling while shadows are short and dense. I avoid shooting landscapes in such conditions – although I will happily shoot architecture, patterns, graphic details and other subjects that benefit from strong lighting. A polarizer is also very effective on a cloudless summer's day, even with the sun overhead, so make full use of it.

◀ **Lake District, England**
Although summer landscapes have a tendency to look rather bland, successful pictures are still possible if you look for the right kind of scene. Here, I decided to crop out the hazy sky and focus attention on the vibrant green of the fields and trees. A polarizing filter increased colour saturation.

NIKON F90X, 80–200MM ZOOM LENS, TRIPOD, CABLE RELEASE, POLARIZING FILTER, FUJI VELVIA, ⅕ SEC AT F/11

▲ Rydal Water, Lake District, England
A stormy autumnal day is hard to beat if you want dramatic landscapes.
I captured this scene during later afternoon, when warm light and a low sun
brought out the rich colours of the fells and trees. A strong wind was blowing
too, making it difficult to keep my camera still – several other frames of this
scene were blurred.

HORSEMAN WOODMAN 5X4 CAMERA, 150MM STANDARD LENS, TRIPOD, CABLE
RELEASE, 81B AND 0.6 ND GRADUATE FILTERS, FUJI VELVIA, 1 SEC AT F/22

Autumn – mists and mellow fruitfulness

The arrival of autumn marks the start of a dramatic change in
the landscape. Temperatures fall, and as they do the leaves on
deciduous trees slowly die and turn to a myriad of beautiful
rustic shades before falling to the ground to create colourful
carpets in woodland and gardens. On moors and heathland
brackens and ferns turn from green to gold and glow in the late
afternoon sunlight. The weather also becomes less predictable.
Brief storms are common, creating dramatic conditions for
landscape photography, and early frosts are not uncommon.

These changes create some of the most beautiful conditions
for landscape photography, and it's no surprise that the majority
of photographers cite autumn as their favourite season.

A sunny autumnal day complete with blue sky reveals
autumn's beauty at its best, so whenever such conditions
occur, try to make the most of them. Early morning and late
afternoon are prime times to shoot because the sunlight is
naturally warm and the sky is a deep, lustrous blue. Use a
polarizer to deepen the sky, and an 81B or 81C warm-up filter
to enhance the natural warmth of the light and the landscape.

Use a polarizer even when the weather is dull, as it will cut
through glare on the foliage so colours look richer. Experiment
with warm-up filters, too, or stronger 85-series orange filters to
enhance the foliage colour. Soft-focus, mist and fog filters can

also be used to inject added atmosphere – and especially on
backlit woodland scenes – while a red-enhancing filter will
really boost those warm colours.

Late afternoon is another very good time to photograph
woodland, when the low sun casts raking shadows. Open
areas of woodland suit this treatment perfectly because you
can make a feature of the shadows, but also include trees that
are backlit so the foliage glows.

When you're finished with wider views, look for shots on a
smaller scale. Carpets of crunchy autumn leaves make great
studies in colour, pattern and texture, and you can fill the
frame with a standard lens or zoom. Fallen leaves often get
trapped on rocks in rivers and tumbling woodland streams,
their vibrant colours standing out against the mossy green or
drab grey of the rocks and water. Use a slow shutter speed
(1 sec or more) so the water flowing around them records as
a graceful blur to create striking images.

Autumn is also a good season to capture the landscape
being brought to life by dramatic, stormy light, with patches of
sunlight breaking through the dark, brooding sky and rainbows
arching across the scenery. Or why not rise early and make
the most of early morning mist around water or in woodland
and valleys – if you're really lucky, you may be able to capture
the first golden rays of sunlight burning through and creating
stunning images.

The sun rises around 6am and sets at 6pm during mid-
autumn in western Europe and northern USA. On a good day
you can enjoy eight hours of good light for landscape photo-
graphy, though early morning and late afternoon are best.

Winter – a landscape laid bare

The classic winter landscape would show a beautiful scene
covered in freshly fallen snow and basking in bright sunlight. In
many northerly regions, such conditions can be taken for
granted, but in the UK no two days are ever the same, so you
have to make the most of opportunities as and when they occur.

Snow or no snow, however, winter can still be a rewarding
season. The landscape appears barren and subdued once crops
have been harvested and trees lose their leaves, while dull, dark
days soften colours and lend a sad, monochromatic feel to even
the most beautiful scenery. When approached in a positive way,
however, these characteristics can lead to great pictures.

After a cold night the landscape is often coated in heavy
frost while the sky at dawn is a palette of gentle pastel colours.
Trees stand sentinel against the sky, every branch and twig
covered in a sparkling white coat. In clear weather you must
work fast to capture this, as the warming sun will soon melt
the frost away.

If scenes on a large scale aren't so inspiring, then look for
smaller details such as frozen leaves, spiders' webs covered in
frozen droplets of dew, leaves trapped in ice, and so on.

One of the great things about winter is the light. Because

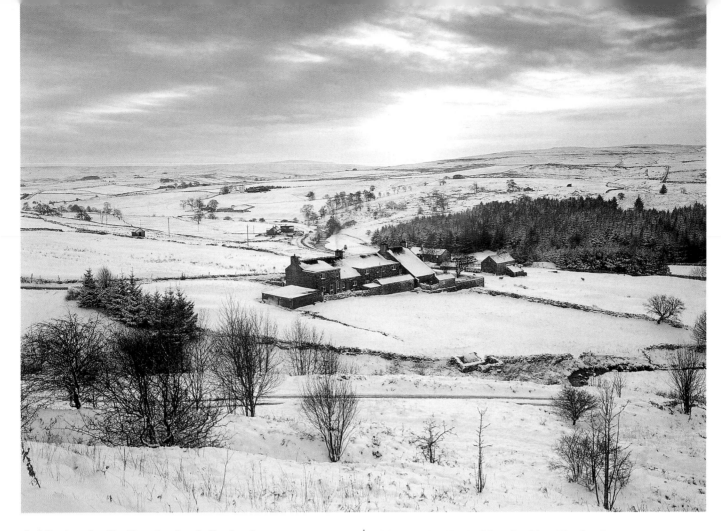

▲ Allenheads, Northumberland, England

Weather conditions vary considerably in winter, but you can usually find something interesting to photograph. This scene was captured on a cloudy afternoon, and although a clear blue sky would have been preferable, by toning down the sky with a ND graduate filter I was able to record a little colour and differentiate it from the landscape.

PENTAX 67, 55MM LENS, TRIPOD, CABLE RELEASE, 0.6 ND GRADUATE FILTER, FUJI VELVIA, ½ SEC AT F/11

▼ Burghley Park, Lincolnshire, England

Deciduous woodland shows the greatest change during autumn as its lush foliage turns to rich yellows and browns. To emphasize this, shoot open woodland during early morning or late afternoon, and use warm-up filters. Denser woodland is best captured in bright overcast conditions.

NIKON F90X, 80–200MM ZOOM LENS, TRIPOD, CABLE RELEASE, 81D WARM-UP FILTER, FUJI SENSIA II 100, ⅕ SEC AT F/11

the sun never rises more than 20° above the horizon, the light is attractive all day long, so you can shoot non-stop from dawn to dusk. Long shadows help to reveal texture and modelling in the landscape, even at midday, while the colour temperature rarely exceeds 4500k, so in clear weather the light always has a pleasant warmth. Blue sky is also bluer in winter, and the effect of a polarizing filter is more obvious.

For those of you who hate early starts, the sun doesn't rise until around 8am in the UK. On cold, misty mornings the sun's orange orb also looks amazing as it rises above the cold, blue landscape, often looking bigger than normal because light rays are scattered by the misty atmosphere.

The sun usually sets around 4pm – earlier in some areas. But despite the shortness of the day, you can still enjoy many hours of good light, and where landscape photography is concerned, it's quality that counts, not quantity.

Expressionist landscapes

Most landscape photographers strive to produce perfect classic landscapes – sweeping vistas captured in beautiful light. However, there are more ways to shoot the landscape: we can take a more abstract approach, where the scene is stripped down to its bare essentials, or produce images that are outward expressions of our sense of order, and our personal vision of the world.

Applying the KISS principle

There is an acronym among photographers known as KISS. It stands for 'Keep It Simple, Stupid', and it's one that is worth remembering when you're taking pictures of the landscape.

All too often we try to include more in a composition than is really necessary, and this can result in pictures that contain so much detail and information that the viewer doesn't really know where to begin. So the next time you're photographing a scene, look at ways of trying to simplify your pictures – you may be surprised at how effective this approach can be.

Using a telephoto or, even better, a telezoom lens will help you to simplify things because it magnifies the scene so you can be more selective about what's included in a picture and, just as importantly, what's excluded. Zooms are ideal for this abstract approach to landscape photography because you can keep making small adjustments to focal length until the composition is perfect. There's nothing more annoying than composing a shot only to find that you can't exclude a distracting element because the focal length of your lens is fixed, but with a zoom this is no longer a problem.

When you scan a scene, try to find order in the chaos of the bigger picture. Look for smaller details that make good

What you need

Camera Any type of camera that accepts interchangeable lenses is suitable

Lenses Telephoto and telezoom lenses are ideal, though wide-angle lens can also be used. A focal length range of 28–200mm should cover your needs

Film Slow-speed film (IS 50–100) is recommended for abstracts, fast film (ISO 400+) for grainy images, and don't forget black and white

Filters Use a polarizer to add impact to abstract images. Soft-focus and warm filters are handy for impressionistic shots

Accessories A tripod is always useful for landscape photography, especially when shooting with long lenses or in low light

pictures in their own right – the lines created by stone walls and hedges; the sinuous snaking of a river as it stretches into the distance; the bold patterns and colours created by fields planted with different coloured crops and so on. Pick out individual elements – a single tree standing in the middle of a field, a rock pool on a beach reflecting the colour of the sky, and so on.

▶ Namib Desert, Namibia

Deserts are great places for abstract photography, simply because the landscape is stripped down to its bare essentials – mainly sand and sky. Here, side lighting plunged one half of a single dune into shadow while revealing the rich orange colour of the other half beneath the perfect blue sky. The single tree provides a useful focal point. I used a telephoto lens to crop in right and simplify the scene as much as possible.

NIKON F90X, 80–200MM LENS, TRIPOD, CABLE RELEASE, POLARIZER, FUJI VELVIA, ½ SEC AT F/16

◀ Aegina sunset, Greece

I've always had a soft spot for grainy images – they have a wonderful impressionistic quality. This picture started out as a slightly wider view shot on ISO 1600 colour slide film, but to enhance the grain and simplify the image even more I had a 6x9cm duplicate slide made, then copied part of that dupe back onto slide film by placing it on a lightbox in a darkened room.

NIKON F90X, 105MM MACRO LENS, TRIPOD, CABLE RELEASE, FUJI VELVIA, ¼ SEC AT F/16

Less is more

If your usual approach is to shoot wide-angle views, noticing these smaller pictures within a vast scene may not be easy; but the more time you spend looking, the more you will begin to see them.

How simple can you go? Well, that has to be your decision. Landscape photography is all about making visual judgements, so if you feel something works, shoot it.

One thing you will notice when you use a telephoto lens to photograph the landscape is that your pictures will lose the three-dimensional quality of wide-angle shots. The lack of foreground interest is partly responsible for this, but instead of seeing it as a drawback, use it to your advantage. Abstract photography is about producing images that rely on the use of colour, shape, line and texture for their appeal, rather than what the actual subject matter is, so by removing depth from the equation you take your picture one step further away from reality and one step closer to pure abstraction.

Weather conditions and lighting can help. Snow simplifies the landscape significantly because it obscures most of the detail we're used to seeing, and only the boldest features remain visible. And a cloudless blue sky is very useful, too, because it makes a perfect backdrop to abstract views of the landscape. In such situations, use a polarizing filter to deepen the sky even more, and boost colour saturation.

▲ Trees in snow

I had walked past these trees hundreds of times and had never given them a second glance, as they offered little in the way of photographic potential. However, after a night of heavy snow it was a different story. Suddenly the skeletal trees stood out boldly against the crisp white covering and the murky grey of the sky behind, and the ordered shape of their grouping emerged. Realizing this would make a strong black-and-white image, I raced home for my camera to capture it on film. To heighten the simplicity of the scene I then made a print on grade IV paper to boost contrast and make the trees appear to be literally floating in space.

OLYMPUS OM4-TI HANDHELD, 28MM LENS, FUJI NEOPAN 1600, 1⁄60 SEC AT F/11

▲ Esthwaite Water, Lake District, England

A telephoto lens allows you to isolate small parts of a scene and make a feature of the natural designs in the landscape. Here I wanted to do this with the sunlit trees and their reflection in the lake – a feature that paled into insignificance in a wide-angle view, but when magnified by a telezoom creates a simple but appealing composition.

NIKON F90X, 80–200MM ZOOM LENS AT 200MM, TRIPOD, CABLE RELEASE, POLARIZER, FUJI VELVIA, ⅛ SEC AT F/11

▶ Aegean Sea, Greece

I took this photograph while peering over the side of a ferry travelling between the Greek islands. It was a perfect summer's day and the sea was reflecting the intensity of the blue sky. I then noticed the crisp white surf being created as the ferry sliced through the water, and realized there was the makings of a powerful abstract image.

OLYMPUS OM4-TI HANDHELD, 28MM LENS, POLARIZER, FUJICHROME 1600, ½₅₀ SEC AT F/16

Light on the **land**

Of all the factors you need to consider when photographing the landscape, it is the quality of light that should be given priority. Variations in the weather, the changing seasons and the passing of time each day all influence the quality of light, and this in turn shapes and models the landscape so that a scene never stays the same for very long. By revisiting locations you can take many different pictures.

Changes throughout each day

The greatest factor influencing the quality of daylight is the time of day. As the sun arcs its way across the sky between sunrise and sunset, the colour, harshness and intensity of the light undergo a myriad of changes, all of which can be used to your advantage.

Before sunrise there's a period known as pre-dawn, during which any light present is reflected from the sky so it is very soft, the shadows are weak, and the world takes on a cool blue/grey hue. This is a good time to photograph coastal views and scenes containing water, especially in calm weather, when the surface of the water is unruffled so it reflects the scenery around you.

As first light approaches, pastel colours begin to appear in the sky and the landscape looks very atmospheric. In clear weather in temperate regions, visible light may occur as early as 2am during midsummer, but not until 6.30am during the depths of winter. In the tropics, twilight is very brief at either end of the day.

Once the sun peeps over the horizon it's all change. In a matter of minutes the sky becomes much warmer and any clouds present near the horizon reflect light and colour from the sun, though the landscape is still being lit by the sky overhead and often appears cool and subdued until the sun appears.

When it does, warm sunlight rakes across the landscape, casting long shadows that stretch across the ground, revealing texture and picking out even the smallest rises and dips in the

▲ Embleton Bay, Northumberland, England

If you want to make the most of sunrise, decide on a suitable location in advance and get there in plenty of time. I often arrive in darkness, set up my equipment, then wait for the magical moment to arrive. If weather conditions are favourable, this is what you can expect – golden light and glowing sky.

FUJI GX617 PANORAMIC CAMERA, 180MM LENS, TRIPOD, CABLE RELEASE, 81C WARM-UP FILTER, FUJI VELVIA, 4 SEC AT F/22

What you need

Camera Any type with good exposure control

Lenses Lenses of 28–200mm are the most popular and versatile for landscape photography.

Film Slow-speed film (ISO 50–100) is generally preferred for colour landscape work

Filters Polarizer, warm-ups, neutral density graduates – all help you make the most of daylight

land. Shadows are weak when the sun is close to the horizon because they're partially 'filled in' by light from the sky, and at sunrise they often appear blue in colour because the sky is predominantly blue itself. This makes it possible to create beautifully evocative photographs at sunrise, with prominent features such as buildings or trees lit by the warming rays of the sun while the rest of the scene appears cool and subdued.

Early morning is the most productive time to be out in the landscape. The light undergoes many changes in a short

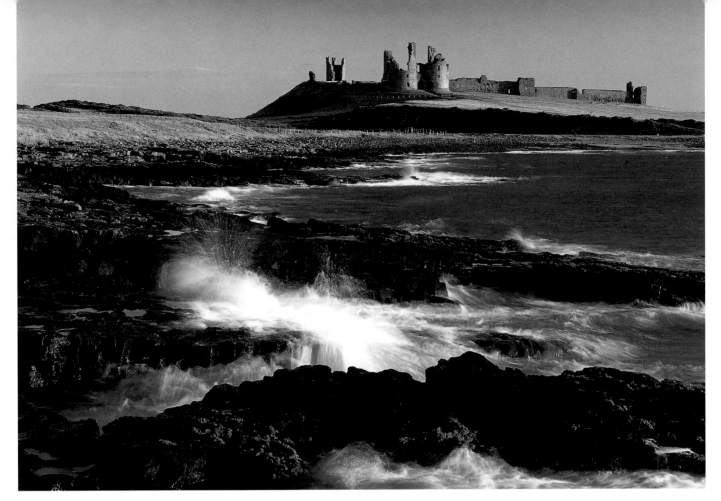

space of time, and you will often take more pictures during the first two hours of daylight than the rest of the day put together.

As the sun starts to climb into the sky the earth warms, the light becomes more intense, and shadows grow shorter and denser. The warmth in the light also begins to fade back to neutral, and stays that way for much of the day. This is known as 'mean noon daylight'.

Once the sun climbs higher than 36° above the horizon the light reaches maximum intensity. During the summer this point is reached five hours after sunrise – usually around 9am – and remains so until at least 4pm. In spring and autumn the period is shorter – usually between 10am and 2pm – while in winter the intensity of the light and the angle of the sun remain low enough to provide attractive light throughout day.

With the light at its most intense and the sun overhead, the landscape can easily look bland and flat. This doesn't mean you should stop shooting altogether – smaller details can still make great pictures, and scenes that are full of strong colours

▲ Dunstanburgh Castle, Northumberland, England

If the sun rises into a clear sky it casts golden sunlight across the landscape. Here the sun rose over the sea to my right with no obstacles to block it, so the effect on the castle and surrounding scenery was immediate and dramatic.

PENTAX 67, 165MM LENS, TRIPOD, CABLE RELEASE, POLARIZING AND 81B WARM-UP FILTERS, FUJI VELVIA, 1 SEC AT F/22

▶ Tuscany

From late morning to mid-afternoon the sun is high in the sky and the light is neutral in colour. Landscape pictures look clear and crisp, with deeply saturated colours – ideal for a scene like this – though in clear weather the light can be very harsh and some detail will be lost in the shadows.

PENTAX 67, 45MM LENS, TRIPOD, CABLE RELEASE, POLARIZING FILTER, FUJI VELVIA, ⅛ SEC AT F/16.5

such as flower meadows will look amazing – especially if you use a polarizer to increase colour saturation. For general landscape photography, however, care should be taken if you want to avoid taking rather dull, uninspiring pictures.

Summer is the worst season for this as the sun continues to climb until it's almost overhead – up to 60° or more above the horizon at midday in temperate regions, and as much as 90° at the equator – by which time little or no shadow detail is visible, and the contrast is often too high to be recorded fully by colour film.

By mid-afternoon the sun will have begun its descent towards the horizon again, and conditions improve. As it falls ever lower in the sky the light warms up and shadows become longer and weaker, revealing texture and modelling to give pictures a real three-dimensional feel.

Make the most of the golden hour

Perhaps the most photogenic time of day is the hour or so before sunset, when the world is bathed in beautiful golden light and even the most ordinary scene is brought to life. The quality of light is often much warmer than at dawn because it's scattered and diffused by the thicker atmosphere – that's why the sun often looks bigger at sunset than it did at sunrise – and your pictures will come out warmer than you expected because film can't adapt to changes in the colour temperature of the light like your eyes can.

Long, soft shadows also scythe across the landscape once more, revealing maximum texture and detail. Delicate undulations such as the gentle ripples on a sandy beach are clearly defined by the raking light, as is the texture in surfaces that just a few hours earlier appeared smooth.

And then, of course, there's the sunset itself. There are few sights more magical than the sun's golden orb slowly dropping towards the horizon, and in the right conditions it's pretty much impossible not to take great pictures.

To make the most of a sunrise or sunset, use a telephoto lens to exaggerate the size of the sun's orb – a 200mm lens will do the trick, but a 300mm, 400mm or 500mm is better. Never look directly at the sun through your camera's viewfinder if it's bright, as you could damage your eyesight.

At sunset, contrast is high if you're including the sun's orb in your picture, so you will have to decide how you want to expose the scene. The usual approach is to create silhouettes of key foreground details such as buildings, trees and people with the fiery sky behind. This is done by exposing for the sky and sun, which your camera will naturally do if you leave the exposure to its metering system. All you have to do then is to bracket a series of exposures, up to around two stops over the metered exposure, and you will be guaranteed several successful frames.

Where you want to record detail in the foreground without the side effect of possibly burning out the sky, use a strong neutral density graduate filter – 0.9 or 1.2 – so as to reduce the brightness between the sky and landscape. You can then expose for the landscape, and the glorious colours in the sky will record as well.

If you need to enhance the light at sunrise or sunset, use an 81-series warm-up filter – an 81C or stronger is ideal.

For a more obvious warming, use an orange 85-series filter or a sunset graduate.

Once the sun has disappeared, twilight transforms the sky into beautiful shades of blue, purple and pink, providing you with yet more opportunities to take successful pictures – if you're shooting scenes containing water, where the sky is reflected, you can continue shooting until it's almost too dark to see.

Changes in the weather make a difference

If every day was clear and sunny, then the light would be predictable and landscape photography very easy (and also boring). For most of us, however, coping with unpredictable and constantly changing weather conditions adds a whole new dimension to the quality of light.

You only have to watch how the light changes when a cloud passes over the sun to realize the influence of the weather on its character. Suddenly shadows become weaker, the light is less intense, and contrast drops significantly. The effect is just like putting a studio flash unit inside a softbox – the cloud softens and spreads the light. And replace that single cloud with a grey, overcast blanket, and the effect is even stronger. Light levels fall dramatically, shadows almost disappear, and the sky acts like an enormous diffuser.

The soft light of an overcast day is ideal for sweeping views, but some types of scene and subject can benefit from it too, such as woodland, waterfalls and small details in the

◄ Aït Benhaddou, Morocco

As the sun descends towards the horizon the light becomes ever warmer. The last hour or so before sunset is one of the best times of day to photograph the landscape – in this case, golden sunlight enhanced the natural colour of the mud walls in a Moroccan kasbah.

NIKON F90X, 80–200MM ZOOM LENS, TRIPOD, CABLE RELEASE, 81C WARM-UP FILTER, FUJI VELVIA, ⅙₀ SEC AT F/11

▲ Berwick-upon-Tweed, Northumberland, England

The dramatic contrast between the warm light on the town and the blue of the sky creates a stunning effect in this panoramic picture. Taken just minutes before sunset, the sun suddenly dropped below the cloud and lit the town like a beacon. Being in the right place at the right time is essential to capture such beautiful light – though luck plays a part, too.

FUJI GX617 PANORAMIC CAMERA, 90MM LENS, TRIPOD, CABLE RELEASE, 0.3 CENTRE ND FILTER, FUJI VELVIA, 2 SEC AT F/22

▼ Hound Tor, Dartmoor, England

Stormy weather may be frustrating and unpredictable, but it's worth braving, because should a break appear you will find yourself photographing some of the most dramatic light of your life. I predicted that a short break was imminent while exploring this location, so I set up my camera and waited, and eventually my hunch paid off – long enough to expose just two sheets of film before the sun disappeared once more.

HORSEMAN WOODMAN 5X4 CAMERA, 90MM LENS, TRIPOD, CABLE RELEASE, 0.6ND GRAD FILTER, FUJI VELVIA, 1 SEC AT F/32

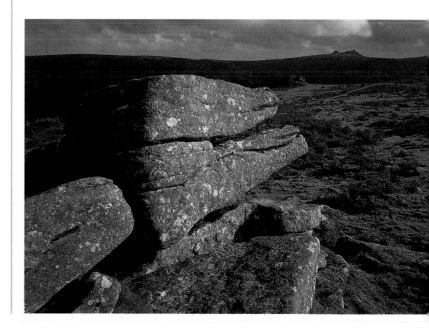

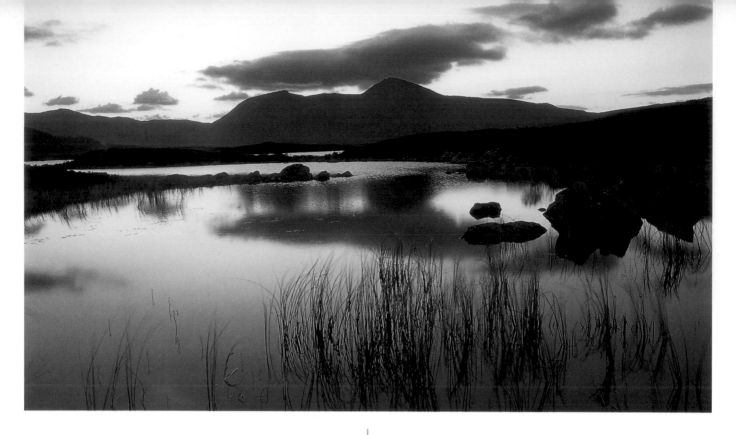

▲ Rannoch Moor, Scotland

Once the sun has set and twilight approaches, the colours in the sky fade from orange to blues, pinks and purples. This is an ideal time to photograph scenes containing water, as it reflects the beautiful colours in the sky.

NIKON F90X, 28MM LENS, TRIPOD, CABLE RELEASE, FUJI VELVIA, 1 SEC AT F/16

landscape. You can also produce very moody, evocative black-and-white landscapes in such conditions.

Mist and fog are more interesting, reducing the landscape to two dimensions. Fog is less photogenic because it reduces visibility, weakens colours, and makes everything appear rather flat, but a light mist at dawn can be incredibly photogenic.

Dull, rainy weather is less inviting, but you can produce successful pictures in heavy downpours. Try using a slow shutter speed to blur the rain so it records like mist, or shoot against a dark background so the raindrops are clearly visible.

Stormy weather can also be very rewarding. If the sun breaks through against a dark and stormy sky, the contrast in light creates incredibly dramatic conditions for landscape photography. If you're lucky you may even have the chance to capture a rainbow or bolts of lightning.

Varying the position of the sun

Allied to the quality of light is the direction from which it strikes your subject, because this too can make a big difference to the success of your pictures.

It's tempting to keep the sun over your shoulder – a habit novice photographers find difficult to break – but this can be the worst place to put it when shooting landscapes because with the light striking your subject from the front, shadows are cast away from the camera and out of view, so you end up with a picture that's evenly lit and easy to expose, but which is ultimately flat.

A much better approach is to keep the sun on one side of the camera, so that any shadows become an integral part of the scene, revealing texture and form to create a three-dimensional effect. Sidelighting is at its most effective early or late in the day, when the sun is low in the sky and long shadows rake across the scene.

Shooting into the light can also be effective on the right type of scene. If you expose for the bright background a silhouette will be created because your main subject, being in shadow, is underexposed. This works well at sunrise and at sunset, but you can produce silhouettes at any time of day – a misty woodland scene shot into the light in this way can look incredibly atmospheric.

Shooting towards the sun also works well in stormy weather, especially if the sun is hidden behind clouds so you get a dramatic cloudburst effect, or when there's water in the scene and the sun creates shimmering highlights across its surface, be this placid or disturbed.

TOP TIPS

- You can learn a lot about light by going back to the same locations time after time and seeing how different times of day, in addition to the seasons and weather conditions, affect the pictures you take. See also pages 106–107
- If you arrive at a location and the light isn't right, try to determine when it will be, so you know the best time of day to return – a compass can help you track the position of the sun

Chapter eight
urban landscape

▶ **Tower Bridge, London**

NIKON F5, 15MM LENS, TRIPOD, CABLE RELEASE, FUJI VELVIA, 10 SEC AT F/11

External views

Architecture is one of the most accessible photographic subjects available, since no matter where you live or travel, you're bound to encounter buildings. And as they come in all shapes, sizes and designs, from crumbling old cottages and magnificent cathedrals to modern office blocks and stark factory units, architectural photography offers endless opportunities to take creative, inspiring pictures.

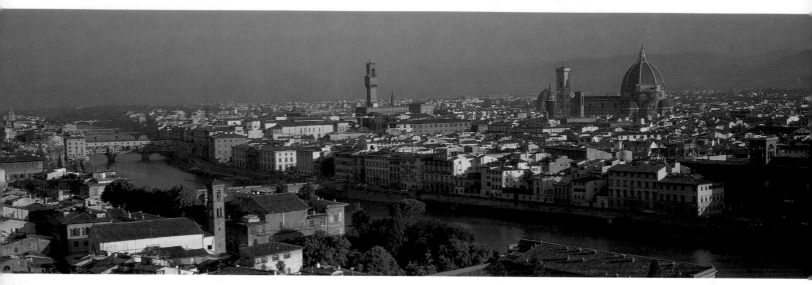

▲ Florence

Most towns and cities have at least one vantage point where you can capture a stunning view of buildings stretching off into the distance. This picture shows the rooftops of Florence from Piazzale Michelangelo and includes all the main architecture of the city – the Ponte Vecchio covered bridge to the left, the Duomo and cathedral to the right, and the Uffizi in the centre. I made my first visit on the previous evening to shoot sunset and night pictures, but knew it would also be an ideal spot for dawn shots as well – which is when this picture was taken.

FUJI GX617, 180MM LENS, TRIPOD, CABLE RELEASE, 81C WARM-UP FILTER, FUJI VELVIA, 1 SEC AT F/22

What you need

Camera Any type of camera can be used to photograph buildings, though the versatility of a 35mm SLR makes it ideal

Lenses Wide-angle lenses from 17–35mm are ideal, though you will find moderate focal lengths from 24–35mm generally more useful

Film Stick to slow-speed film (ISO 50–100) for general use. Black and white is also well suited to architectural photography

Filters Use a polarizer to deepen blue sky and remove unwanted reflections, warm-ups to enhance the colour of older brick and stone buildings, and neutral density (ND) graduates to tone down bright skies

Accessories A tripod and cable release, plus a spirit level to check your camera is square

Viewpoint and composition

The viewpoint you shoot from can make all the difference in architectural photography, so before taking any pictures, spend a little time looking at the building you intend to shoot, using different positions until you find the most successful one.

Pay particular attention to rivers, streams and ponds, which may feature an interesting reflection of the building that you could use as foreground interest – or as the subject for your picture. Trees can be used to frame the building and fill out unwanted sky or hide ugly details such as parked cars, lamp-posts and other features you'd rather not include, while flower beds, paths, hedges and gardens can be used to add interest to the foreground.

In built-up areas your choice of viewpoint may be restricted due to the close proximity of other buildings, traffic, street furniture and so on, in which case you will have to make the most of what you've got. A wide-angle lens can be invaluable here, allowing you to shoot from close range and to exclude any unwanted features.

One possible solution is to ask permission to shoot from a building opposite, so you're off the ground and clear of clutter at street level. An elevated view will also overcome problems with converging verticals, and give you completely different pictures to those taken from down below.

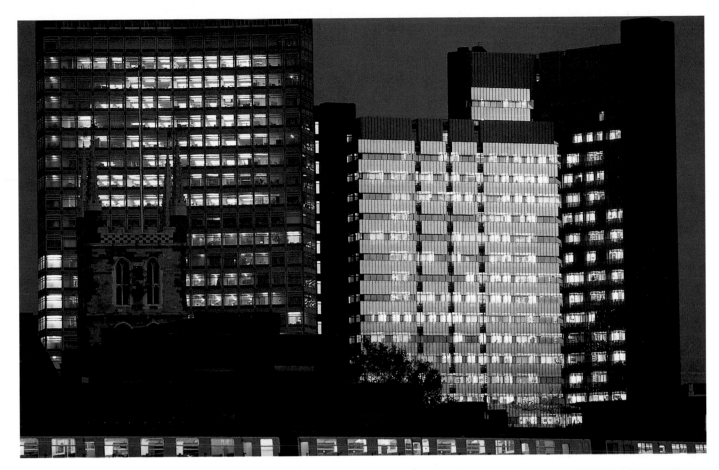

▲ London high rise

Photographer Simon Stafford lives not far from London and makes regular visits to the city to photograph its amazing architecture. This superb telephoto shot of Southwark Cathedral in the shadow of towering modern office blocks shows the effect you get by photographing modern buildings that face the rising or setting sun – the orange glow on the façade of the central building is a reflection of the western sky at dusk.

NIKON F90X, 500MM LENS, TRIPOD, CABLE RELEASE, KODACHROME 64, 2 SEC AT F/16

If you're really lucky you may even find there's a café, bar or restaurant with a public viewing gallery several storeys up that you can shoot from – though you will probably still need permission. Professional architectural photographers put a lot of effort into this planning and groundwork so they can get the best possible pictures, and you should do the same, by asking around to see if there are any interesting viewpoints available.

Wherever you're shooting, look out for alternative angles, especially if the subject building is popular with photographers. Holes in walls, a gap between other nearby buildings – things like this can give your pictures an unusual twist. Alternative viewpoints also work well – get really high off the ground if possible by climbing a church tower or shooting from the top of a multi-storey carpark. Alternatively, get down low, perhaps shooting from ground level with a wide-angle lens in order to exaggerate converging verticals and produce really powerful compositions – if you get low enough you could frame the

▲ Hampton Court

Older buildings look their best when bathed in the warm glow of the evening sun, as it emphasizes the natural colour of the stone and brick used in their construction. The dramatic perspective in this picture by Simon Stafford was created by using a 14mm ultra-wide-angle lens. Tilting the camera even slightly with such a long lens causes dramatic converging verticals (see pages 126–127).

NIKON F5, 14MM LENS, TRIPOD, CABLE RELEASE, FUJI VELVIA, ⅕ SEC AT F/16

▲ Canary Wharf

The bold lines, sweeping curves and repeated features of modern architecture are ideal for creating graphic compositions, and busy city centres are the places to go to find them. This is Canary Wharf in London's Dockland – a Mecca for architectural photographers in an ever-changing urban landscape. Simon Stafford used an ultra-wide-angle lens from close range to cause dramatic converging verticals.

NIKON F5 HANDHELD, 14MM LENS, FUJI VELVIA, ¹⁄₆₀ SEC AT F/11

▶ Santorini

In complete contrast to the picture of Canary Wharf above, this shot shows a much more graceful and soothing kind of architecture. Older buildings are generally less angular than modern ones, and this church on the Greek Island of Santorini appears almost to have been shaped by hand from soft clay. The seamless curves all melt together gracefully, and contrast nicely with the painted windows beneath the white dome, an effect enhanced by the rich blue sky in the background.

NIKON F90X, 18–35MM ZOOM LENS, TRIPOD, CABLE RELEASE, POLARIZING FILTER, FUJI VELVIA, ⅛ SEC AT F/16

building with flowers, or use things like lamp-posts as dynamic lines to lead the eye through the shot.

Make the most of light

The best time of the day to photograph a particular building depends upon its aspect – the direction it faces – because this will determine whether or not it's in shadow.

Buildings that face east will be lit in the morning, while west-facing façades will be at their best in the afternoon, and a southerly aspect will receive light through most of the day. If you're lucky the light may be perfect when you arrive, but often you'll have to wait for a while, or even return the next day, either earlier or later, to catch it at its best.

Warm light from a low sun enhances the mellow stonework or worn brickwork of old buildings, while sidelighting will reveal texture in the coarse surface of masonry. So if you want to photograph churches, castles, cottages or other old buildings, do so during early morning or late afternoon.

Modern office blocks look more dynamic when they're bathed in bright sunlight against a deep blue sky, as this heightens their graphic strength. Blue sky also makes a good background. For the best results, used a polarizing filter to deepen the sky, remove reflections from the windows and make the building stand out more boldly. The same applies when photographing whitewashed buildings of the type you see in Mediterranean countries such as Spain and Greece – the stark whiteness will be enhanced if it's captured against a rich blue sky.

Dusk is another excellent time to photograph modern skyscrapers or magnificent cityscapes. Once the sun has set and the sky fills with colour, glass-fronted buildings will mirror this brilliantly if you shoot the west-facing wall, while the area behind will be a soft blue sky in the east.

Midday isn't the best time of day to shoot, as the light is too contrasty and lacks character. However, in built-up urban areas, such as financial and business districts in big cities, you may have no choice but to shoot at midday, as at any other time of day the building you want to photograph is in the shadow of other nearby buildings. Even then, there may only be a period of perhaps 30 min when you can get the shot – if at all.

Shadows can also be a problem when photographing street scenes during the morning or afternoon with the sun on one side of the camera. It's not uncommon for one half of a street to be bathed in sunlight, while the other half is shaded. In such situations you can wait until all of the scene is in shadow, so the contrast is reduced to a level that film can cope with, and obtaining an accurate exposure is easier. However, a more practical option is to use a neutral density graduate filter at an angle so it covers the sunlit part of the scene. That way the difference in brightness between the sunlit and shady areas will be reduced according to the density of

▲ **Brixham Aquarium, Devon, England**
There are a lot of buildings that don't deserve a second glance by day, but often come alive at night. In this picture it was the rich red glow from the illuminated sign against the deep blue of the twilight sky that made the scene worth photographing.

OLYMPUS OM1, 50MM LENS, TRIPOD, CABLE RELEASE, FUJI RFP50, 16 SEC AT F/11

the filter – two stops for a 0.6ND grad – so you can give more exposure to the shady area and prevent it coming out too dark, without overexposing the sunlit area.

The only time shadows become an ally is if you want to record buildings as silhouettes – the ruins of an old castle or abbey at sunset, say. This is best achieved by shooting from a viewpoint that puts the building between the camera and the sun, so when you expose for the bright background the building is underexposed and records as a solid black shape.

TOP TIPS

- The quality of light is crucial, so always be willing to wait for it to improve, or return on another occasion in better weather or at the right time of day
- Town and city centres are much quieter on Sundays because offices are closed. This makes it much easier to take pictures without people or traffic, though it also means you won't be able to enter any of the buildings to gain a better view – the lesser of two evils, really
- Buildings can look more interesting at night when they're floodlit and come to life against the twilight sky

All square

One of the most frustrating problems when photographing buildings is converging verticals, usually caused by using a wide-angle lens from close range. When you tilt the camera up to include the top of the building, the vertical sides suddenly appear to be leaning inwards – converging – as if the building is falling over backwards, because the film plane is no longer parallel to the building's front.

Using camera movements

If you have a large-format camera, as most professional architectural photographers do, you can set up the camera so that the film plane is parallel to the front of the subject building, then, instead of tilting the whole camera backwards to get the top of the building in, you simply move the lens upwards until the whole building is in the shot. This movement is known as 'rising front'.

What you need

Camera A roll-film or large-format field/monorail camera with movements is ideal, though a 35mm or medium-format SLR can be used successfully too
Lenses Shift lenses will correct converging verticals, but normal wide, standard and telephoto lenses can be used as well
Accessories A tripod is advised to keep your camera steady, plus a cable release

Using a perspective control lens

For many 35mm SLRs and some medium-format cameras you can buy a special lens known as a perspective control (PC) lens, also referred to as a 'shift' or in some cases 'tilt-and-shift' lens.

This works like any other lens, but with one major difference – the front section is adjustable so you can raise it in the same way that a large-format lens can be raised using rising front to eliminate converging verticals. On most models you can also lower the front section, while with tilt-and-shift lenses you can tilt the front section as well, although raising it is the only function you need to control converging verticals.

The main drawback with these lenses is they are very expensive – £1000+, depending on the model – so unless you're really serious about architectural photography they're not worth spending the money on.

Filling the foreground

If you can't stretch to a shift lens or large-format camera, the easier way to avoid converging verticals is simply to keep the camera back parallel to the building and move far enough away from it so that you can include the top of it in your picture – or adjust your zoom lens to a wider focal length.

◄ Caernarfon Castle, Wales
If you don't have the benefit of a shift lens or large-format camera, you need to use other 'tricks' to avoid converging verticals. In this case, I made use of the vivid reflection of the castle, which allowed me to keep the camera square – and without ending up with lots of boring foreground in the bottom part of the picture.
OLYMPUS OM4-TI HANDHELD, 28MM LENS, POLARIZING FILTERS, FUJI VELVIA, 1/30 SEC AT F/8

◀ **Bowes Museum, Co. Durham, England**
The movements offered by large-format cameras make avoiding converging verticals easy because you simply set up the camera so it's perfectly square, then raise the lens until the top of the building is in your shot. This was the first picture I ever took with a large-format camera – it wouldn't have been possible with a normal camera and lens.

CALUMET CADET 5X4 MONORAIL CAMERA, 150MM STANDARD LENS, TRIPOD, CABLE RELEASE, POLARIZING FILTER, FUJI PROVIA 100, ¼ SEC AT F/22

TOP TIPS

- It's not worth investing in a shift lens or large-format camera unless you do a lot of architectural photography, as both options are expensive
- If your camera accepts interchangeable focusing screens, fit a grid screen – this will help you ensure that verticals are kept vertical
- When photographing a building, set up your camera so there are no converging verticals initially, then see how much of the building is missing from the top of the frame. This will help you decide what steps to take to solve the problem without creating converging verticals

The drawback with this technique is that you will end up with lots of foreground; but if you ensure that this is interesting, it will add to the picture. Thus a colourful flower bed, ornamental lake, fountain, pathway, topiary – all kinds of things can be used as foreground interest. Stop your lens down to at least f/16 for this, so there's enough depth of field to keep everything sharp.

Choosing a higher viewpoint

Architectural photographers often carry a stepladder in the boot of their car so they can shoot from a slightly higher viewpoint. This may not only give a better view of the building, but it will also help to eliminate converging verticals because you will be looking more towards the building instead of up at it.

You can also gain height by standing on the roof of your car if it's strong enough, standing on a wall, shooting from a building opposite if possible, or finding a naturally higher viewpoint by walking up a slope in the surrounding area.

Backing off

If you back away from the building and use a short telephoto lens to photograph it, rather than using a wide-angle lens from

Exploiting converging verticals

Of course, it isn't essential that you correct converging verticals – when used intentionally, they can produce striking results.

If you stand directly in front of a tall building and look skyward through a wide-angle lens, the sides will converge dramatically to create a powerful composition, and the wider the lens is, the stronger the effect will be.

The key is to make sure the building is central in the frame, so each side converges equally, otherwise the effect can look odd.

close range, you may find you won't need to tilt the camera at all to include the top of the building.

Post production

Minor convergence can be corrected at the printing stage, by tilting the enlarger head and baseboard so the image strikes the printing paper at an angle. You can also scan the image into your computer then manipulate it with Adobe Photoshop.

▼ **Canary Wharf**
Instead of trying to correct converging verticals, make a feature of them. This picture by Simon Stafford shows the kind of amazing effects you can achieve by using a wide-angle lens to photograph high-rise buildings from close range. The wider the lens, the greater the effect.

NIKON F5, 14MM LENS, TRIPOD, CABLE RELEASE, KODAK EKTACHROME E100VS, ¹⁄₃₀ SEC AT F/16

Bits and pieces

Although we tend to think of buildings in their entirety, they're the sum of many fascinating parts, all of which can be eye-catching pictures. Modern architecture is full of strong lines, sweeping curves, patterns and bold designs, while older buildings feature intricate carved details such as faces, columns and buttresses.

Less is more

A telephoto zoom is going to be your biggest ally when you are shooting architectural details, because it will allow you to isolate small parts of the buildings you encounter and eliminate anything from the picture that you don't want to include.

When you first arrive at your location, spend a short while looking around and checking out its potential before rushing into taking pictures. Having decided on the areas that interest you, it's then a good idea to mount your camera on a tripod and compose the first shot. Using a tripod is advised because it fixes the position of the camera and makes it easier for you to fine-tune your compositions until they're just right. This is where a telezoom will prove its worth, because you can make small changes to focal length until the shot is just as you want it – or as close as it's ever going to be.

Initially the obvious details will catch your eye, such as the pattern of identical windows in modern office blocks, or the columns in old Georgian buildings. With repeated features like this you can either shoot them head on, or move round to an angle. The latter approach tends to work better, especially if you're using a long lens, because then the foreshortening of

<div style="border:1px solid #000; padding:8px;">

What you need

Camera: A 35mm SLR is ideal, though you could use any type of camera

Lenses An 80–200mm or similar telezoom will allow you to isolate interesting architectural details

Film Use slow-speed film (ISO 50–100) to maximize image quality

Accessories A tripod keeps your camera in position and makes it easier to shoot upwards, which is often what you will need to do

Filters A polarizer to deepen blue sky and increase colour saturation, plus an 81B or 81C warm-up to enhance the warmth of stonework

</div>

perspective will make the features look crowded together.

Contrasting old buildings against new ones can produce dramatic results. In city centres you often find old churches in the shadow of tower blocks, or an old cottage surrounded by newer buildings. Terraced houses also make great subjects because they feature so many repeated details – the staggered rooftops, lines of chimney pots and so on all make interesting pictures. The same applies with the bold and colourful details of beach huts, whitewashed houses and so on.

Initially you may find it difficult to pick out details from all that surrounds them, but the more you try it, the sharper your eye for interesting architectural detail will become.

On reflection

Reflections in windows always make great subjects, especially in modern office blocks where most of the exterior is clad in glass panels that reflect everything from the sky to other buildings nearby. The way glass distorts shapes can also make the reflections even more eye-catching.

Use a 70–210mm or 75-–300mm telezoom lens to fill the frame with interesting reflections, and remember to focus on the reflection itself rather than the surface of the window. For the best results, shoot in bright sunlight, when the buildings being reflected are in good light, so the reflection itself is bold and colourful.

Shoot a theme

Architectural details are a great subject to shoot as the basis of a theme project. You could choose a specific architectural feature, such as doors, windows, door furniture or door numbers. Alternatively, why not look for interesting carved features, such as faces on old stone buildings, or shoot buildings of a specific period or those painted a certain colour?

TOP TIPS

• You don't need to visit big towns or cities to find lots of architectural details – a typical street anywhere can be the source of great pictures
• Don't be misled into thinking that shooting details is an excuse for sloppy camerawork – you still need to think about each picture and compose it carefully
• Make use of bold lines, patterns, textures and interesting shapes, rather than just filling the frame with bits of buildings

◀ **Sum of parts**

This set of pictures shows a diverse range of architectural details, all photographed with 35mm SLRs and telephoto or telezoom lenses. It shows that any type of building, whether old or new, big or small, can be the source of eye-catching details.

NIKON F90X AND NIKON F5, 80–200MM, 300MM AND 500MM LENSES, TRIPOD, CABLE RELEASE, FUJI VELVIA, VARIOUS EXPOSURES AND APERTURES

Shooting **interiors**

Building interiors look simple to photograph, but still demand care and thought. Working in a confined space is a problem because without ultra-wide-angle lenses you may struggle to get a decent view. However, larger interiors don't solve the problem because you still want to get as much in your picture as possible – the only option is to use a wider lens, which may not always be possible.

Low light means long exposures

The main problem you're likely to encounter is low lighting. Exposure times often run into many seconds when you're using a small aperture to provide sufficient depth of field and slow film for optimum image quality, so a sturdy tripod will be essential.

Interior lighting also tends to be very contrasty, particularly in old buildings such as churches, which usually rely mainly on windowlight for their illumination. In sunny weather light levels are high close to the windows, but fall away quickly so there will also be lots of dark, shady areas. If you expose for the highlights most of the interior will come out too dark, while if you expose for the darker areas the windows will burn out.

Shooting in dull weather can help, because the difference in brightness between indoors and outdoors will be reduced. Another option is to shoot very early or very late in the day, when light levels are lower. Some architectural photographers wait until nightfall so there's no daylight coming through the windows; others tape neutral-density gels over the glass to reduce the amount of light coming in.

If none of these options is open to you, all you can really do is bracket your exposures widely, then choose the frame that

What you need

Camera A 35mm SLR is fine for interiors, though medium- and large-format cameras are favoured by professionals for the improved image quality and, in the case of large-format, movements to avoid converging verticals

Lenses Wide-angle lenses from 17–35mm are ideal for interiors, plus a standard zoom for smaller areas and details

Film Stick to slow-speed film (ISO 50–100) for general use. Tungsten-balanced is handy for interiors lit by tungsten lighting. Colour negative film is also more forgiving when it comes to the colour casts caused by artificial lighting

Filters FLD to balance daylight film for fluorescent lighting, and a blue 80A to balance it for tungsten lighting

Accessories A tripod and cable release, plus a spirit level to check your camera is square

gives the best compromise between highlight and shadow detail. It's also a good idea to keep windows out of your pictures, so that if they do burn out at least you won't see the effect.

Interior lighting is much better in modern buildings because architects are conscious of the need for more even light levels, so problems with contrast are more or less solved for you. Unfortunately, another obstacle presents itself – artificial lighting.

If you use normal, daylight-balanced film for shots of interiors that are mainly lit by artificial means, your pictures will come out with a colour cast.

◀ Cordoba Mosque, Spain
Taking pictures inside old buildings like this can be tricky. Light levels are often very low and tripods tend to be forbidden, so you have no option but to handhold and hope for the best. Tim Gartside took a chance and used a tripod, but he was only able to expose a single frame before he was told to leave. Thinking this might happen, he used colour print film, which is more tolerant to exposure error, to make sure the single frame he did expose was likely to be successful.

MAMIYA 645, 35MM LENS, TRIPOD, CABLE RELEASE, FUJI REALA, 10 SEC AT F/8

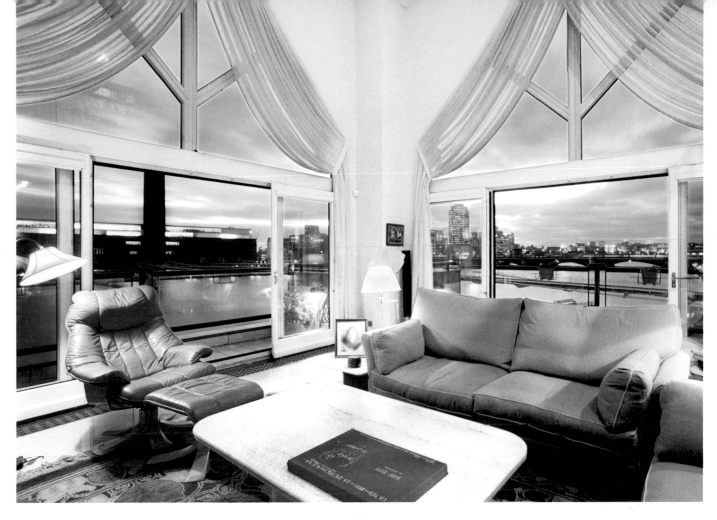

▲ River view

The stunning contrast between the interior lighting of this room and the blueness of the ambient light outdoors was created by colour-correcting the images at the printing stage to cool down the warmth of the interior tungsten lighting. This was achieved by increasing the blue filtration, which had the added advantage of making the scene outside much cooler. The same effect can be created digitally, by using a blue 80A filter on your lens when taking the picture or by shooting on tungsten-balanced film.

NIKON F801S, 17MM LENS, FILL-IN FLASH, TRIPOD, CABLE RELEASE, 10 SEC AT F/8

Watch your colour casts with artificial lighting

Tungsten and fluorescent are the two most popular types of interior lighting used, and they produce an orange and green cast respectively.

The orange cast from tungsten lighting can be avoided using tungsten-balanced colour film such as Fujichrome 64T or Kodak Ektachrome 64T. A blue 80A filter on your lens will also balance tungsten lighting for normal daylight film. Fluorescent lighting is more tricky to balance because the colour cast varies depending upon the age and make of the tube, but a pale magenta FL-D filter is a good compromise when using daylight film.

If the interior is lit by mixed sources you can't balance them all, so filter out the main source and accept that other areas will have a colour cast. If you use an FL-D filter to balance fluorescent lighting, for example, any windows and areas lit by daylight will come out with a pale magenta cast the same as the filter. If you use a blue 80A filter to balance tungsten lighting, windows and areas lit by windowlight will come out blue.

There's nothing you can do about this, other than cover the windows with colour corrective gels. Orange 85B gels will balance the windows for tungsten film, and pale green will help to cancel the magenta colour you get in daylight areas when using an FL-D or CC30 magenta filter in fluorescent lighting.

An alternative is to use colour negative film, which tends to be more forgiving in artificial light than slide film; this is mainly because colour casts can be balanced at the printing stage. You can also get rid of colour casts by scanning the picture into a computer and adjusting the colour levels, or by shooting on a digital camera and adjusting the white balance so that everything looks neutral.

Using flash to light interiors

One way of overcoming the problems of artificial illumination is to use electronic flash as your main source of illumination. For relatively small interiors, such as an average-sized living room, an electronic flashgun with a guide number (GN) of 30 (m/ISO100) or more will be more than powerful enough – all you need to do is bounce the light from the ceiling so that it spreads out and covers a greater area.

If you want to get more serious than that, two or three flashguns or studio flash units can be set up to light specific

areas of the interior, then triggered when you press the camera's shutter release so they all synchronize together. This is what professional architectural photographers do, often spending hours setting up the lights for a single interior, each one carefully hidden behind columns, corners and pieces of furniture so that it does a job without being seen.

Shooting in tight spots

Space is often restricted inside buildings, so a wide-angle lens of at least 28mm will be required to capture a good view. A 17–35mm zoom would come in handy, though the wider the lens is, the more it 'stretches' perspective, so even a small room will appear cavernous if you shoot it at 17mm.

Converging verticals can also be a problem, so choose your viewpoint carefully. Small rooms are easy to cope with – stand on a chair to shoot from a slightly higher position – but if you try to include the ceiling of a tall building you may have no choice but to live with convergence.

In buildings where a tripod is not allowed, such as museums, stately homes and National Trust/English Heritage properties, look for something that you can rest the camera on, or lean against a wall to give yourself more stability – with a wide-angle lens you should be able to shoot down to ⅕ sec without camera shake being evident.

Where a tripod is allowed, it can solve a problem with photographing public buildings, where you may have people walking in and out of the scene. Use a tripod, stop the lens down to its smallest aperture, and use a long exposure – 10 sec or more won't record anyone, providing they keep moving for the duration of the exposure.

▲ Chelsea Harbour Shopping Centre

Photography in shopping centres and malls is generally forbidden unless you seek written permission first. However, it is possible to take pictures if you shoot handheld because you can get the shot before anyone realizes what's going on. Tim Gartside used an ultra-wide-angle lens which gave him lots of depth of field, even at a relatively wide aperture with a decent shutter speed.

NIKON F801S HANDHELD, 17MM LENS, FUJI REALA, ⅕ SEC AT F/5.6

▼ Sun City, South Africa

Tim Gartside wanted to use electronic flash to help illuminate this interior, but his flashgun wasn't powerful enough to do that in a single burst. To overcome this he used his camera's multiple exposure facility to make five 3-sec exposures on the same frame of film, giving a total of 15 sec. This meant there was enough time between each exposure for his flashgun to re-charge so he could make five flash bursts instead of one – a useful trick.

NIKON F801S, 17MM LENS, TRIPOD, CABLE RELEASE, FLASHGUN, FUJI VELVIA, 15 SEC AT F/8

Chapter nine
nature

► **Butterfly**

MINOLTA X700, 90MM
MACRO LENS, TRIPOD,
CABLE RELEASE, STUDIO
FLASH, MIRROR, FUJI
VELVIA, ⅟₆₀ SEC AT F22

Captive **wildlife**

If you're beginning to explore the world of nature photography, one of the best ways to start is to visit a zoo or wildlife park where the animals live in authentic enclosures but are easier to spot and more accessible than if they were living in the wild. A further benefit of shooting captive wildlife is that you will be able to take pictures of species from all over the world, without having to fly across oceans.

Choose the right time of day

Most captive animals tend to be more active when it's cool, so early morning and early evening are the most productive times. With this in mind, it's a good idea to arrive nice and early so you can start shooting as soon as members of the public are admitted. Making an early start also means that you will miss the crowds and be able to take pictures without people getting in your way or the animals being too distracted. If there's a zoo or wildlife park local to you, you may also be able to gain permission to visit when the gates are closed to the public. Offering a few colour prints in return for this favour may help.

Feeding times can also provide lots of opportunities to get excellent pictures of captive animals, so find out when certain species like the big cats are fed each day – and make sure you're there, as lions, tigers, leopards and cheetahs tend to be inactive for much of the day.

Falconry centres are ideal for pictures of rare birds of prey such as exotic owls, eagles and hawks. These birds tend to be tethered to perches so members of the public can get very close, and because they're used to seeing people at close

What you need

Camera A 35mm SLR is the best tool for the job – small, light, quick to use, and compatible with a range of lenses and accessories

Lenses More often than not you will need a telephoto or telezoom lens to fill the frame. A 75–300mm zoom or equivalent is ideal, though longer lenses of 400mm or 500mm can be useful too

Film Slow-speed ISO 100 film is a good speed to use – fast enough to give you decent shutter speeds, but offering high image quality

Accessories An electronic flashgun for close-ups or when taking pictures inside where light levels are low. A 1.4x or 2x teleconverter will also be useful for making your telephoto or zoom lenses more powerful. Finally, a monopod is worth taking with you to provide support for long lenses

▼ Crocodile

You would need a lot of courage to get this close to a hungry croc in the wild, but in the safe confines of a zoo it's no problem. Such pictures are well within the range of anyone with a 35mm SLR and 70–210mm or similar telezoom.

CANON EOS 1N HANDHELD, 300MM LENS, CANON 540EZ FLASHGUN, FUJI SENSIA 100, 1/250 SEC AT F/8

▲ Orang-utans
Paul Exton photographed this pair of orang-utans at Chester Zoo, although this is such a well-taken photograph that his subject could quite easily have been in the wild. Using a long lens to fill the frame makes the shot work so well, because it focuses all our attention on the fascinating faces of these great apes.

CANON T90, 300MM LENS, TRIPOD, KODACHROME 200, ⅟₂₅₀ SEC AT F/4.5

quarters they're easy to photograph – you can move in nice and tight and take frame-filling pictures.

Fill the frame for impact

When photographing captive animals and birds, you need to frame the picture so that no clues are included that suggest your subject is actually captive. Watch out for nest boxes, fences, concrete, brick walls or people in the background; and the easiest way to keep such things out of the picture is by cropping as tight as you can on your subject.

Sometimes you will have no option but to shoot through wire mesh. Get as close as possible to the obstruction, then set a telephoto lens to its widest aperture and carefully focus on your main subject. The mesh or bars will be thrown so far out of focus that they don't appear on the final picture. The background will also be nicely blurred by the shallow depth of field, making the animal or bird stand out strongly.

To photograph animals and reptiles behind glass, fix a rubber hood to your lens and press it against the glass to cut out any reflections. To prevent problems with colour casts use an electronic flashgun to provide the illumination – press it against the glass 30.5cm (12in) or so to one side of your camera. Ask beforehand whether flash is allowed.

▲ Goshawk
This is the kind of amazing picture you have the opportunity to take at bird-of-prey centres. Paul Exton used a burst of electronic flash to illuminate his subject. Doing so brought out the vivid colour of its eye, as well as allowing Paul to darken the background so the goshawk stands out proudly.

CANON EOS 1 HANDHELD, 100MM MACRO LENS, CANON 540EZ FLASHGUN, FUJI RDP100, ⅟₆₀ SEC AT F/11

TOP TIPS

- If you contact officials at the zoo or wildlife park you intend to visit, you may be able to get in before the gates officially open and take pictures in peace and quiet
- Feeding times tend to be the most active periods to photograph captive wildlife – plus dawn and dusk, when it's cooler
- Use your longest lenses to fill the frame for dramatic pictures, and use wide aperture to throw distracting backgrounds out of focus

Pets on **parade**

The most accessible of all animals and birds are family pets – dogs, cats, rabbits, horses, snakes, hamsters, tropical fish, lizards, parrots. You name it and someone, somewhere, keeps it as a pet, so although you may not have any of your own, you're bound to know someone who does. Failing that, pop along to your local pet shop and ask if you can photograph anything interesting in stock.

Photographing our canine companions

Dogs are perhaps the most common and the most intelligent pets, so they also tend to be the easiest to photograph. A well-trained dog will respond to commands and do as it's told, so you can usually get dogs to do pretty much what you want, whether it's to sit still, jump for sticks, offer a paw, lie down and so on.

Your best bet when taking pictures of a dog is to take it for a walk to the local park or beach where it can have a good run around to burn off excess energy. This will give you the chance to shoot action pictures, setting a fast shutter speed to freeze it, or a slow shutter speed for panned shoots (see chapter 10 for tips and advice). Dogs also like water, so let your subject go for a splash, then photograph it shaking the water off afterwards. Taking along a friend, or the dog's owner if it doesn't belong to you, is a good idea as you need an extra person to control the situation and offer a distraction.

This extra help will also come in handy when you take some posed portraits. Initially, get your subject into position in nice light against an uncluttered background, then ask your companion to make a sudden noise, such as a click of the tongue, or whisper the dog's name, to encourage an alert response that will add character to your pictures.

Use a telezoom lens for both action shots and portraits. An 80–200mm or similar lens will be ideal for filling the frame but without your having to be too close, while an aperture of f/4 or f/5.6 will throw the background nicely out of focus.

Picture your furry friends

Cats are great photographic subjects. Kittens are incredibly cute, and because they're so inquisitive you can usually keep them occupied with something as simple as a ball of string or piece of fluff. Another option is to take the kitten or cat outdoors into the garden, then photograph it peering through long grass towards you. Shoot from ground level, and rustle the grass with your hand to attract its attention – kittens respond well to anything like this, as they are practising hunting skills.

Other pets such as rabbits and guinea pigs can be photographed in a similar way. They will stay in position for ages if you give them some food to nibble on, so all you need to do is position your subject on the lawn, then back off, stretch out on the ground, and fire away. Backlighting the animal's fur with the sun will add interest.

◄ Greyhound
The boundless energy of this dog has been perfectly caught by Geoff Du Feu. The picture was taken on a Norfolk beach where his subject had endless space to stretch his legs, giving Geoff lots of opportunities to take action shots like this.
CANON EOS 1-RS HANDHELD, 70–210MM ZOOM LENS, FUJI SENSIA 100, 1/250 SEC AT F/5.6

▲ Kitten

Cats and kittens get themselves into the most awkward places – this one was photographed peering from a log pile. Its facial expression suggests getting in was easier than getting out again!

CANON EOS 1-RS HANDHELD, 50MM LENS, FILL-IN FLASH, FUJI VELVIA, ¹⁄₁₂₅ SEC AT F/11

A bird in the hand

Birds are best photographed sitting on a perch rather than behind the bars of a cage. Position the perch close to a window so the bird is attractively lit, or use your flashgun to provide the illumination – bouncing the flash off a wall or the ceiling will soften the light, though if you're taking a close-up, you can aim the flash directly at the bird. To prevent the flash being overpowering, set the output on your gun to –½, or –1 stop if it has flash exposure compensation.

To make your pictures more interesting, use a sheet of colourful card as the background – choose a colour that complements the colour of the bird's plumage, or you could use a contrasting colour if you want a more dynamic effect.

▲ Green iguana

Exotic pets like this aren't common, but if you visit a local pet shop or reptile centre you will be able take pictures there – especially if you offer to return the favour with a print or two. Geoff Du Feu set up this shot using electronic flash to light his subject against a simple backdrop.

CANON EOS RT, 100MM MACRO LENS, TRIPOD, CABLE RELEASE, ELECTRONIC FLASH, FUJI VELVIA, ¹⁄₆₀ SEC AT F/11

TOP TIPS

- Be patient – pets are used to being around people, but that doesn't always means they will do what you want, when you want
- Write a list of picture ideas before you start so you've got something to work on
- Do any groundwork such as setting up your camera equipment before introducing the animals or bird into the situation. This will give you more shooting time before they become restless

Wild **pictures**

Once you start photographing animals and birds in the open, most successful wildlife photographers would tell you that a fascination for and love of natural history is far more important in many ways than the type of camera or lens you use, because without intimate knowledge of different species of animals and birds, your chance of taking good pictures will be seriously reduced.

Learning how to see but not be seen

What you wear when photographing wildlife is important, because it reduces the chance of being spotted by your subject. Camouflaged jackets and trousers are perfect, though any dull or green colour works. Cover up any light spots, such as hands with gloves, and use a net cover over your face when stalking animals such as deer. Also make sure there are no shiny bits on cameras, lenses and tripods that reflect the light – you can cover these with black tape.

Many animals rely on their sense of smell rather than sight, so you need to make sure they don't pick up your scent. Avoid wearing aftershave, deodorants and perfumes, and always stay downwind. A useful tip is to roll on the ground so your clothing picks up a natural smell.

When an animal is in sight you must move very slowly, and crouch down rather than stand up, as you will be harder to see; and if you're spotted remain perfectly still until the animal relaxes again: any sudden movements and they will be off. The key is to be patient. Make slow, careful movements and make sure you see your quarry before it sees you.

Long lenses can be a great help because they allow you to shoot from a safe distance. However, you still need to get within a few metres with a 400mm or 500mm lens, so they don't let you off the hook completely. Also, different animals

> ### What you need
> **Camera** A 35mm SLR is the best camera for wildlife photography
> **Lenses** The longer the better for wild animals and birds – at least 300mm, but preferably 400–600mm
> **Film** Carry a range – ISO 100 for decent light and ISO 200–400 for poorer weather or shady locations
> **Accessories** A monopod or beanbag to support your lens, netting and camouflaged material to disguise your gear, a 1.4x or 2x teleconverter to increase the focal length and magnification power of your lenses

have a different 'fear zone' depending on the species and their habitat. Deer in the wilds of Scotland have a fear zone of about 1.5km (1 mile) due to hunting and culling, while those in Richmond Great Park are used to seeing humans, so their fear zone is down to about 40m (125ft). The thing is, if an animal doesn't see or smell you, there's nothing for it to fear, so you can often get within 3–4m (9–12ft).

Using a hide can help

Working from a hide is an excellent way to photograph timid animals and birds, because it allows you to get close to your subject without them being aware of your presence.

Hides can be made very easily by draping a large sheet of camouflaged or drab canvas over a framework of poles driven into the ground. A selection of holes in the sides will allow you to poke the lens through, and undergrowth can be added as further concealment. Purpose-built hides collapse into a small storage bag for easy carrying and can be erected in a matter of minutes, like modern dome tents.

◀ **Deer in mist**
There are few sights more breathtaking than adult red deer stags standing motionless in the early morning mist. Fortunately, Simon Stafford didn't need to trek to the Highlands of Scotland to get this superb picture – he just nipped along to Richmond Park near London on a crisp winter's morning.
NIKON F5, 500MM LENS, TRIPOD, CABLE RELEASE, FUJI PROVIA 100, ⅛₂₅ SEC AT F/5.6

▲ Kingfisher

One of the UK's most magnificent birds, the kingfisher is also very elusive. Paul Exton and a friend set up a hide and perch on the edge of a mere with the prime intention of attracting kingfishers. A glass tank partly submerged in the water and regularly baited with small fish encouraged the birds to use the perch, and this is one of dozens of pictures taken by Paul. The kingfisher was only 2.5m (8ft) away, but being so small – 15cm (6in) from beak tip to tail – he still needed to use a 100–400mm zoom at 400mm.

CANON EOS1N, 100–400MM IMAGE STABILIZING ZOOM LENS AT 400MM, TRIPOD, FUJI SENSIA 100, 1⁄60 SEC AT F/8

▼ Red squirrel

Red squirrels are rare in the UK, so if you're lucky enough to see one, make the most of it. Paul Exton stalked this one through woodland, edging over closer with his camera on a tripod until he could fill the frame.

CANON EOS 1, 300MM LENS WITH 1.4X TELECONVERTER (420MM), TRIPOD, KODAK EKTACHROME 100, 1⁄25 SEC AT F/5.6

Before using the hide you first need to find a suitable location where wildlife activity takes place. This could be the nest site of a blackbird or kingfisher, a badger run or a deer's favourite watering hole.

So the animals and birds aren't alarmed by the sudden appearance of the hide, you should erect it quite a distance away at first, wait a few days, move it closer, wait another few days, move it even closer and so on until it is in the desired spot. Patience is the key – if you try to rush this process you'll end up with no wildlife to photograph because you will frighten it away. Once you're ready to enter the hide it can also be useful to take a friend along to act as a decoy – he or she can leave when you're inside, and this will fool most animals and birds into thinking no one is there.

It may take many hours of waiting quietly and patiently before any activity begins, so make sure you have food and

▲ Grass snake

This is a young male, no bigger than a clenched fist when coiled like this. Paul Exton heard of an area where grass snakes were often seen, so he decided to visit. Over two hours of searching were in vain, then he spotted movement in the undergrowth and discovered this perfect specimen, which he photographed in afternoon sunlight.

CANON EOS 1N, 100MM MACRO LENS, TRIPOD, FUJI VELVIA, ⅛ SEC AT F/16

▼ Common tern

You don't always have to use long telephoto lenses to take successful wildlife pictures. Here, Paul Exton set up his camera and wide-angle zoom on a ground spike pushed into the sand near the tern's nest, then waited for the bird to return before taking this environmental portrait of the bird in its natural surroundings. The camera's shutter was fired from 40m (140ft) away using a remote infrared release.

CANON EOS 5, 20–35MM ZOOM LENS AT 28MM, REMOTE RELEASE, GROUND SPIKE, FLASHGUN, FUJI SENSIA 100, ½₆₀ SEC AT F/11

drink at hand to sustain you throughout your stay, plus warm clothing to keep you comfortable if the temperature drops. Committed wildlife photographers stay in their hides for days on end, watching and waiting and always keeping a camera ready in the event that something comes into range. They may also leave the hide in position and return to it over time.

Use long lenses to magnify your subject

Long telephoto lenses are essential for serious wildlife photography, simply because most animals and birds are very timid, making it difficult for you to get close to them. As a minimum you may be able to get away with a 300mm for some subjects, but a 400mm, 500mm or 600mm lens is much better because it will allow you to fill the frame from further away.

If you can't afford such a powerful lens, a 2x teleconverter will double the focal length of a shorter telephoto lens, turning a 300mm lens into a 600mm lens, for example, or a 70–210mm zoom into a more versatile 140–420mm.

A monopod will also come in handy for supporting the lens and preventing camera shake. Alternatively, rest the camera on natural supports such as a tree stump, rock or fence, and use a beanbag as a cushion.

▶ Razorbill

Seabirds tend to live in large colonies and provide relatively easy pickings for photographers – in parts of the UK, boats ferry visitors out on an almost daily basis. You still need a long lens to take pictures like this, however.

CANON EOS 1, 300MM LENS, 1.4X TELECONVERTER (420MM), TRIPOD, KODAK EKTACHROME 100, ½₂₅₀ SEC AT F/5.6

Garden **wildlife**

A good way to cut your teeth as a nature photographer is by concentrating on the species of animals and birds that are common visitors to gardens. Although garden wildlife is more timid and elusive than that found in zoos and wildlife parks, photographing it is more challenging and satisfying because your subjects are truly wild, and have the sharp senses that all wild animals do.

What type of subjects might you see?

The animals and birds you're likely to see in a garden depend to a great extent on how big it is, the type of trees and plants it contains, and whether you're in a rural or urban area.

Common birds in most gardens include robins, tits, blackbirds, starlings, sparrows, thrushes and so on. In bigger gardens you will also see magpies, jays, pigeons and doves, perhaps even owls, woodpeckers, kestrels and sparrowhawks. Don't worry if you only see a few of these species, though – you can take great pictures of any type of bird.

Animals are thinner on the ground usually, especially in a typical small garden with lawn and flowerbeds – to see a reasonable variety you need to visit bigger parks and gardens that are planted with trees and shrubs and offer hiding places in the undergrowth. Then the list will include hedgehogs, squirrels, rabbits, mice, shrews, and in some cases foxes, badgers, and the occasional deer. Insects, butterflies and reptiles such as frogs, toads and newts are also fairly common, along with slow worms and grass snakes.

What you need

Camera A 35mm SLR is ideal for photographing garden wildlife
Lenses Use your longest lenses – telezooms and telephotos up to 300mm should be powerful enough, but the longer the better. A 50mm standard lens, macro lens, or the close-focusing setting on your telezoom will be useful for close-ups of smaller subjects such as frogs, mice, butterflies and so on
Film ISO100 is a good general speed for wildlife photography
Accessories A tripod or monopod to keep your camera stable

Actually, once you start to think about the type of animals and birds that frequent gardens, the list is quite extensive, so rather than think of garden wildlife as the poor cousin of more exotic species found in the wild, make photographing it a challenge – great pictures are possible.

Use food to attract wildlife to your garden

Animals and birds generally visit gardens in search of food, so if you make sure there's always a reasonable supply, you will be rewarded with regular visits. Bacon rind, breadcrumbs, suet and nuts are ideal for attracting birds, for example, while most animals will find their own food – squirrels collect nuts in readiness for winter and can often be seen burying them in lawns and flowerbeds – even plant pots – so they can retrieve

◄ Robin

This superb portrait of a robin is a good example of the type of picture you can take in your own back garden. The subject is very common, but it has been photographed in a very polished, professional way.

CANON EOS 1N HANDHELD, 100–400MM IMAGE-STABILIZING ZOOM LENS AT 400MM, FUJI SENSIA 100, 1/25 SEC AT F/5.6–8

► Common frog

For this shot, Simon Stafford placed some old plant pots among undergrowth in his garden, then waited for a resident frog to hop inside. Because he had controlled the situation, Simon was able to set up his camera and be ready to take the picture when the frog was in place.

NIKON F5, 200MM MACRO LENS, TRIPOD, KODAK EKTACHROME E100VS, 1/60 SEC AT F/5.6

► **Marbled white**
Butterflies are common garden visitors during spring and summer, and pictures like this can be taken fairly easily using a standard 50mm lens, or the close-focusing setting of a zoom lens – if you have a macro lens, so much the better.

CANON EOS 1V, 180MM MACRO LENS, TRIPOD, CABLE RELEASE, WHITE REFLECTOR, FUJI SENSIA 100, ⅛ SEC AT F/8

them later when stocks are low. If you have a pond, frogs will soon find it and may use it as a breeding ground.

Where you put the food is as important as what you put out because it gives you control over the situation. So choose specific locations where the background is interesting and where you can take pictures from a concealed position. It's also a good idea to hide the food from view as well, so the animals and birds can find it without too much trouble but you can't see it, so it won't appear in your pictures. For pictures of birds, for example, you could set up a natural perch from an old branch so it's against an uncluttered, natural background, then put food on the rear side. You can then wait in position until birds land on the perch and get your pictures.

A fork or spade stuck in the ground works well, too – robins can often be seen sitting on a garden fork waiting for worms to appear in the soil below.

How to get close to your subject
An average telezoom lens in the 70–210mm or 75–300mm range should be powerful enough for you to take successful pictures of garden wildlife, though you still need to be fairly close to fill the frame with small birds.

Shooting through an open window from inside your house or a garden shed will keep you well hidden, so try to tempt your subjects to come as close as possible by putting food out in strategic spots.

Another option, if your garden is big enough, is to erect a hide. You can buy purpose-made hides that are basically like

tents fashioned from camouflaged fabric. However, making your own is relatively easy. All you need to do is drive four wooden poles into the ground, tie crossbars between each pair to make a frame, then drape canvas sheets, tarpaulin or the flysheet of an old tent over it – anything that's drab in colour will work.

Stake the bottom edges of the sheet to the ground with tent pegs to stop it flapping in the wind, leaving an area free so you can get in, then cut a flap or hole in the front face of the hide so you can poke your lens through, and a series of small spyholes in other areas so you can see what's going on outside the hide.

Finally, place a waterproof groundsheet inside the hide so you can sit on the floor without getting damp, plus a folding stool or large cushions so you can sit comfortably for long periods.

TOP TIPS

- Be patient – it may take days or even weeks before you start taking successful pictures, so don't give up too soon
- If your own garden is not very big – or you don't have one – ask a friend, neighbour or colleague if you can take pictures in theirs. A local park is also a good place to photograph wildlife
- Shoot at wide apertures such as f/4 or f/5.6 with a telephoto lens so the background is thrown well out of focus

◄ **Grey squirrel**
This species is a regular visitor to both urban and rural gardens. If you put out suitable food, especially during early autumn, this should encourage grey squirrels to come close enough for you to take frame-filling pictures with a moderate telephoto lens. You should still hide away so you're not seen.

CANON EOS 1, 300MM LENS, TRIPOD, FUJI SENSIA 100, 1/250 SEC AT F/5.6

Chapter ten
movement

▶ **Venice dawn**

NIKON F90X, 80–200MM
ZOOM, 81C WARM-UP
AND SOFT-FOCUS
FILTERS, TRIPOD, CABLE
RELEASE, FUJI VELVIA,
1 SEC AT F/22

Expressing **movement**

When photographing moving subjects it's tempting to set a fast shutter speed and freeze all traces of action. This can produce amazing results, but isn't always the best solution because by freezing movement you can easily lose drama and excitement. The easiest way to show movement is by intentionally introducing some blur into your pictures, and there are two ways to do this.

Use a slow shutter speed to blur your subject

The easiest is to use a slower shutter speed than would be needed to freeze the subject, so it blurs. This speed can be anything from ¹⁄₆₀ sec to many seconds, depending on how fast your subject is moving, and if you keep the camera still your subject will simply blur as it passes, while the background and anything stationary in the scene remains sharp.

Examples of where this technique can work include runners at the start of a marathon, athletes passing by during a track race, a canoeist passing through a slalom gate, commuters rushing off a train in the morning, or any situation where crowds are moving, such as a busy marketplace, in a sports stadium, on a nightclub dance floor and so on.

If you use a shutter speed of ½–1 sec to photograph the start of a marathon, for example, all the people in the shot will blur to give a strong sense of motion, while a shutter speed of maybe ⅛–¼ sec would work for a tighter shot of athletes, and 1–2 sec for commuters. With crowds you can use longer exposures – of several seconds – so the sea of moving bodies

▼ Zanzibar

This beautiful image captures the colour and character of life on the tropical island of Zanzibar perfectly. While exploring the island, Pete Adams noticed that as the tide went out fishermen would cycle back home along the beach, and it occurred to him that this would make a great panned shot with the colour of the ocean behind. Setting himself up, he then waited for the fishermen to make their daily trip and took a series of pictures, using a slow shutter speed to create an impressionistic effect.

OLYMPUS OM4-TI HANDHELD, 50MM LENS, FUJICHROME VELVIA, ¹⁄₃₀ SEC AT F/16

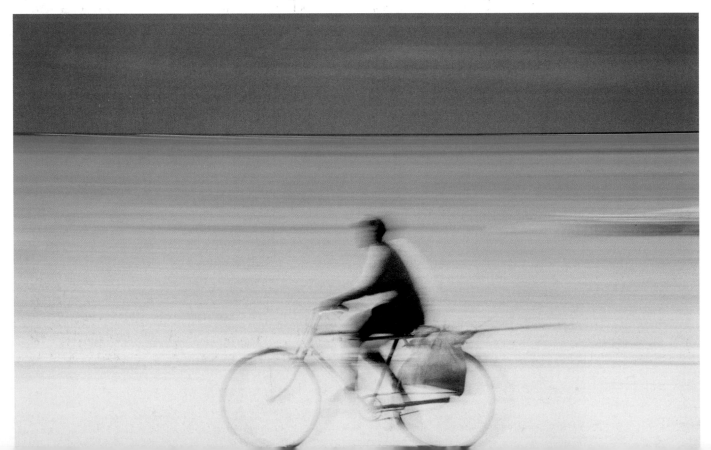

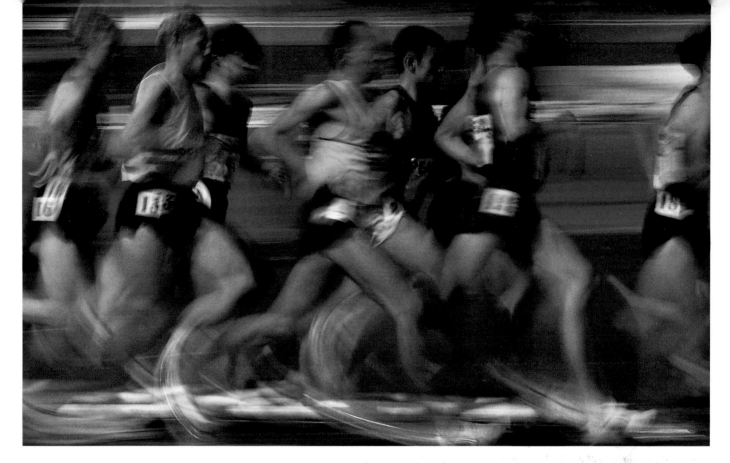

▲ Athletes

By using a slow shutter speed and panning the camera, photographer Simon Stafford has captured a wonderful feeling of grace and flow in this picture that just wouldn't have been present if he had frozen all traces of movement. Ironically, creating such effects is also easier than using high shutter speeds to freeze action, but the impressionistic effect you get is far more effective in capturing a sense of movement.

NIKON F4S HANDHELD, 200MM ZOOM LENS, FUJI RDP 100, ⅕ SEC AT F/16

records as a series of streaks or swirls, while any small groups of people standing fairly still will come out sharp – a bit like moving water flowing around a rock in the middle of a stream. Try this effect on fairgrounds or crowded markets at dusk, when you can use exposures of maybe 10 sec.

Pan the camera to blur the background

A technique that works even more successfully, and can be used for just about any moving subject, is panning. Again, a slow shutter speed is used, but instead of keeping the camera steady you track your subject with it by swinging your body, and trip the shutter while you're moving. This produces an image where your subject comes out relatively sharp but the background blurs. The effect can look stunning, whether you're shooting a professional event or a school sports day.

Subjects that follow a predetermined route are well suited to panning, as you can predict where they will be in relation to the camera and capture them in the right place at the right time. Ideally, your subject should also move directly opposite you so it remains the same distance away from the camera throughout the exposure. If your subject is moving diagonally, the effect of

the pan won't be as smooth, though uneven panning can produce interesting results, so it's always worth experimenting.

To show the panning effect at its best, choose a background containing details that will look effective when blurred, such as foliage. Plain, neutral backgrounds don't work so well because there's less evidence of blurring.

The shutter speed you use is also very important – if it's too fast you won't get enough blur, while if it's too slow you will get blur in both the background and subject – though doing so can work well on some subjects, so it's worth experimenting with a range of shutter speeds, noting which speed was used for which frame, then comparing the results with your notes to see how the effect varies with different shutter speeds. Do this with different subjects, too, using the following speeds as a guide:

Person jogging	⅕ sec down to 1 sec
Person running	¹⁄₃₀ sec down to ½ sec
Cyclist	¹⁄₃₀ sec down to ½ sec
Galloping horse	¹⁄₆₀ sec down to ¼ sec
Family car	¹⁄₁₂₅ sec sec down to ¹⁄₄₅ sec
Motor racing	¹⁄₂₅₀ sec sec down to ⅛ sec

The slower the shutter speed, the more blur you will get, and if your panning technique is uneven this will result in images that have a strong impressionistic feel. That said, once you master the panning technique you will be able to keep your subject sharp even when using very slow shutter speeds.

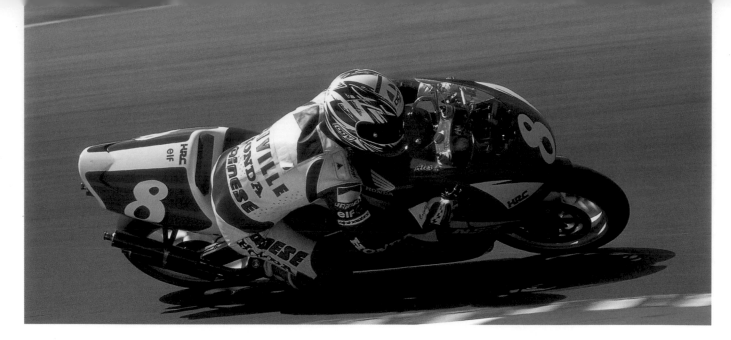

▲ Motorsport

Producing perfect panning pictures like this takes skill and great timing. The key is to match the pace of the pan with the speed of your subject so that it remains in the same part of the frame throughout the exposure, and to use a shutter speed that's slow enough to record blur in the background, but not too slow that your subject blurs as well – with fast-moving subjects like this, shutter speeds of $\frac{1}{125}$ sec or $\frac{1}{250}$ sec are slow enough.

CANON EOS 1N HANDHELD, 100–400MM IMAGE-STABILIZING ZOOM LENS AT 400MM, FUJI PROVIA 100, $\frac{1}{250}$ SEC AT F/8

Step-by-step guide to panning with any subject

Take a meter reading with your camera and make sure the shutter speed you need to use is suitable for the subject. If it's too fast, set a smaller lens aperture so you also need to set a slower shutter speed. If it's too slow, set a wider lens aperture and faster shutter speed. Choose the point you're going to focus the lens on – ideally a point opposite you where your subject will pass.

As your subject approaches the predetermined spot, track it with your camera by looking through the viewfinder. Try to move the camera at the same pace as your subject so it stays in the same part of the frame.

Just before your subject reaches the point you've focused on, gently press the camera's shutter release button while still swinging the camera to keep your subject in the viewfinder. Don't wait until your subject reaches the point, otherwise you may start the pan too late.

Keep the camera moving with your subject throughout the exposure, and even after the shutter has closed to end the exposure. This will ensure a smooth result.

Although it sounds, and is, straightforward, panning takes a lot of practice to master, so don't expect perfect results on your first attempt.

The key to success is moving the camera smoothly at an even pace and not jerking it mid-exposure. To achieve this you should swing the camera from the hips, keeping your elbows tucked into your side so the whole of your upper body moves

in one fluid action. When using a long lens it's also a good idea to mount the camera or lens to a monopod so it provides support, and also a handy pivot which can aid your panning technique while avoiding camera shake when using a heavy telephoto or telezoom.

If you can't master panning but like the effect, try a similar technique known as tracking. With this, you move alongside your moving subject and fire away so your subject is frozen but the background blurs. Car photographers use this technique all the time by shooting through the open side window of a moving car, or by crouching in the boot.

▼ East Gill Force, North Yorkshire, England

Using a long exposure allows you to capture the graceful motion of moving water. This tends to work better than trying to freeze the water, and it is a popular technique among photographers simply because it's so effective. The key is to use a shutter speed of 1 sec or longer.

PENTAX 67, 165MM LENS, TRIPOD, CABLE RELEASE, POLARIZING FILTER, FUJI VELVIA, 8 SEC AT F/16

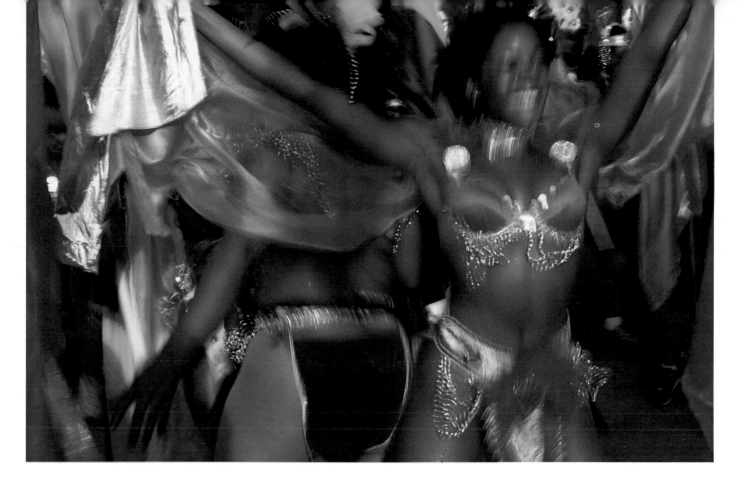

Zooming the camera suggests movement

Another way to introduce a sense of motion to your pictures – even if the subject isn't actually moving – is to use the zooming technique. Set your camera to a slow shutter speed – anything from $\frac{1}{8}$ sec down – then as you trip the shutter, zoom the lens through its focal length range from one end to the other. This turns your subject into a series of stunning colourful streaks converging on the centre of the frame.

As with panning, you need to zoom the lens smoothly and evenly through the exposure so the zoomburst effect is also smooth and even, rather than jerky. It's therefore a good idea to have a few practice runs, perhaps without film in the camera, to gauge how fast or slow you need to zoom the lens so that you don't reach the end of the focal length range before the shutter closes to end the exposure.

▲ Trinidad

Intentionally blurring movement is a great way to capture the drama and excitement of an event, whether it's fast-moving sport or, in this case, people having fun. The mixture of bright colours, blurring and the expressions on the faces of the people depicted is both evocative and intoxicating – you can almost hear the music and sense the party atmosphere all around.

OLYMPUS OM4-TI HANDHELD, 50MM LENS, FUJI VELVIA, ¼ SEC AT F/11

▼ Piccadilly Circus, London

Zoom your lens to add a sense of movement and drama to everyday scenes and subjects. In this case I wanted to capture the hustle and bustle of one of London's busiest areas, and this proved to be the most effective way of achieving the effect I had in mind.

OLYMPUS OM4-TI HANDHELD, 35–70MM ZOOM LENS, FUJI VELVIA, ¼ SEC AT F/16

TOP TIPS

- Wait until light levels are low to photograph crowds – that way you can set a long exposure to record lots of blur
- Experiment with slower shutter speeds of a second or more on everyday subjects, and create interesting impressionistic images
- Combine panning with a burst of electronic flash and you can produce stunning results (see pages 20–21)

Freezing **action**

Think of a great action shot, and the image you're likely to picture in your mind shows a fast-moving subject stopped in its tracks – a pole vaulter arching over the cross beam, a high diver caught with his fingertips just above the pool's surface, a sprinter at full stretch just crossing the finish line. These dramatic images freeze a split second in time.

What you need

Camera Modern 35mm SLRs make action photography easier than ever before – super-fast shutter speeds and fast, accurate autofocusing will increase your hit rate

Lenses Long lenses, from 200mm up, are the norm for sport and action photography because, more often than not, the subject is some distance away from the camera. However, where you can get in nice and close, even wide-angle lenses can be used successfully

Film Use the slowest film you can. Outdoors, in bright sunlight, ISO 100 film will be fast enough. In poor weather or indoors, ISO 400 or faster will be required

Time your shots to perfection

The key with good action photography is being able to predict and capture that split second – no mean feat when you think about it. To do that you need to have an understanding of the event or subject you are photographing so you can plan ahead and have a pretty good idea when a great opportunity is likely to arise. You also need to make quite sure that you're in the right position to get a good view, and that you have the right equipment for the job.

Capturing action at its peak is easier with some sports than others. In many cases, there's an optimum moment when everything comes together and time seems to slow down. Think of a pole vaulter clearing the beam – as he reaches the required height and arches his back, there comes a point when he seems frozen in mid-air. It's the same with show jumping, motocross, the long jump, hurdling and any other sport that involves leaving the ground momentarily.

A tennis player about to serve is the easiest to photograph,

▶ Motocross

Capturing airborne subjects is a real test of your focusing and timing. Although pre-focusing is the best approach, you literally have to focus on thin air because that's where your subject is going to appear. Using the top of the hill as a guide will help you to determine where best to focus – then it's simply a case of waiting until your subject appears. Sounds easy – just try it!

CANON EOS 1N, 300MM LENS, 1.4X TELECONVERTER (420MM), MONOPOD, FUJI SENSIA 100, 1/500 SEC AT F/5.6–8

when the ball is airborne and his racket is swung backwards. Similarly, a rugby player about to take a penalty kick makes an easier target as his leg swings back in readiness to boot the ball. This crucial moment is easier to capture because it's easier to predict – you know exactly what's going to happen and when it's going to happen, so you can plan and prepare for it.

Choose the right shutter speed

An important consideration when freezing action is choosing a shutter speed that's fast enough for the job. There are three factors that dictate this – how fast your subject is moving, how far away it is from the camera, and the direction it's travelling in relation to the camera.

If your subject is coming head on, for example, you can freeze it with a slower shutter speed than if it's moving across your path. Similarly, a faster shutter speed will be required to freeze a subject that fills the frame than if it only occupies a small part.

A shutter speed of $\frac{1}{1000}$ or $\frac{1}{2000}$ sec is fast enough to freeze most action subjects. Unfortunately, light levels won't always allow you to use such high speeds, even with your lens set to its maximum aperture, so you need to be aware of the minimum speeds required for certain subjects.

▲ BMX

Getting in close with a wide-angle lens can produce amazing results. In this case, Paul Exton stood on the top of the ramp and used a 15mm fisheye lens to give a really dramatic perspective – the BMX rider was only 30cm (12in) from Paul, who was almost knocked off the ramp on a couple of occasions! A burst of flash helped to freeze his subject in mid-air and brighten the picture.

CANON EOS1N HANDHELD, 15MM FISHEYE LENS, FLASH FILL-IN, FUJI SENSIA 100, $\frac{1}{250}$ SEC AT F/8

Use the table below as a guide.

Subject	Across path full frame	Across path half frame	Head-on
Jogger	$\frac{1}{250}$ sec	$\frac{1}{125}$ sec	$\frac{1}{125}$ sec
Sprinter	$\frac{1}{500}$ sec	$\frac{1}{250}$ sec	$\frac{1}{125}$ sec
Cyclist	$\frac{1}{500}$ sec	$\frac{1}{250}$ sec	$\frac{1}{125}$ sec
Trotting horse	$\frac{1}{250}$ sec	$\frac{1}{125}$ sec	$\frac{1}{60}$ sec
Galloping horse	$\frac{1}{1000}$ sec	$\frac{1}{500}$ sec	$\frac{1}{250}$ sec
Tennis serve	$\frac{1}{1000}$ sec	$\frac{1}{500}$ sec	$\frac{1}{250}$ sec
Car at 40mph	$\frac{1}{500}$ sec	$\frac{1}{250}$ sec	$\frac{1}{125}$ sec
Car at 70mph	$\frac{1}{1000}$ sec	$\frac{1}{500}$ sec	$\frac{1}{250}$ sec
Formula 1 car	$\frac{1}{2000}$ sec	$\frac{1}{1000}$ sec	$\frac{1}{500}$ sec
Train	$\frac{1}{2000}$ sec	$\frac{1}{1000}$ sec	$\frac{1}{500}$ sec

Anticipating the action

Allied to accurate focusing is the need to time your shots very carefully so you capture the most exciting moment. If you're new to action photography this seems like an impossible task – everything happens so quickly, and before you get the chance to trip the shutter, it's over.

The key is to anticipate what's going to happen next so you're ready to capture it. With sports, understanding the event helps a great deal because you'll know where your subjects are going and will be able to recognize the build-up to something exciting.

Getting to know your equipment inside out will help, too. If you have to fiddle around with the controls, or even think about what you're doing, you'll miss great shots, whereas if you can operate instinctively you'll be able to concentrate fully on your subject. As always, practice makes perfect.

Finally, it's no good waiting until your subject is exactly where you want it to be before tripping the shutter, otherwise during the time it takes for your brain to tell your finger to hit the release your subject will have passed. Instead, you need to fire just before your subject reaches the desired point.

Anticipating the action is much easier with subjects that follow a predetermined course because you've got obvious reference points where you know that action will take place, and if you miss it the first time there will be plenty of other opportunities. Horse-racing, motor-racing, hurdling, pole-vaulting, swimming and ski-jumping are just a few examples.

▲ Jet skier

Subjects that follow a set course are quite easy to photograph because you can pre-focus and wait. That said, you still need perfect timing, because a subject moving at high speed can cover a lot of ground in a fraction of a second, and shots can easily be missed.

CANON EOS 1N, 300MM LENS, 1.4X TELECONVERTER (420MM), MONOPOD, FUJI SENSIA 100, 1/500 SEC AT F/5.6

TOP TIPS

- Don't think that machine-gunning your subject with a fast motordrive will guarantee success – you still need to time your shots carefully to capture the peak of the action
- Accurate focusing is vital if you want your subject to be sharp. See pages 54–56 for advice on focusing on action
- Spend time looking for the best viewpoints so you can capture your subject against clutter-free backgrounds, and fill the frame for impact

► Kayak championships

The expression on this kayaker's face says it all, and photographer Simon Stafford's timing couldn't have been better. You literally have a fraction of a second to take a picture like this – hesitate and the moment will be lost – so great skill and judgement is required to get it right time after time. Fortunately the reward – a superb shot – makes the effort worthwhile.

NIKON F90X HANDHELD, 300MM LENS WITH 1/4X TELECONVERTER, FUJI PROVIA 100, 1/500 SEC AT F/4

Everyday action

Although fast-moving sporting events undoubtedly make for exciting pictures, don't ignore subjects that are around you every day. Action photography is all about capturing movement, so anything that moves makes a potentially great action picture. And when shooting everyday action you can get closer to your subject than with many sports, so you don't need long telephoto lenses, either.

Choose your subject

Kids are ideal subjects when taking pictures of everyday action. You can photograph them playing football in the park, racing around on their bicycles or skateboards, running around with their pet dog, or taking part in school sports day events. Kids have boundless energy, so they're always on the move, presenting you with a whole host of great photo opportunities. They will also love the idea of being photographed while they're actually doing something – it's much more fun than posing for formal portraits.

Family pets are another accessible subject. Dogs, in particular, love to run wild when you take them out for a walk, so next time, why not take a camera as well and capture their antics on film – jumping for sticks, racing around to burn off some energy, splashing in water and so on.

With kids and animals, use a slow shutter speed, or have a go at panning so your pictures capture the sense of energy and excitement. Alternatively, shoot at fast shutter speeds for action-stopping shots – this is ideal for pictures of your dog caught in mid-air as it jumps to catch a stick or ball.

Where there are people there's action

For movement of a different kind, all you need to do is pop along to your local town or city centre on a busy shopping day. There you will find crowds of people hurrying in and out of shops and down the streets. Fill the frame with people using a telephoto lens, then set a shutter speed of 1 sec or slower so they blur beyond recognition (see the athletes on page 147). Crowds arriving at or leaving soccer games provide the perfect ingredients for some impressionistic slow-shutter speed pictures if you can photograph them from a high viewpoint. Hoards of commuters rushing along station platforms every morning also make great subjects, as do people milling around in markets.

Fairs, carnivals and processions provide yet more subjects to photograph – such events often feature attractions such as

motorcycle display teams, bungee-jumping and so on. Or why not visit the fairground when it rolls into town and photograph the action there – dodgem cars, and spinning rides such as the big wheel and waltzer?

A walk in the park can be productive photographically – kids on roller-skates and skateboards, joggers and cyclists, all these provide opportunities not only to practise your action photography skills but also to produce interesting pictures at the same time.

Basically, if it moves – shoot it.

◀ In a spin

As well as capturing action you can also create your own. My son loves to be swung around, so while fooling around in the garden one day I decided to take a picture of him mid-swing. To do this I held my son's right hand in my left, while my wife held his left hand in her right. The three of us then spun around while I held and operated the camera with my right hand. Using a slow shutter speed caused the background to blur, while a burst of flash froze any movement in Noah.

NIKON F90X HANDHELD, 28MM LENS, VIVITAR 283 FLASHGUN, FUJI SENSIA II 100, 1/15 SEC AT F/16

▶ Fairground ride

Funfairs are great places for action shots – the dodgem cars and spinning rides all providing colourful and exciting photo opportunities. One option is to combine a slow shutter speed with flash, as for the shot of the car above, to record frozen and blurred images on the same frame, or, as here, simply to use a long exposure and record the spinning lights as colourful light trails. It's an easy technique, but always produces interesting results.

OLYMPUS OM4-TI, 28MM LENS, TRIPOD, CABLE RELEASE, FUJI VELVIA, 30 SEC AT F/11

▲ Porsche

Another set-up shot, though you could take similar pictures simply by waiting for interesting cars to pass by. I used to own this car, a gleaming old Porsche 911, prior to the arrival of the bundle of fun in the picture opposite, and often used to photograph it for posterity. On this occasion I asked my wife to drive the car up and down a quiet country lane while I fired away. It was dusk, so light levels were low. This enabled me to use slow shutter speeds to get plenty of blur into the shots, while a burst of flash momentarily froze the car to record a sharp image as well. The blue cast was created by exposing unfiltered tungsten balanced film in daylight.

NIKON F90X HANDHELD, 28MM LENS, VIVITAR 283 FLASHGUN, FUJI RTP TUNGSTEN-BALANCED FILM, 1/8 SEC AT F/8

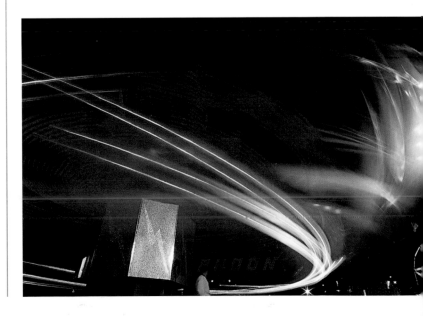

Passing **time**

Our whole lives revolve around time, and time controls our very existence, governing exactly what we do with unerring precision. The rhythms of nature are based on passing time – the ebbing and flowing of the tide each day, the rotation of the earth on its polar axis, the changing of the seasons – and these are the yardsticks by which certain cultures still measure their existence.

Shooting a time-lapse sequence

Time-lapse photography is a great way of representing time, and any number of subjects can be used – a sunrise or sunset, a flower opening, a butterfly emerging from a chrysalis, the same scene photographed during the four seasons of the year or at different times of day.

For the best results your camera needs to be set up in exactly the same position and the same lens and aperture used, so each picture is identical except for the physical changes brought on by the passing of time.

For short-term sequences this is easy – you can mount your camera on a tripod and leave it in position until you've finished. If the time lapse you are shooting takes place over just a few minutes or maybe a few hours – such as the way the quality of light changes through a single day – you can stay beside your camera and take another picture at pre-determined intervals.

Where this isn't possible, you can either return to the camera as and when required, or buy a special electronic release with a timer that can be set to trip the shutter at preset intervals. This approach works well on time-lapse sequences that are being captured in a studio setting, because you can leave everything in place.

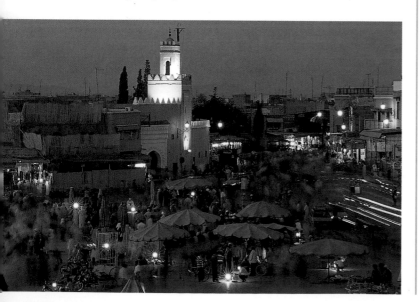

What you need
Camera Any type with a long exposure capability – 35mm SLRs are ideal
Lenses Depends what you are photographing – a wide view would suit a wide-angle lens, and close-ups a macro lens
Film Use slow-speed film (ISO 50–00) for optimum image quality
Accessories An electronic remote release with timer is handy for time-lapse sequences, plus a tripod to keep your camera in the same position

Where you're shooting outdoors – to capture the same scene every month or season of the year – it would be impractical and risky to leave your camera *in situ*. Instead, mark the spot where the first picture was taken from, putting a peg in the ground for each tripod leg, say, and make notes of camera, lens, film and so on. It's also a good idea to take the first picture along with you to check the composition when you return to take the next one in the sequence.

Use long exposures to record time

Every picture that we take represents time, simply because it captures a specific moment. On a day-to-day basis, however, we work with shutter speeds that are just fractions of seconds, so the amount of time recorded, in real terms, is tiny, and there is no sense of passing time in the final picture.

If you use a long exposure, however, you can record a greater period of time on a single frame of film, and this can produce fascinating effects. At night, for example, a long exposure of 30 sec or so will record moving traffic or exploding fireworks as light trails, or if you point your camera towards the

◀ **Marrakech**
A 30-sec exposure was used to record this dusk scene in the Djemaa el Fna in Marrakech, Morocco. By using a long exposure I was able to record the movement of people and traffic, but the effect has been enhanced by the fact that some people were stationary for the entire exposure and have recorded relatively sharp.

NIKON F90X, 80–200MM ZOOM LENS, TRIPOD, CABLE RELEASE, FUJI VELVIA, 30 SEC AT F/11

sky and use an exposure of several hours, stars will do the same thing due to the rotation of the earth on its axis. We can't see this with our naked eye because it happens so slowly, but your camera can record it.

Long exposures can be used effectively in other ways. Try photographing a coastal scene at dawn or dusk with an exposure of several seconds and the sea and clouds will blur, suggesting the passing of time, or woodland on a windy day so the swaying branches come out blurred.

Capturing time in the middle of the day isn't quite as easy because light levels are high, so exposure times are brief – even with slow film and your lens stopped down to its smallest aperture you will struggle to obtain a shutter speed slower than ⅕ or ⅛ sec.

The easiest way around this is to use neutral density filters. A 1.2 ND filter will require a four-stop exposure increase without changing the colour balance of the scene, so instead of shooting on ⅛ sec you could use 2 sec. Add a second 1.2 ND and that 2-sec exposure becomes 32 sec.

▶ Seasonal changes
Photographing the same scene through the seasons of the year is a great way to show the passing of time and its effects on the landscape. For this sequence, Pete Adams returned to the same spot every few months and took another picture.

OLYMPUS OM4-TI, 28MM LENS, TRIPOD, CABLE RELEASE, FUJI VELVIA, VARIOUS EXPOSURES AND APERTURES

▲ Sahara Desert
Camping in the Sahara Desert, I was amazed by the clearness of the night sky so I decided to photograph it. Setting my camera and tripod on a low sand dune, I pointed the lens skywards and locked the shutter open for two hours. The rotation of the earth during this period caused the stars to record as light trails – a fascinating rendition of time.

NIKON F90X, 17–35MM ZOOM, TRIPOD, CABLE RELEASE, FUJI VELVIA, 2 HOURS AT F/4

Index

Acknowledgments

All photographs are by the author except:

Tim Gartside: pages 12–13 (all), 53 (right), 130, 131, 132 (both)
Derek Horlock: pages 20, 22
Billy Stock: page 21
Simon Stafford: pages 23, 25, 53 (autumn leaf set), 54, 55, 56 (both), 121, 123 (both), 124 (top), 127 (bottom), 128 (left row, middle shot), 138, 143, 147, 153
Martin Lillicrap: pages 24, 133
Kathy Harcom: pages 76, 77
Chris Rout: page 86
Paul Cooper: page 87
Rod Edwards: page 88
Bjorn Thomassen: page 90
Umit Ulgen: pages 91, 92, 93 (both)
Tim Robinson/Sue Evans: pages 94, 95 (both), 99
Paul Exton: pages 134, 135 (both), 139 (both), 140 (both), 141, 142, 144 (both), 148 (top), 150, 151, 152
Geoff Du Feu: pages 136, 137 (both)
Peter Adams: pages 146, 149 (top), 157 (bottom, set of four)